PAINTING STILL LIFE IN GOUACHE

Kevin Scully

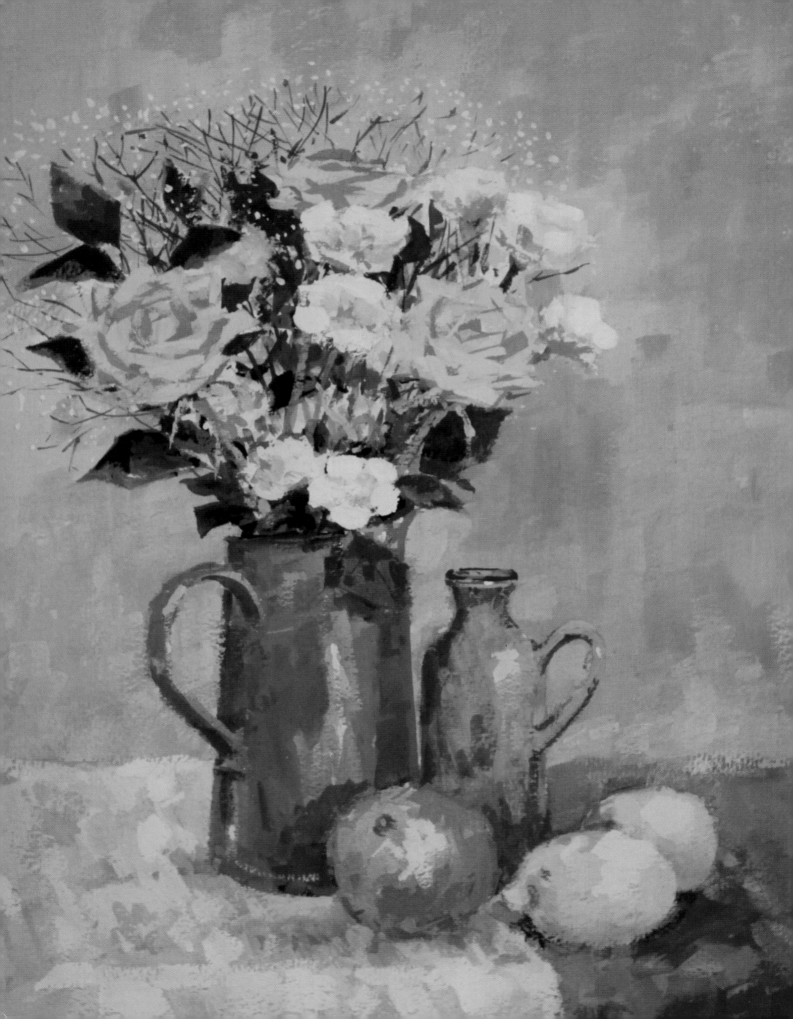

PAINTING STILL LIFE IN GOUACHE

Kevin Scully

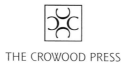

THE CROWOOD PRESS

First published in 2015 by
The Crowood Press Ltd
Ramsbury, Marlborough
Wiltshire SN8 2HR

www.crowood.com

British Library Cataloguing-in-Publication Data
A catalogue record for this book is available from the British Library.

ISBN 978 1 84797 977 3

Acknowledgements
This book is dedicated to all of those artists, famous and not so famous, both present
and past, whose work I studied and admired during the long process of writing it.
I would especially like to thank Jane Askey, Elizabeth Vann, Clare Wake and Malindy
Argyle, who kindly gave permission for their paintings to be included in this book.
 I would also like to thank the following establishments for allowing me to use their
images for reproduction: Museo Archeologico Nazionale, Napoli (*Still Life with Glass
Bowl of Fruit and Vases*); Dobiaschofsky Auktionen AG, Bern (*Vegetable Still Life*); Los
Angeles County Museum of Art, California (*Still Life with Cherries and Peaches*).

Frontispiece
Blue Jug, Green Jug, Kevin Scully. This painting demonstrates how by adding light
touches of similar colours into each of the objects, a harmonious composition can be
created.

Typeset by Jean Cussons Typesetting, Diss, Norfolk

Printed and bound in Malaysia by Times Offset (M) Sdn Bhd

CONTENTS

Introduction: A brief history 7

1. Materials and equipment 15

2. Subject matter and composition 25

3. Colour and techniques 43

4. Painting flowers 59

5. Objects and backgrounds 83

6. Advanced techniques 103

7. What next? 117

Recommended art suppliers 142

Index 143

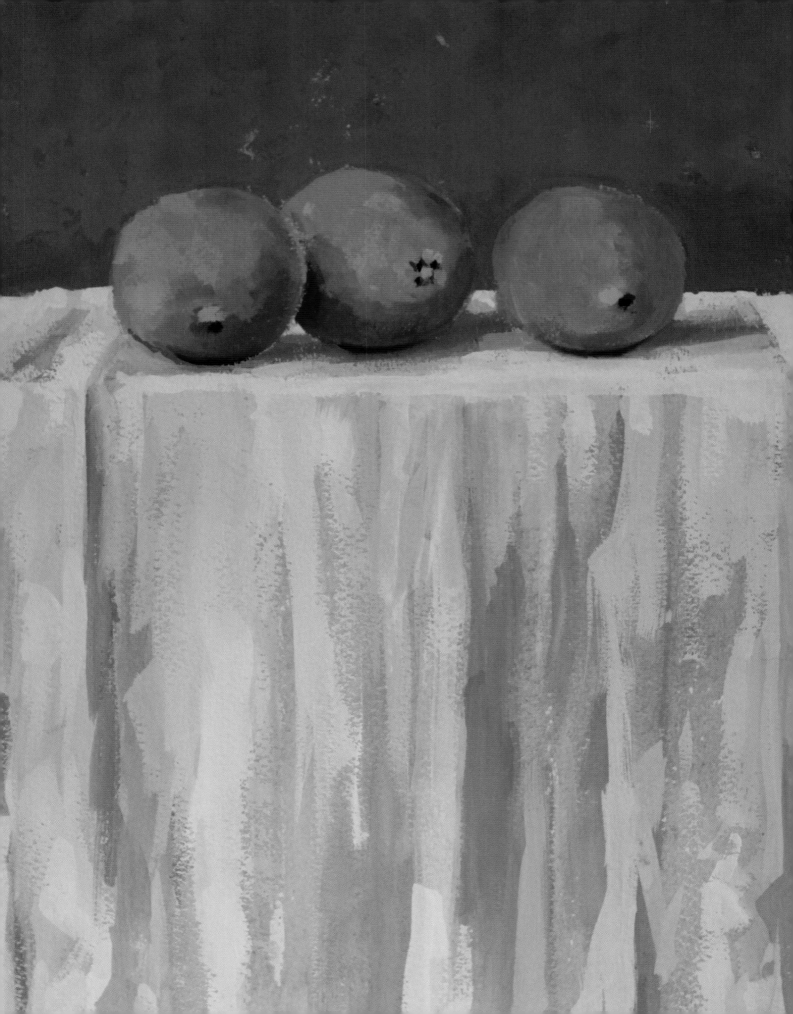

INTRODUCTION: A BRIEF HISTORY

As with many things, the precise history of gouache is vague and there are many versions to be found. However, the use of pigment in conjunction with a binder to create an opaque paint can be traced back to primitive cave paintings. The process of adding various forms of gum to pigments so that they adhere to different surfaces is also ancient.

It is generally believed that the word gouache is derived from the Italian *guazzo* or *aguazzo*, which refers to the process of applying oil paint over an egg tempera base. At some stage in history this term seems to have been transported to France, where it emerged as 'gouache' and became a generic term for all water-based paints.

The Ancient Egyptians used various binders for the pigments they used in their vibrant decorative work. These included beeswax, eggs and tragacanth, a natural gum made from the sap of assorted plant roots. Another substance was casein glue, made by mixing milk with lime. The limestone walls of tombs and temples were covered with a thin layer of plaster onto which the colours were applied. They depicted images of offerings to the gods in a rather two-dimensional way. The paint needed to be fairly opaque so that it could be applied to the stone or plaster walls of buildings and tombs. Similarly, before the existence of paper the rough surface of papyrus did not suit transparent colours.

Inanimate objects have been the subject of paintings for thousands of years. The Romans arranged groups of objects together in their mosaics and wall paintings. However, during the Middle Ages art was regarded as something to be utilized in the service of Christianity, so virtually all of the still life objects in paintings were included to embellish the religious message. It wasn't until

OPPOSITE: Three Lemons, *Kevin Scully. A painting in which a very limited colour range has been used. The focal point has been placed high up in the composition, and from here the vertical folds in the cloth lead the viewer's eye down to the bottom of the picture.*

much later that still life as we know it today became the subject of paintings in itself.

In the Middle Ages the monks used a form of gouache for illuminating their manuscripts by adding gum to their water-based media, some of these colours being as rich today as when they were first painted. As early as the late fifteenth century the German artist Albrecht Dürer was using gouache to create beautiful paintings of great subtlety and depth. Between the sixteenth and eighteenth centuries a form of gouache was being used by both Western and Eastern miniature painters and a similar medium, distemper, made from animal glue was being used in decorative application. Raphael's cartoons for the tapestries of the *Lives of SS Peter and Paul* (1515–1516), which were to be hung in the Sistine Chapel in Rome, were painted in a form of gouache.

In the seventeenth century there was a movement of still life artists in Holland that produced paintings of complex composition, depicting a huge abundance of food and drink alluding to life's rich fertility, and by the mid-eighteenth century the Dutch were at the forefront of the genre. Many Dutch and Flemish artists were working in Paris during this period and they undoubtedly had an influence on French painters. Jean-François Eliaerts (1761–1848) was one such renowned painter who has been credited with importing the Dutch still life style into France. His talent was such that he became Professor of Art at the Institute of the Légion d'Honneur at Saint Denis and so was in a position to pass on his undoubted skills to his students. During this period he exhibited many still life paintings at the Salon, with compositions set among intricate surroundings. Some of these paintings in gouache were on wood panels.

By the eighteenth century the medium had become increasingly popular with artists in other parts of Europe, including the French artist François Boucher (1703–1770), whose decorative works made great use of its subtle, matt qualities. During this period the English artist Paul Sandby (1730–1809) was using gouache extensively in his large landscape paintings, including several images of Rochester from across the Medway River and views of Windsor Castle painted in a freer, more colourful style than his earlier topographical works in watercolour.

Still Life with Glass Bowl of Fruit and Vases. *A Roman wall painting of around AD70 from a house in Pompeii.*

It is just possible that gouache was introduced into England by painters of French ancestry, such as Joseph Goupy (1689–1769), nephew of the French portrait painter Louis Goupy. Joseph was drawing master to the royal family of George I, but towards the end of his career he produced small copies of Old Masters paintings in both pastel and gouache. Paul Sandby and Joseph Goupy were contemporaries and well acquainted, so it seems fairly likely that the influence lies here.

From around 1740 gouache was much favoured by English topographical artists, but other than these painters, its use had begun to decline into purely decorative painting on household furnishings and theatrical props. There is little evidence of gouache being used in still life painting in England during this period. The Swiss topographical artist Louis Ducros (1748–1810), who was working in Italy and Malta on large format, romantic landscape paintings in gouache and watercolour, continued almost alone in his use of the medium in fine works of art. In the 1830s there was something of a revival by several Victorian watercolour artists, who continued to use gouache until the end of the century.

The medium was also adopted by the Pre-Raphaelites, and many of the most famous works by artists in this movement were painted in gouache, including the set of ten beautiful paintings by Edward Coley Burne-Jones in his Perseus series. These are housed in their own wood-panelled room at the Southampton City Art Gallery. In 1840 J.M.W. Turner painted *Fish Market on the Sands* in which he used gouache with great effect to create the illusion of an early morning foggy sky. Turner was probably the first artist to use gouache in a more innovative way, and he began to experiment with it by incorporating it into his atmospheric watercolours. In many of his paintings an array of techniques can be detected, including semi-opaque washes, wiping out and even on occasions scratching out some of the paint from the surface. The colours are left to drip and then smudged across the paper and blotted.

In the mid-1800s it was becoming popular for artists to work

outdoors and those who chose to do so were now able to carry tubes of colour rather than having to rely on paints prepared in the studio and stored in jars. Watercolour and gouache were ideal for painting *en plein air*, as all that was needed to dilute them was water. Among the many famous artists who produced paintings in gouache were Rubens, van Dyck, Poussin, Singer Sargent, Degas, van Gogh, Egon Schiele and Matisse. Matisse's famous series of 'Blue Nudes', painted in the mid-twentieth century, were produced in gouache.

A More Modern History

As early as 1825 a poster advertising 'The Opening of the Stockton & Darlington Railway' in Yorkshire was painted in gouache. In France in the 1890s Toulouse-Lautrec, among others, was using gouache to produce posters for advertising and theatre productions. In the 1920s a style was set for a whole series of railway and Underground posters, painted by a great number of prolific artists, that remained in production for many years.

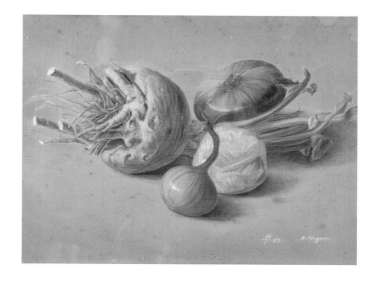

ABOVE: Vegetable Still Life, *Elise Puyroche-Wagner, 1842. A gouache painting displaying the way in which the medium can be used in both transparent and opaque applications.*

Still Life with Cherries and Peaches, *Paul Cézanne, 1885–1887, oil. Although not executed in gouache, this painting demonstrates a more modern, casual style of still life composition that had not featured in earlier art movements.*

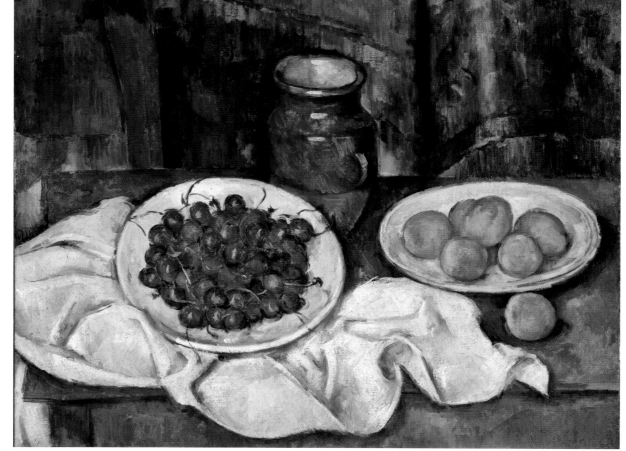

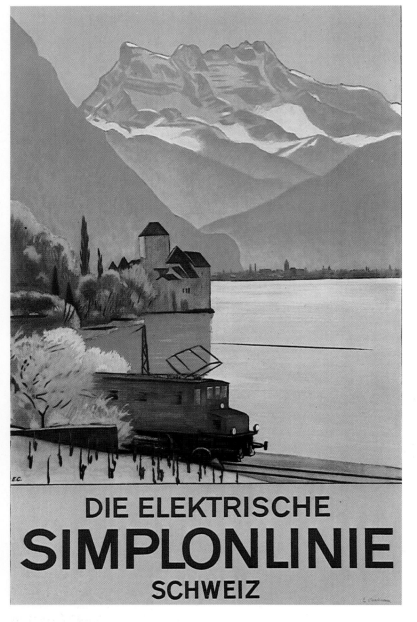

Simplonlinie Montreux, *Emile Cardinals, 1928. A poster advertising the Simplon railway link through Switzerland. One of the many thousands of transport and travel posters painted in gouache that were produced in the first half of the twentieth century.*

overshadowed by oil, acrylic, pastel and watercolour. With a few exceptions, artists using gouache for still life painting are a bit of a rarity. Because of the demand by designers and illustrators for the production of brighter, richer colours, gouache ceased to be regarded for a time by fine artists as a medium of true integrity. In the mid-twentieth century gouache was rather hijacked by illustrators as their medium of choice. It was used in posters, magazine illustrations and greetings cards by some very talented artists who chose the commercial route by which to make a living. There was – and still is – a fine line to be drawn between some commercial art and some fine art. It could be argued that anything painted with a view to selling could be considered 'commercial'. This is a matter for debate, but is probably hotly disputed by many 'fine artists'!

As with other media, there were (and still are) many ranges of gouache available that contain pigments of dubious quality and colours of a gaudy hue.

To increase the opacity of water-based paint, various substances have been added over the centuries, including chalk, marble dust and numerous other white pigments. Today's artist's quality gouache paint has little or no white pigment additives, but rather contains a much greater quantity of pure pigment than watercolour, and is suspended in gum arabic.

In the twentieth century gouache became a favoured medium among illustrators and designers working to tight deadlines in advertising and publishing, as its quick-drying quality and matt finish make it excellent for accurate reproduction at the printing stage.

In 1920s Chicago a group of artists was commissioned to produce a series of posters for the utility companies. These posters, executed in gouache in a variety of styles, included work by figurative artists Oscar Hanson and Willard Elmes and graphic artist Ervine Metzel. Some examples of the transport posters can be seen in London's Victoria & Albert Museum.

To a certain extent, gouache as a medium for producing fine art paintings has been overlooked in more recent times, being

An Alternative Medium

Watercolour, as with other media, has specific qualities unique to itself. The beauty of this medium is its ability to produce subtle effects fairly rapidly with a minimal amount of effort. The transparency of the paint allows the paper to shine through, creating a luminous glow. To retain this quality, certain techniques have to be employed and decisions made regarding how you want the finished painting to look. Is it to be painted in a loose, free-flowing style or will a careful and detailed execution produce the effect you are after?

Those who have experimented with watercolour will know

of the frustrations and disasters that can be encountered when applying layers of transparent washes, while trying to keep the painting fresh looking. All too easily a once-delicate painting can soon be reduced to a muddy, dead-looking mess. With careful planning and a great amount of skill it is, of course, possible to achieve success with watercolour, but this can be a rare occurrence, and can sometimes be attributed to pure luck. A successful painting created with quick and confident brushstrokes is much to be admired, but is usually the result of a great amount of practice and experience. Most people who start painting choose watercolour as their preferred medium and it does indeed have many attractions. It is a very portable medium and very little is required in the way of equipment. A small watercolour set with a retractable brush can fit comfortably in a jacket pocket, and all that is needed other than this is a watercolour sketch-pad and some water. It is ideal for making quick colour washes over a pencil or ink sketch as reference for a more finished painting back at the studio, or for creating finished paintings on the spot. Great effects can be achieved by painting wet-in-wet, allowing the colours to run into each other and perhaps manipulating the result by tilting the angle of the painting as it begins to dry. Some colours when mixed together contain pigments that 'granulate', causing them to separate and float across the surface of the water without actually staining the paper.

Water-based paints are familiar to almost everyone who has ever picked up a paintbrush as a child at school or at home, and thus are the obvious choice of medium with which to start painting. To paint in watercolour is extremely easy. To paint well in watercolour is extremely difficult. Although watercolour painting is perceived as a particularly British medium and very popular, it is rarely taught in art schools and those who take it up are usually left to their own devices, take lessons with a tutor at private art classes, or enroll in adult education courses. Perhaps water-based painting suits the temperament of those living in a northern climate, as it certainly lends itself to the soft, misty land and seascapes found there, and is perfect for creating scenes of moody, evocative beauty.

Watercolour, however, does have some drawbacks. An ill-considered or unplanned painting by an inexperienced artist, perhaps painted in haste, will usually be doomed to failure. Too much water added to subsequent colour washes can cause the dreaded 'cauliflower' or 'mushroom cloud' effect that is almost impossible to rectify and will remain there to haunt you for ever. Forgetting to leave areas of white paper to signify highlights can be another problem, as the paints are very difficult to wash out, particularly if the colour used has had a staining effect on the paper. Repeated efforts to lift out the colour will damage the surface of the paper, and any subsequent washes over these areas will sink in as if applied to blotting paper.

For the beginner, the first brushstrokes can often be crucial. Will the wash dry too light? Will there be streaks in the sky? Have I mixed up enough paint? Have I painted over the highlight areas? There are, of course, artists who relish this challenge and thrive on the excitement of watercolour's relative unpredictability and constraints.

Oil paints usually suit those of a different temperament. The application of oil paint is a much more physical process. Some people like its buttery consistency and the way it can be applied with less care in terms of the accuracy of initial brushstrokes. It can be applied with a brush or palette knife and then smudged, wiped, used thinly or thickly and even scraped off if you're not happy with the painting's progress. A promising painting that has taken a wrong turn somewhere along the road can be completely wiped clean with a rag and some white spirit. There are many reasons why people either like or dislike oil paint. There are those who can't stand the smell of oil paint, and those who love it. There are even those who are allergic to the oil used in its composition and to certain painting media used for thinning the paint. It is certainly not as portable and lightweight as watercolour, and more equipment is needed. It is, of course, also rather messy, so those painters who are particularly neat and tidy by nature find all the paraphernalia of cleaning brushes, palette knife and so on rather irritating. The extended drying time involved in oil painting also puts some people off, although fast-drying oil paints are now widely available, which are touch-dry overnight.

Acrylic paint is water-based and has its own pros and cons. Its fast-drying properties appeal to some people, whereas others find it a bit of a handicap, although there are additives available to slow the process down. It can be applied to many surfaces and, once dry, is pretty indestructible. It can be painted over with many layers of colour without any ill effect. It can, though, be a destroyer of brushes if they are not thoroughly washed after (and sometimes during) each painting session. An acrylic painting can resemble an oil painting, and it is sometimes difficult to distinguish one from the other, although it could be argued that it does have the suggestion of a slightly 'plastic' look to its finished surface in contrast to the depth and richness that can be achieved with traditional oil paint.

Why Choose Gouache?

Gouache as a painting medium is not at the forefront of everyone's mind and in truth many people are unaware of exactly what it is. It is a rather forgotten medium, but one with endless possibilities. It is often labelled commercially as 'Designer's Gouache', which may perhaps be the reason why it is often

A demonstration of the way in which some colours granulate when used in a wash; the pigment separates from the water and sits on the surface of the paper.

dismissed as something that should only be used by designers and illustrators, and not fine artists.

Any of the media described previously can be used to produce wonderful still life paintings, so why choose gouache? Perhaps in its use, gouache is a combination of some of the painting processes used in both watercolour and oil paint. If cost is a consideration, then gouache is cheaper than both. If you have found the drama and occasional disappointments of using watercolour a little too much, maybe here lies the medium for you. It is far less likely to make you want to tear your hair out and rip up your failed painting efforts. The process of producing a painting in gouache can be approached in much the same way as that of a watercolour. Initial washes can be applied with the paint thinned to a pale consistency without worrying too much about any small blemishes. Subsequent applications of paint containing more pigment and less water can be tackled in a way more akin to that of an oil painting, slowly adjusting the tonal intensity as the painting progresses. These layers can be a combination of both transparent and opaque colour. Colour can be adjusted and mistakes corrected without too much fuss, either by painting over with another colour or by carefully washing out the offending area and repainting it once dry.

Gouache is generally used on fairly smooth paper; as the paint contains finely ground pigments, it *sits* on the surface of the paper, in contrast to watercolour, which tends to sink *into* the paper. This gives gouache a smooth, matt finish that makes it ideal for illustrations that have to be scanned or photographed for reproduction. It is also a fairly fast-drying medium suited to the rigours of commercial deadlines. Today's designers and illustrators have largely abandoned the use of paint in favour of

computer software such as Photoshop and Illustrator, so perhaps fine artists are turning to gouache once again.

Because it flows more smoothly than acrylic paint, it is ideal for abstract and contemporary stylized paintings that require areas of flat colour. It is a versatile medium that can be used by artists to paint subjects in an array of personal styles. In short, gouache has many of the properties of other media without many of their limitations.

What is Gouache?

Gouache is a water-based medium and is closely associated with watercolour. Unlike watercolour, it is intended to be an opaque medium, although it can also be applied in transparent washes and sometimes the result is virtually indistinguishable from watercolour. One of its advantages is that it can be used in both transparent and opaque washes. The initial laying-in of colour can be executed in the same manner as one would approach a watercolour painting. Subsequent applications of colour can be painted more thickly, as in an oil painting. As there is not much of a purist tradition associated with gouache as a medium, there are not really any hard and fast rules to follow. So, in one sense you have a free hand to experiment with the medium's capability without the fear of worrying about whether or not you are doing the right thing.

Gouache possesses a great many of the qualities of both watercolour and oil paint, and if you enjoy painting in both or either of these media then you will probably find it fairly easy to get along with.

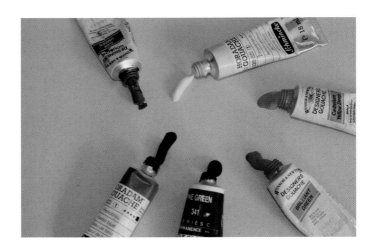

Tubes of gouache from some of the ranges of artist's quality paint available, showing the medium's rich, buttery consistency.

Why Still Life?

Still life painting is often thought of as something that artists get up to when they can't think of anything else to paint, or because it's too cold or too wet outside for painting landscapes. Or there may be many other practical or physical reasons why artists revert to still life. To a certain extent this may be true, but a successful still life painting still demands as much creative thinking and planning as any other form of painting, whether it's landscape, seascape, portrait or abstract. In any of these various categories of painting certain decisions have to be made: where will the emphasis or focal point be? What kind of mood do we want to suggest? Will the colours be harmonious or contrasting? What shall I leave out or what should I add?

Even if you are a landscape painter, you will feel a lot more comfortable making these decisions in the comfort of your home, by completing your final painting from sketches or photographs. As well as these considerations, in producing a still life painting you will need to utilize your drawing and compositional skills. Just because painting still life subjects may have practical advantages over some more challenging aspects of painting, it should never be considered a lesser form of art. A good painting is a good painting no matter what category it falls into. Similarly, a bad painting will always be a bad painting.

Any time spent drawing and painting is time well spent. It will improve your observational skills, your technical skills, your compositional skills and your decision-making.

MATERIALS AND EQUIPMENT

Artist's quality gouache nearly always comes in tubes. There are several good products available, including those made by Winsor & Newton, Daler-Rowney, Schmincke, Sennelier, Pebeo T7, Talens, Lefranc & Bourgeois, Lukas and M. Graham. There are other brands that are perhaps of an acceptable quality, but depending on availability I would recommend starting with a few tubes from the range of one of these manufacturers. Cheap, low-quality paints are to be avoided like the plague, as are the 'poster' paints sold in round pans. If you encountered these during your schooldays, you will remember them as being particularly non-user friendly. No amount of scrubbing the rock-hard cakes of pigment with a wet brush could persuade them to release enough colour to cover a postage stamp.

Gouache is normally available in 15ml and 38ml tubes, but sizes vary according to the brand. White is available in larger sizes and some brands sell gouache in larger jars. As with watercolour, gouache colours possess different degrees of permanence, and this is indicated on the labels. Depending upon which brand you use, it will be indicated either by a code of letters or some other grading system. Winsor & Newton's system gives the most permanent colours an AA or A rating and the least permanent a C rating, with B in between. Daler-Rowney's rating system uses asterisks. The greater the number of asterisks, the greater the degree of permanency. They represent the degrees in these terms: Permanent, Normally Permanent, Moderately Permanent and Fugitive. Fugitive colours are likely to fade over a period of time, so if you are worried about your paintings losing their initial brilliance when they are hanging in the Tate or the National Gallery to be admired by future generations, perhaps they are best avoided other than in very small quantities.

There are some brands of gouache available, such as Holbein & Turner from Japan, that are acrylic-based, and a recent product on the market is Shin Han Pass, which is a hybrid paint that can apparently be used as both gouache and watercolour. As

with most new products, the reviews are mixed, but perhaps this is something that you might find suits your style of painting. The pigment in this paint is very strong and some of the colours can stain the paper, which makes 'lifting out' difficult when used in thin, watercolour washes. This is a technique used by watercolour artists to lighten certain areas already painted by rewetting them with clean water and dabbing with tissue.

Quite often your choice of brand will be dependent on where you live and availability. If you are a lover of bees, I would suggest using M. Graham's range of gouache from the USA that incorporates honey into the manufacturing process of its paint. You will quickly become very popular with the local honeybee population, who will soon be buzzing around your painting to see what you're up to.

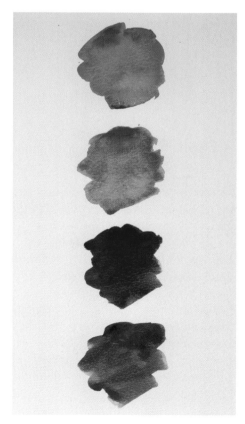

Even when painted in a semi-opaque manner, certain colours will granulate. The examples shown here are (from the top): Cerulean Blue, Raw Sienna, Burnt Sienna and Ultramarine.

OPPOSITE: *A selection of the materials that you need for painting in gouache.*

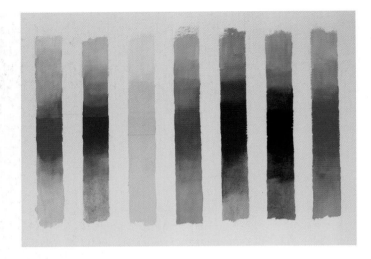

This image shows gouache in its opaque form in the centre of these bands of colour. Towards the top, white has been gradually added, and at the bottom water has been added. Although the colour at both ends of these bands appears to be quite similar, where the paint has been diluted with water, the granulation effect is evident.

> *'They'll sell you thousands of greens. Veronese green and emerald green and cadmium green and any sort of green you like; but that particular green, never.'*
>
> Pablo Picasso, 1966

A Basic Palette

Start off by buying a few individual colours, rather than a 'starter set'. These sets certainly contain some useful colours but there will also be colours that, for whatever reason, you may never use, or may use so infrequently that over a long period of time they will solidify in the tube. If you haven't painted before, a good selection of colours includes:

Permanent White	Ultramarine
Cadmium Red	Brilliant Violet
Cadmium Yellow Light	Pine Green
Raw Sienna	Raw Umber
Cerulean Blue	Burnt Sienna
Cobalt Blue	Lamp Black

In some of the demonstrations in this book other colours were also used; they included: Cadmium Orange, Tyrien Rose, Helio Blue, Scarlet, Turquoise and Magenta.

If you have used watercolour, acrylic or oil paint before, you will have your own favourite colours. Different brands use differing names in their colour ranges, so a colour chart will come in useful when deciding which ones to buy. Cobalt Blue from one manufacturer may be quite different in appearance to a colour with the same name from another manufacturer. As you produce more paintings over a period of time you will naturally accumulate extra colours for specific projects: a vivid Magenta for a particular flower, or a Viridian or Turquoise Green for a certain fabric, and so on. There will be colours that you are just unable to mix from your basic colour range and these will have to be purchased when necessary.

COLLECTING COLOUR CHARTS

It may be that you already have some favourite colours, but gather together some manufacturers' colour swatches and you may find some colours that you hadn't previously thought of using. These swatches will also be useful for future reference should you need to buy a certain colour that your local art shop doesn't stock. Specific colours can then be ordered from a variety of suppliers. Remember, though, that printed colour charts may not be a 100 per cent true representation of the actual colour in the tube, although most of them will probably be accurate enough for your purposes. Hand-painted colour charts are sometimes available but can be expensive.

Paper

There are many papers on the market that are suitable for painting in gouache, most of which are sold as watercolour paper. There are three main types of this paper from which to choose: Rough, Not, and Hot-pressed (HP). Rough, as the name suggests, has a textured surface, which creates variations in the appearance of a colour. Where the paint sits in the slight indentations it can appear slightly darker in tone because of the shadow created by the undulation of the paper. This gives a slightly mottled look, so attractive in a watercolour painting. Using thin transparent gouache washes will give a similar result. Using the paint more thickly won't produce quite the same effect, as it will fill in the crevices of the paper. HP paper is the smoothest in the range and is perhaps more suitable for small, precise paintings.

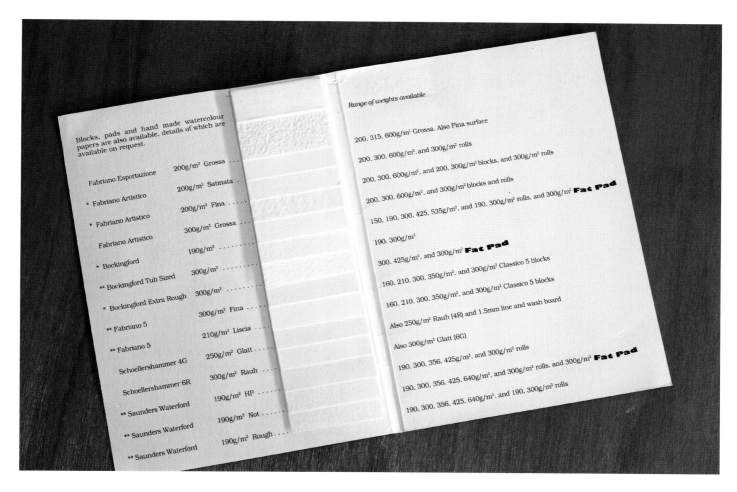

A book of watercolour paper samples showing just some of the vast variety of papers available in HP, Not, Rough and Extra Rough finishes, and the range of weights available. Although all of these papers are classed as white, it is noticeable that some of them are whiter than others.

The image shows the effects of the same colour applied to some of the different watercolour papers available. They are (from the left): Fabriano Artistico HP 200gsm, Daler-Rowney Saunders Waterford Not 190gsm and Bockingford Rough 190gsm.

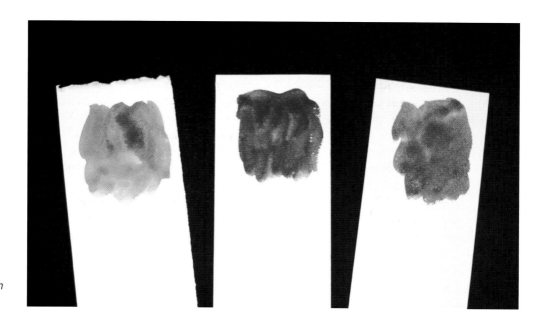

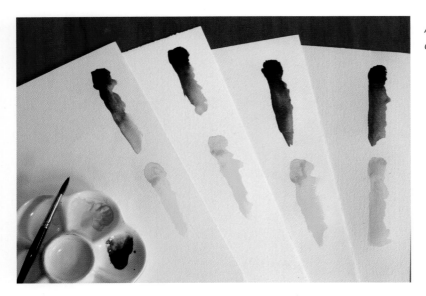

A range of tinted watercolour paper showing the slightly different effects that the same colours have on each.

On larger works the paint will tend to slide across the surface of the paper as it is less absorbent than either Rough or Not. The most commonly used paper is Not, which has just about the right balance of texture and absorbency. There are considerable variations in the degree of texture and absorbency from one manufacturer to another, and, as paper is made from a number of different raw materials and processing methods, it can behave in different ways, so it is best to experiment with a range of papers until you find one that suits you.

Watercolour paper has a right side and a wrong side. Either along the bottom or in the corner of a sheet of watercolour paper there will be either a manufacturer's watermark or an embossed logo. The right side for painting is the side where you can read the watermark correctly or the side where the embossed logo is raised and legible. It is possible to use both sides, but on each side the paint may behave in a slightly different way.

Paper also comes in a bewildering array of weights and is specified as either grams per square metre (gsm), or pounds per ream (lb) and sometimes both. All you have to remember is that the higher the number, the thicker the paper. Usually 300lb (600gsm) is the heaviest easily available and 60lb (120gsm) the lightest. If you choose a paper less than 200lb (410gsm) you will have to stretch it, as you would when preparing a watercolour. If cost is not an issue you can paint on the board-like 300lb weight without fear of the paper buckling from the application of generously diluted paint. Heavyweight paper is expensive so a compromise would be to use 200lb paper or perhaps stretch some 90lb paper. This method is described here.

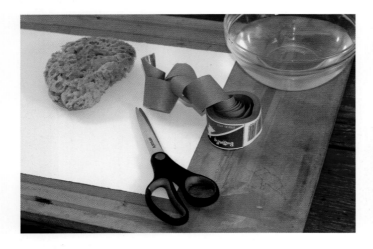

The equipment needed for stretching paper: a sturdy drawing board, watercolour paper, Gumstrip, sponge, scissors and a bowl of clean water.

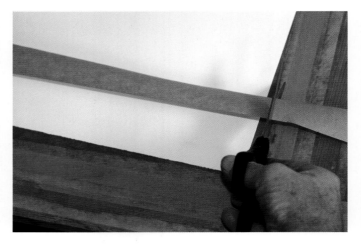

Cutting the Gumstrip to size. Make sure the strips are long enough to overlap at the corners of the paper.

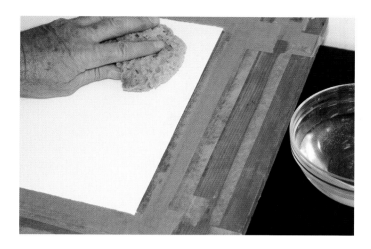

Dampening the paper with a sponge. If you have already drawn out your composition on the correct side of the paper, and you don't want to smudge the drawing, it is possible to dampen the back instead of the front.

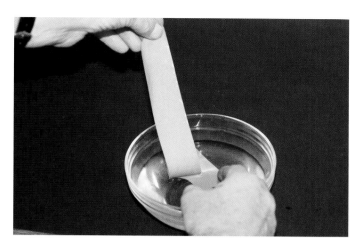

Holding the Gumstrip at both ends, run it through a bowl of water, making sure that the whole strip is wet.

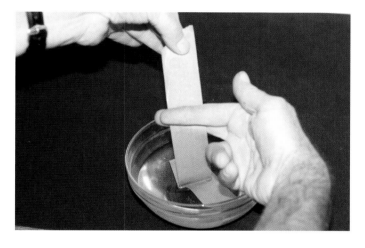

When all of the Gumstrip is wet, remove the excess water by running it between your forefinger and middle finger. Tape each strip down immediately, starting with the two longest sides, smoothing it out to flatten it if necessary.

Make sure half of the Gumstrip is on the paper and the other half is on the board. Run your fingers along the edges to make sure it has stuck securely.

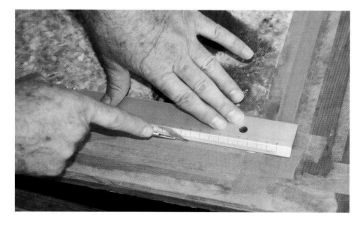

When you have finished your painting, you can release the watercolour paper from the board by cutting through its edge with a scalpel. Be sure to use a steel-edged ruler when using a scalpel or craft knife.

Stretching Paper

There are various methods of stretching paper onto a drawing board and many people advocate soaking the sheet in a bath of water for various lengths of time ranging from thirty seconds to half an hour. The reason for doing this is to expand the fibres of the paper. Once the paper has been stuck down and begins to dry, the fibres contract and the paper becomes taut. When the paper becomes wet during the painting process, it may buckle slightly, but as it dries it becomes taut again. Personally, I find this lengthy soaking is usually unnecessary. So try this quick method.

1. Cut your paper to the required size, adding an extra inch or so all around.
2. Cut or tear two strips of Gumstrip to a length 2 or 3 inches longer than the longest sides of the paper. Repeat this for the shortest sides of the paper. Make sure your roll of Gumstrip doesn't get wet, or it will stick to itself and become useless.
3. Fill a bowl or tray with water.
4. With a clean sponge, dampen one side of your paper, making sure all of it is covered. It's not necessary to completely soak the paper.
5. Lay the paper flat onto your drawing board. You have to work fairly quickly now as the paper, depending on its thickness, may start to curl.
6. Holding each piece of Gumstrip at both ends, run it quickly through the water in the bowl or tray and then remove the excess water by running the Gumstrip between your index and middle finger. Alternatively, you can just run both your paper and the lengths of Gumstrip under a gently running tap.
7. Working on the longest sides first, stick the paper down to the board, making sure half of the Gumstrip is on the paper and the other half on the board. Carefully flatten the watercolour paper if necessary and then repeat the process for the shortest sides of your paper. Overlap the Gumstrip at the corners.
8. Check again that the Gumstrip has stuck to both the paper and the board by running your thumb along its width. Be careful not to wipe the glue from the Gumstrip onto your watercolour paper.
9. Leave to dry. If you are really impatient to start painting, you can very gently use a hairdryer to speed up the process. Keep the hairdryer moving over the whole area in a circular motion, but not too close to the paper. The aim is to get the paper and Gumstrip to dry at the same rate.

Once your painting is finished, it won't be possible to remove the Gumstrip. Instead, run a scalpel or sharp craft knife along the edge of your watercolour paper. You will be able to see the raised edge of the paper where it's stuck to your board. The Gumstrip that remains along the edge of your painting can be hidden under a mount when the masterpiece is framed.

The method described here is just one of many, so feel free to experiment. If you find that your paper hasn't dried flat, you can always remove it and start again. With a little practice, stretching paper is a process that can be completed successfully each time.

MASKING TAPE OR GUMSTRIP?

You may be able to use masking tape to secure your paper to your board, but there is a chance that it will lift and the paper, once wet, will buckle. Depending on the weight of your paper, it may start to curl once you have either soaked it in water or dampened it with a sponge, so you will have to work quickly. It's important to have your Gumstrip already cut to the required lengths, with a bowl of water or running tap to hand.

Daler-Rowney's 'Saunders Waterford' 90lb Not is perhaps a good starting point. This is now available in a 'High White' finish that enhances the effect of luminous transparent washes, but do experiment with other papers as they can differ greatly. Many watercolour papers are a shade of off-white and some can be rather creamy in colour. For the sake of economy, it's usually best to buy sheets of 'Full Imperial' size paper and cut them down to the required size.

There is also a limited range of tinted watercolour papers obtainable in subtle shades of grey, pale blue, cream and beige. Depending upon the subject matter, these can add an all-over unifying mid-tone to a composition. Because with gouache the highlights are created with opaque paint, it's not always necessary to begin with a pure white paper, which is the best starting point in a watercolour painting where the highlights are created by retaining the white paper. Pastel papers come in a great range of colours but because they are pretty flimsy they will have to be stretched to avoid buckling. There are also various handmade papers to consider experimenting with. Pastel Board and Illustration Board are other alternatives but are expensive. Mount Board, which comes in many colours, is another possibility providing you don't use too much water, as the surface paper can lift away from the base of the board (which is a kind of compressed paper or cardboard).

Despite its name, Bristol Board is actually a smooth, heavy-

Pastel paper is an alternative to watercolour paper, and is available in a great variety of shades. It has two different sides: one side has a rather mechanical texture and the other side is smoother.

weight paper produced predominantly for airbrush and smooth, line and illustration work. This too can be used as a painting surface for gouache. Because of the paper's smoothness and lack of absorbency, the paint will tend to slide across the surface when used in a thin wash, resulting in an effect characteristic of this particular paper.

For very small paintings it's even possible to use good quality,

STRETCHING PASTEL PAPER

Because pastel paper is rather lightweight, it should always be stretched. You should ensure, however, that you only dampen the paper slightly before stretching it as there is a possibility that it will tear as it dries under the tension of the Gumstrip holding it in place.

thick cartridge paper, providing you are not too liberal with the water.

Painting Equipment

It is not necessary to spend a lot of money on equipment to paint in gouache, and if you already paint in watercolour then you will probably have it all anyway.

Brushes

If you are just starting out in painting, you can get away with just four or five brushes. The best brushes available are Kolinsky

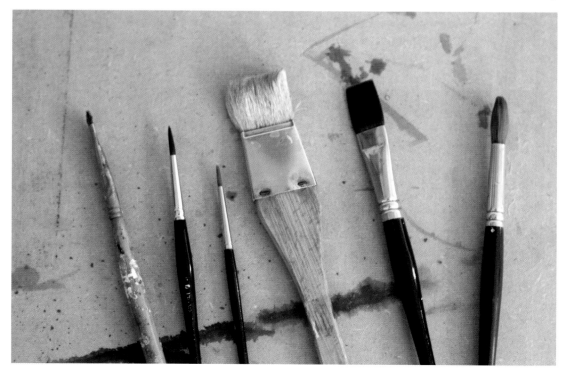

A small selection of brushes in different sizes and shapes is all you really need to get started. Sable brushes are the best, but semi-synthetic ones do the job adequately.

sable. These are expensive but will last a very long time. Investing in a No. 3 and a No. 7 will cover most eventualities, but if you like to paint in great detail then you could also add a No. 00 or No. 1 sable. A wide Hake brush for large washes and a square-ended flat brush size No. 10 or 12 will complete the set. There are many other brushes you could buy but most of them are unnecessary to begin with. If you want to economize, there are brushes of a sable/synthetic mixture that are perfectly adequate for most jobs. Another useful addition is an old brush that you can use for re-wetting paint that has dried on your palette. This is something for which you may not want to use your expensive sable brushes, as the repeated gentle scrubbing will have an abrasive effect on them and over a period of time will reduce them to stumps of tufty hairs and render them useless.

Palettes

There are many palettes available commercially, both plastic and ceramic. The disadvantage of plastic is that it usually becomes discoloured through the staining effect of some of the pigments and this cannot be removed. If you are a painter who likes to work with pristine materials, then a ceramic palette is probably the one to choose. If possible, find a large one or perhaps a few small ones that are capable of holding a reasonable amount of colour for large areas of washes. As gouache dries out fairly quickly you might consider a 'Stay-Wet' palette, of the sort primarily produced for acrylic painters to prevent the paint drying out. It consists of a plastic tray supplied with a transparent lid, together with sheets of absorbent paper and membrane

paper. Water is added to the bottom of the tray over which is placed the absorbent paper. On top of this is laid the membrane paper. The colours are squeezed onto this and are kept sufficiently damp and workable by the moisture that seeps upwards. When the lid is added, the colours will remain in a workable state for several days. There is probably not much need for this kind of palette unless you are using large amounts of colour that you have mixed and want to keep for subsequent painting sessions, where the need for consistency is an important factor. With economy in mind, a couple of white china plates make perfectly acceptable palettes.

Media

Water is, of course, the main medium for gouache painting and can be kept in any container from a jam jar to a large bowl. It is useful to have two containers of water, one for washing your brushes and another for diluting your paint. These should be replenished regularly to prevent your colours from becoming muddy. A bucket of water on the floor is an excellent vessel in which to quickly swill around your brush, in preparation for the next colour mix.

There are many media on the market for extending gouache's creative potential. Ox gall liquid can be added to the paint to improve its flow and you may want to add Blending Medium to slow down the drying process if you are painting outside, particularly in a hot climate. If you like to apply the paint in layers, the addition of a little Gum Arabic will help reduce the possibility of cracking. However, too much Gum Arabic will increase transparency and gloss. If for any reason you want to make the paint

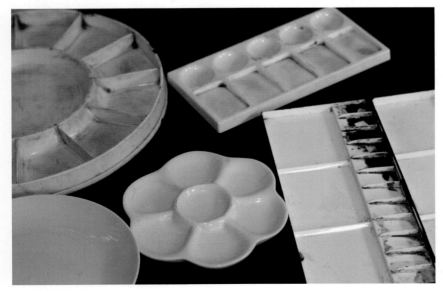

Over a period of time plastic palettes inevitably become stained. More expensive alternatives are ceramic or enamel palettes, but these are usually only available in smaller sizes.

Beach Finds, *Michele Webber. A seashell still life, painted in the studio and featuring a large cream shell and a yellow starfish, plus smaller shells and pebbles. This painting was rendered in a combination of watercolour, gouache and watercolour pencil, to capture the delicate chalky texture of these lovely natural objects.*

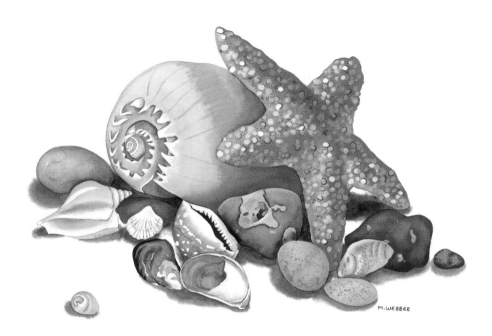

water-resistant when dry, you can add Acrylic Matt Medium. This will darken the tone of the painting though and contrary to its name will make the finish less matt.

If none of these additives is of any interest to you, just add water. Little else is needed in the way of materials apart from a pencil, rubber and a small natural sponge for wiping out mistakes and even laying-in areas of colour. A hairdryer is useful for speeding up the drying process between washes. A small spray diffuser for re-wetting paint, a drawing board and a roll of Gumstrip for stretching paper completes the list.

of adjustable height is a useful addition for creating dramatic highlights and shadows.

As a painter (or would-be painter), you will probably be something of a collector of objects. You may have things squirrelled away that once took your fancy in a junk shop somewhere but you couldn't find a home for. Jugs, plates, baskets, teapots, cups and saucers are all things that still life paintings are made of.

Other Equipment

For painting still life subjects you will obviously need something to paint! The subject matter is endless but you will need a few essential props: a table or plinth on which to place the objects, and a collection of backdrops, including fabrics, old curtains, coloured paper, napkins, tablecloths, timber – in fact anything with a variety of colour and texture. A spotlight

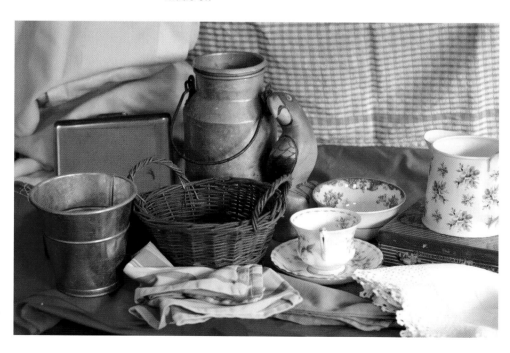

A collection of junk shop and jumble sale finds can be accumulated and stored as future subject matter for your compositions.

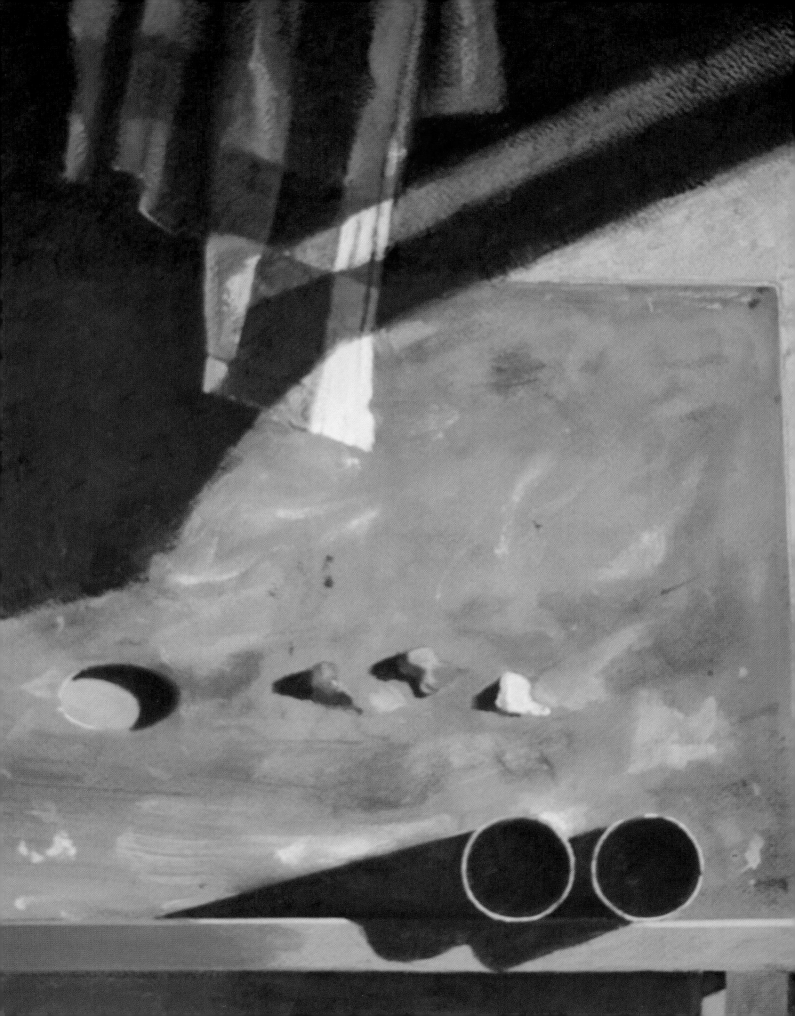

SUBJECT MATTER AND COMPOSITION

'The job of the artist is to deepen the mystery.'

Francis Bacon

Inspiration

Leafing through any lifestyle magazine, you will be immediately aware of the discreet work of stylists, photographers and designers in the images of carefully arranged interiors with a throw nonchalantly tossed over the back of an antique chair, or a rustic bowl on a scrubbed pine table containing a mound of cherries. Each of these objects possesses its own individual beauty, but viewed collectively they take on a far greater splendour. Their work is to be much admired and I'm sure if they could paint as well, their creations would be exquisite.

As with all things, there is an ever-changing fashion element to these images. Similar magazines from previous decades will rarely arouse the same sensation. It is, of course, all a matter of taste and personal preference, but is also surely unlikely that leafing through art books full of Dutch still life paintings from the seventeenth century will inspire you to set up great piles of vegetables, fruit and dead animals draped over silver salvers. Although there is much to be admired in their draughtsmanship, composition and intricate detail, this is probably not the material of great motivation to get you painting. Or maybe it is. However, you may be driven to reach for your pencil and paint brush by chancing upon the image of a still life painting by Cézanne or van Gogh, Degas or Manet. There is virtually no gouache to be detected among these paintings, but no matter. It's the arrangement of interesting, or sometimes fairly mundane, objects in an often rather random fashion that will hopefully send you burrowing into your cupboards and drawers for those vases, cups and saucers and pots and pans.

Recipe books with sumptuous photographs of ingredients are also a great source of ideas. Your fridge or larder can be a treasure trove of painting material and if there isn't much in there, a trip to the market or shops will provide you with some colourful fruit and vegetables. On your way, you may be inspired by a shop display in the high street, where the art of a window dresser has created something wonderful from the objects on sale within. Similarly, a florist's forecourt may exhibit a surprising grouping of flowers that you would never yourself have put together.

You may want to take a photograph for future reference, or perhaps even buy the flowers on display and set them up at home, ready to paint. Your garden, if you have one, may also contain suitable objects for stimulation: terracotta flower pots, garden tools, old sieves, gardening gloves, boots, apple crates, hessian sacks and, of course, flowers.

Look around everywhere, at everything. There will be something somewhere to inspire you.

Collecting Objects and Fabric

Your home is the most obvious source for items to use in setting up a still life. Presumably your home contains things that you like, and painting those things that are special to you is a good starting point. Other people's homes may also contain things that you lust after to paint.

Jumble sales and car boot sales are great places to begin building up a collection of interesting bits and pieces. Here you will find a great assortment of what someone considers to be junk, or just no longer requires. For very little money you can

OPPOSITE: Palette, *Kevin Scully. This semi-abstract painting on pastel paper has employed several different techniques associated with gouache painting. The strong shaft of light shining across the picture creates vigorous, diagonal shapes in contrast with the muted and obscure residue of colours that have been wiped from the palette. The three colours that have just been squeezed out of a tube suggest that perhaps work is about to begin on a painting.*

Inspiration can be found everywhere, and even the most humble of objects can provide the basis for a great painting. This collection of garden paraphernalia offers a wealth of colour and contrasting texture and form for an exciting composition.

pick up a china tea set, an old coffee pot, vases, and yards of assorted fabrics. To a lesser extent, charity shops can provide some interesting bits and pieces. Antique fairs may also include the odd stall that isn't really selling antiques, but merely bric-a-brac that won't be too expensive.

One of the joys of trips abroad is hunting for something interesting to bring back home that will remind you of your holiday. Although, unless you journey to the back of beyond, there is little these days that can be brought back from other countries that can't be found at home; it will just be cheaper over there (providing the cost of getting it back home isn't prohibitive). And painting that beautiful piece of fabric that you bartered so doggedly for in that market in Bolivia will probably have greater meaning for you than painting the piece that you picked up cheaply in a jumble sale at home.

If you set your sights higher and want to paint beautiful but expensive antiques that you unfortunately don't have in your possession, you can always hire them. There are companies that provide this service primarily for film and TV productions, theatres and photographic studios. If painting stuffed animals is your thing, you can hire all sorts of creatures from taxidermy establishments.

The more things you collect the better, as you won't want to paint the same objects over and over again and it may be possible to get together with other artist friends to swap your respective paraphernalia from time to time.

'As practice makes perfect, I cannot but make progress; each drawing one makes, each study one paints, is a step forward.'

Vincent van Gogh

The Importance of Drawing

If possible, you should practise drawing regularly. There are some who consider drawing to be a minor art form compared to painting, but all good paintings are underpinned by good draughtsmanship. There is little virtue in a work skilfully executed in paint if it has been badly drawn in the first place. A beautifully painted picture with suspect perspective and lop-sided ellipses will have been time and skill wasted. If badly drawn, the mistakes will be there to haunt you for ever. It is well worth the effort to spend time getting everything right before you begin painting and a few pencil marks in the right place will be worth a hundred exquisite brushstrokes in the wrong place.

Not every shadow, highlight or undulation needs to be drawn, as this is usually better executed with a brush, but if everything is in the right place to begin with, you're off to a good start. Even a painting carried out very loosely with a minimum of brushstrokes will be successful if carefully planned.

By drawing, you will also be familiarizing yourself with the subject, as the process of drawing involves careful study and observation. Does that leaf go behind that flower? How can I show the thickness of that glass vase? What makes that onion look as though it's actually sitting on that chopping board? These are all questions that can be answered by careful observation. Drawing is the implementation of the solutions to these questions. Problems that arise can all be worked out on a separate, preliminary drawing before tackling the finished composition. With practice, your eye will become sharper and there will be less need to do these initial drawings, though drawing just for the sake of it can be a pleasure and reward in its own right.

I often hear people say 'I can't draw faces' or 'I can't draw trees', but all drawing is down to observation and if through practice you train your eyes to scrutinize and dissect everything you see, eventually you will be able to reassemble all the ingredients on the page. The hours of concentrated observation involved in improving your drawing skills will inevitably pay dividends in the end. Unfortunately there are no short cuts to competent drawing. Constant practice will enable you to draw well, and when you can draw well you can draw anything.

Drawing by Eye

'Sight scale' is a method by which you can establish the approximate proportions of the objects you are drawing and transfer them onto your paper.

This is the traditional method of drawing by sight scale: take a reasonably long pencil and hold it at arm's length away from you. Make sure your arm is straight and close one eye. Choose one object and hold your pencil so that the top of it is in line with the top of the object. Now slide your thumb down the pencil until you reach the bottom of the object. You can now transfer this 'measurement' onto your paper. It helps to be ambidextrous when you do this, as you can tick off the measurement onto your paper using a pencil in the other hand. You can continue doing this with both verticals and horizontals.

The pencil is the traditional tool for this exercise, but a better way to do it is to use a ruler, preferably one that is scaled in millimetres. This makes life a lot simpler if you want to increase the size of your drawing. For example, when you hold your ruler in front of an object and the measurement is 30mm high and you want to make it three times larger, you simply multiply 30mm by three and draw it 90mm high. The same method is then used for the other objects in your composition.

At this stage just make tentative marks to indicate the positions of all the objects. With this process you can keep checking the sizes of objects in relation to one another until you're happy that everything is in the right place.

With both of these methods be sure to keep your position constant, as any variation will affect your measurements.

Composition and Viewpoint

By understanding and applying the basic rules of composition you will be able to create interesting arrangements in your still life paintings. Variation, balance and contrast are all important aspects of a painting and introducing them into a picture will

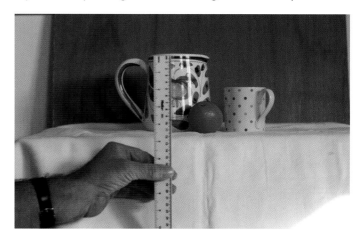

By holding a ruler at arm's length, you can take measurements from your composition and transfer them onto your drawing. If the objects appear too small on your drawing, you can simply multiply each measurement by the required number to increase their size.

Chrysanthemum Fan and Yellow Bird, *Jane Askey. The Chinese temples of Hong Kong inspired the artist to create new and brighter still life paintings on her return to the UK. Their daily ritual of offering fruit and flowers at the altar inspired her practice of creating in her studio a lively mix of flowers, fruit and objects. In the painting a jewel-like pattern is richly detailed and carefully spaced throughout the composition. Actual Chinese objects include the fabric bird and the chrysanthemum fan, and these were mixed with Western finds to create a colour mood reminiscent of what the artist saw out in the Far East. She did not try to copy or recreate, but wanted instead to interpret the idea of the still life being like a religious offering, a celebration of beautiful vibrant colour seen in natural and man-made objects, combined with clashing intensity. As a result of the Hong Kong visit, the artist was inspired to explore a brighter colour palette, taking risks with unusual colour combinations aiming for clarity of colour and vividness.*

help you produce work that is both exciting and stimulating. Even if you are intending to produce abstract work, symmetrical compositions tend to instill a sense of calmness into a picture, but they can also be rather static and dull even though your eye naturally likes symmetry. An asymmetrical arrangement will introduce a slightly more 'edgy' element.

Even in a still life painting, the positioning of objects can give a feeling of movement as the eye is coaxed into travelling from one object to another, finally settling on the main focus of the painting.

Unlike landscapes, seascapes or, to a certain extent, portraits,

still life is a form of painting where the artist can be in total control of the arrangement of the subject matter. When setting up a still life, it's important to bear in mind the size of the objects and how their different proportions relate to each other: large and small, close up and further away. When grouping several things together, the aim is for a unified composition in which nothing looks out of place nor at the wrong scale.

In your compositions, don't rule out empty spaces. The careful positioning of empty space, juxtaposed with areas of interest and detail, can add both balance and impact to a composition.

A viewfinder, which can be simply made from two L-shaped

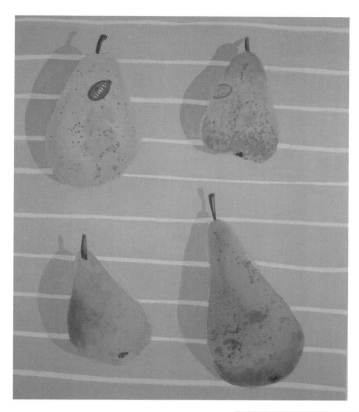

pieces of card held or taped together to form a rectangle, is a useful aid in helping you establish a satisfactory composition. A few pieces of card with squares or rectangles of varying ratios cut in them are useful additions to your painting equipment.

I also think that God arranged our thumbs and forefingers in such a way as to assist artists in deciding on a composition for their paintings.

Rule of Odds

Here are a few things to consider when deciding upon a composition. Collect together a few items that you would like to paint. Begin by arranging just two of those items, perhaps a jug and an apple, so that you are happy with the composition. Then add a third object, in this case a bottle. Although the first composition may be acceptable, by adding a third element the possibilities for producing a well-balanced picture are increased. If you introduce a fourth component into the equation the arrangement then becomes slightly imbalanced again. It is generally accepted that this is because your eye and brain automatically

ABOVE: **Four Pears,** *Jane Askey. A beautiful sky-blue apron was the starting point for this painting of four pears. The artist wanted to create a simple arrangement of objects and pattern to focus the eye on the shape, form and texture of the pears. Gouache was laid down in washes to establish the colour and shape of the pears and the intense blue and the deeper shadows cast by the fruit were added at the last stage. The intense contrast between the foreground and background gives the painting its impact and drama. The white stripes are simply unpainted areas of white paper. Using the luminosity of the paper is essential if the colour is to remain clean and fresh.*

RIGHT: *A rectangle of card with the centre cut out is the ideal tool when you are deciding on a composition. This piece of card has a piece of acetate taped to the back that has been divided into thirds. Experiment by placing over the main focus of your arrangement one of the points where the lines cross.*

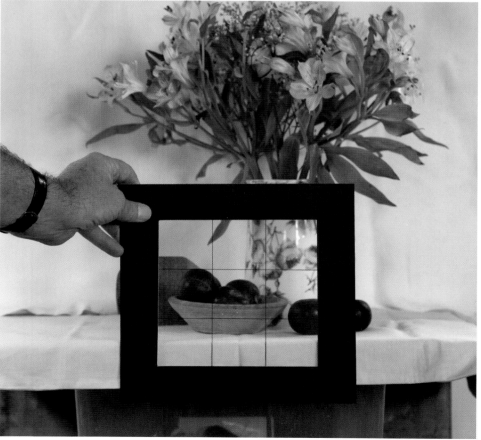

pair things together. By grouping together an odd number of objects your brain is unable to do this and there is always one left on its own. The result of this is that your eye is kept wandering across the picture and in so doing creates a certain kind of dynamism. However, if you set up a still life with a great number of different objects this 'Rule of Odds' is less relevant, particularly if they are of greatly varying sizes, as your eye is going to scan across the whole picture anyway until it focuses in on the main element. Therefore the rule works best when a smaller number of objects are present, perhaps up to as many as nine.

The triangle is a naturally pleasing pattern to humans. If you place three objects in a triangle they will create a symmetrical pattern even though the numbers are odd. So try to introduce an odd number of components into your picture, as this will entice viewers to search the picture and keep them looking until they reach the main point of interest.

When another object is added to the group, it creates an imbalance and the composition looks rather awkward.

Three objects grouped together to form a loose triangular pattern have an aesthetically pleasing shape, which is absent when just two objects are placed together.

Even repositioning the objects doesn't improve the composition.

Rule of Thirds

A simple way to obtain balance in a composition is to apply the 'Rule of Thirds'. Divide a sheet of paper into thirds both vertically and horizontally. Try positioning the main focus of your picture on one of the points where these lines cross or place some of the elements along the lines themselves. Another way of experimenting with this concept is to make yourself a view-

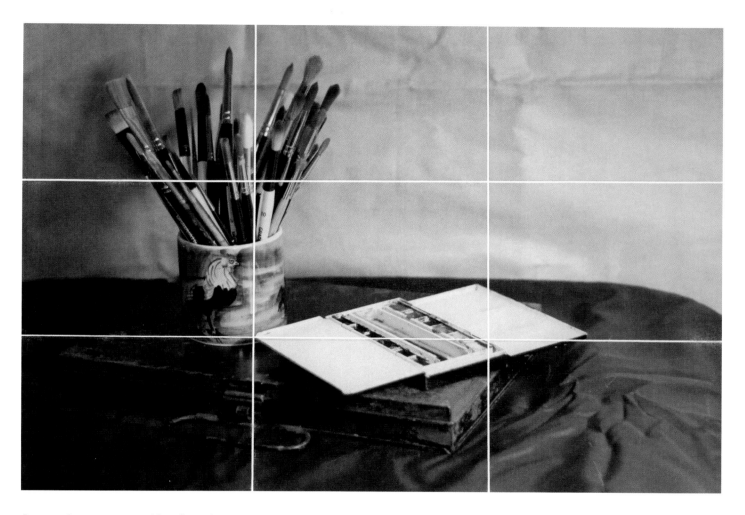

By assessing your composition through an acetate viewfinder divided into thirds, you can adjust your objects or viewpoint accordingly. In this example, it can be seen that the two main objects in the composition are placed along the horizontal lines. If the grid is moved slightly to the left, an even better composition could be created, as both the cluster of brushes and the small paintbox would be centred on cross points.

finder from card. Attach a piece of acetate to your viewfinder and divide it into thirds using a suitable pen. You can then assess your arrangement of objects through the viewfinder and adjust them accordingly.

This simple rule works extremely well and can be used to position the horizontal surface on which your still life set-up is positioned. The conventional viewpoint in still life painting places the viewpoint either above or below the centre of the picture. As with a landscape painting where the horizon line is positioned across the middle of the picture, a still life painting with the objects in line along the centre of the picture plane will almost certainly appear awkward.

These are general guidelines and there is no need to adhere to them with mathematical precision. In the simplest of terms, generally things look better placed if they are off-centre.

There are many compositions that work well and are aesthetically agreeable without following the two previous rules. Traditionally, paintings have nearly always been executed in a landscape or portrait rectangular format and those that are not have almost certainly been cropped, for whatever reason. With the advent of photography, some painters, including Degas, began to experiment with what was once considered unconventional compositions, sometimes with people and objects cropped at the painting's edge. A still life with objects cropped can also create a more informal, less well-rehearsed composition. As a keen photographer, Degas obviously saw the potential in composing images with the use of a camera. Photos with people wandering off the edge were clearly a source of new inspiration for him. Square, or almost square, pictures are a relatively modern idea and Degas used this format to produce some

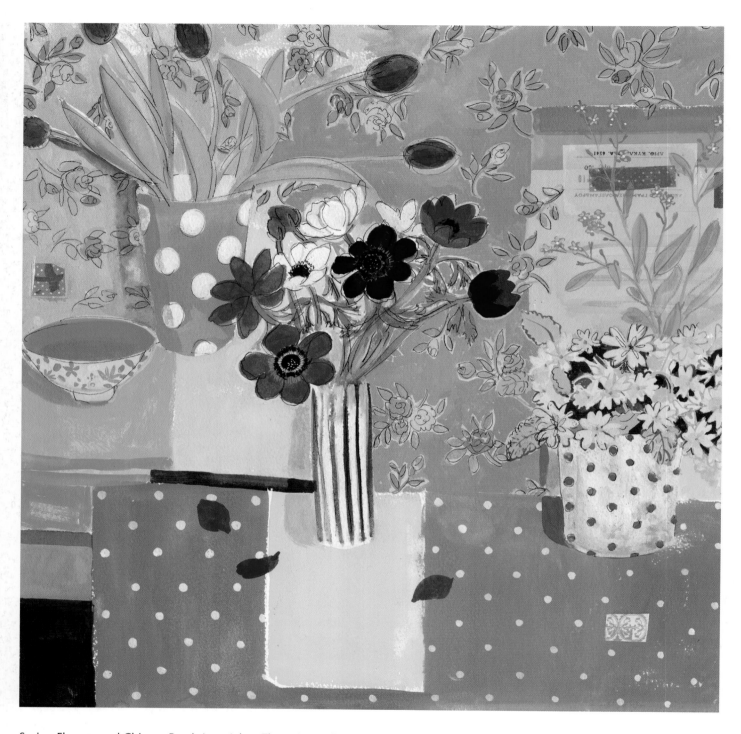

Spring Flowers and Chinese Bowl, *Jane Askey. The artist avidly collects fabrics and objects. She bought the Chinese bowl while on holiday in Hong Kong, a visit that has inspired many colourful compositions. In preparation for this painting she arranged seasonal flowers, patterned fabrics and papers alongside decorative vases and bowls on a table. Many of the artist's compositions explore a shallow depth of field, where shadows and forms are treated to create an almost flattened effect. Her training in printed textile design is most evident in these types of painting. Plain colour blocks help to break up and create areas of calmness and clarity. Detailing and busy pattern are used to create areas of interest and intensity. Polka dots recur in various sizes and these areas of echoing pattern help lead the eye through the different areas of the painting.*

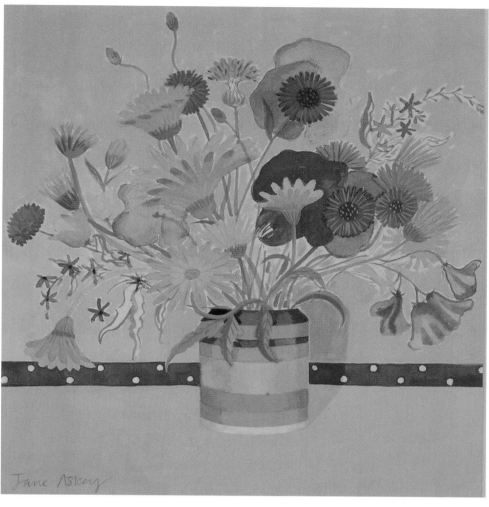

Flowers from Deuchar Mill, *Jane Askey. The colourful bunch of flowers for this painting came from a friend's garden in the Scottish Borders. An intense mix of reds, oranges, magenta and deep blues are echoed in the colourfully striped pot. The blocked background colours complement the stripes of the container and act as a simple foil to the complexity of the inter-twining shapes of flowers, stems and leaves. Colour is kept fresh by working directly onto white watercolour paper. The background colour is filled in at a later stage, working in and around the foreground shapes. A simple shadow suggests form and creates a shallow depth of field. The focus of the painting is the vitality of the flowers and their intense colour combination.*

exceptional paintings. In a square or near-square format, diagonals take on a greater dynamism and a strong sense of tension can be achieved. In his later years van Gogh produced paintings using a double square format. Although watercolour paper comes in sizes that are a particular ratio of height to width, this doesn't mean that you have to stick with a rectangle when you come to produce a painting.

This point is well illustrated by Jane Askey, who chose a square format for her delightful painting *Spring Flowers and Chinese Bowl*, and an almost-square format for *Flowers from Deuchar Mill*.

Viewpoints

There is a tradition in still life painting for choosing viewpoints that usually place objects either at eye level or just below it and directly in front of the viewer. This is the way that we as adults are accustomed to seeing everything, either sitting down or standing up. Alternative viewpoints should be considered, though, to add a touch of drama to a painting.

Viewing your objects from a lower position means you'll be looking up at them and this may give a much more exciting viewpoint and can give the impression of the viewer being seated on a low chair or even on the ground. This could also be a child's view of the world. Perspective will be exaggerated and angles more acute.

A high viewpoint gives the impression of looking down at something, and you can even consider an arrangement viewed from directly above. In each case perspective follows the same rules. In some cases we will see more of the objects and in others, less.

'If the artist does not understand perspective and how to see and use it, all the applications of paint and ink and pencil will not overcome the lack of good perspective'.

Helen Scott

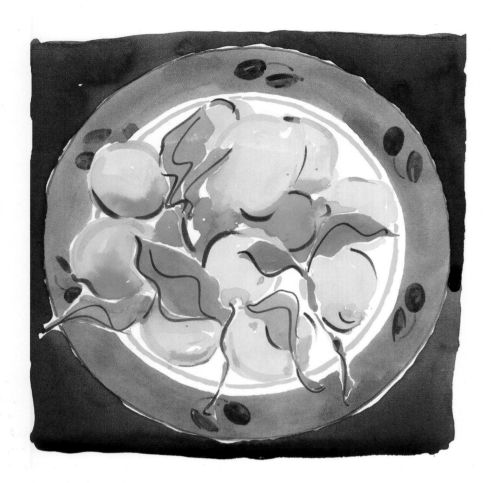

Corfu Lemons, *Kevin Scully. The viewpoint in this composition was directly from above. The background colour echoes that of the dark red olives, hand-painted onto the rustic plate. The lemons and their leaves were painted with vitality to hint at the brightness and freshness of the fruit.*

It is not necessary to take your viewpoint directly in front of your set-up; positioning yourself or your composition so that you have a three-quarter view can also add interest.

Perspective

Unless you are an abstract, stylized or decorative painter, achieving a semblance of realism in a two-dimensional representation involves an understanding of perspective. The basic rules of perspective apply to all forms of painting, including still life. The mere word can strike terror into the hearts of strong men and women, but once the basic rules are understood, there is really nothing to fear.

The first thing you must do is forget the term 'horizon line'. Instead, think 'eye level'. To grasp the basic principles, try this exercise: look straight ahead at a wall, and that spot which is immediately in front of your eyes is your eye level. Now attach a large piece of paper to the wall in front of you and draw a level line horizontally across it at exactly the same level as your eyes; this is your eye level and your starting point. Then place a few objects of different heights on a table or plinth in front of it, positioning some of them so that their tops are above the line and some with their tops below the line. To simplify matters, choose rectangular boxes or tins. Keeping your head at the same level, hold up a ruler in front of you along the edges of the boxes that are sloping away from you towards the wall. You will immediately see that the edges of the taller boxes above the line will slope down towards it, whereas those below will slope up. You will also notice that if you follow the edges of both sides of the box (where you can see them), they converge on the eye-level line at a point known as the Vanishing Point. This is the principle of perspective in its simplest form and a way of rationalizing the way in which your eyes work.

As well as drawing some objects straight on, at some stage you will need to draw them at an angle. 'One Point Perspective' is when an object is seen directly in front of you, and its horizontal edges are all parallel. As soon as you turn the object at an angle, those horizontal lines then meet at a point on your eye level line. Where this point is can be determined by using your ruler again as before. If you have followed all of the lines going away from you, you will then have two points on your eye level line where the different lines converge. This is 'Two Point

Perspective'. If you have just turned the object very slightly away from you, the point at which some of the lines converge will be beyond the extremity of your paper, so a bit of guesswork is required. If you have turned the object away at a sharper angle, the point on the eye level line will be within the edge of the paper.

There are adjustable devices available on the market that transfer the different angles of what you see in front of you onto your paper, but it is advisable to practise drawing by eye. The more you look, the more you see.

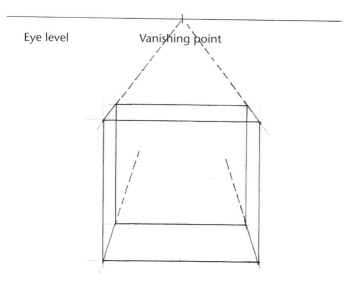

A square box immediately in front of the viewer is constructed by drawing lines to a central vanishing point. This is one-point perspective.

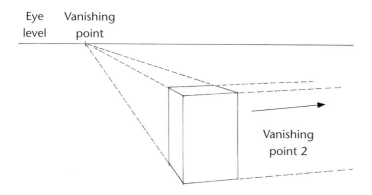

To construct a rectangular box that is turned slightly at an angle, two vanishing points have to be established. Because the second vanishing point is off the page, its location is a matter of guesswork.

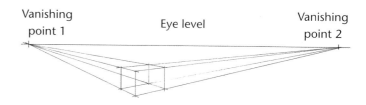

This illustration shows that if you draw an object small enough, you are able to establish both vanishing points on the page. If you were to use these vanishing points to draw a much larger object, the perspective would become distorted.

Ellipses

Unless you studiously intend to avoid them, you will undoubtedly be confronted with ellipses. An ellipse is a foreshortened circle, the oval that you see when looking at a jam jar or flower pot in perspective. Drawing an ellipse can be undeniably tricky. You can have a stab at drawing them freehand and with careful observation this is achievable. However, there is a way to construct an accurate ellipse, and this is where the basic rules of perspective come into it. By completing this exercise, you will have a better understanding of why ellipses appear the way they do.

This is a method by which you can draw a short, cylindrical shape immediately in front of you as if seen from a slightly elevated viewpoint. You will be drawing a transparent box and then constructing a cylinder within it.

Firstly, draw a square in perspective, with your vanishing point in the centre of your eye line. Using a ruler, add the vertical sides and then the top of the box, keeping this below your eye line. Now draw two diagonal lines across the base of your box, connecting all four corners. Where they meet is the centre of your square in perspective. Draw a line from your vanishing point through the centre of this point to the edge of the box, and draw a parallel line across the centre of your box. Now rub out the diagonal lines you originally drew, as these are no longer needed, and you are left with a cross inside a box.

In each of the rectangles draw a curve that joins the outer points where the lines cross. This must be done by eye and with a little practice you will be able to produce a smooth curve and ellipse.

The same process can be repeated for the top of the cylinder, where you will notice a much shallower ellipse is created. Rub out the lines within the ellipses, and then join the two ellipses by drawing the two vertical sides. These vertical lines should be drawn from the edge of the ellipses and not necessarily from the points where the lines meet.

Things change slightly when your object is over to one side. Begin by moving your vanishing point slightly over to the left. As before, draw a transparent box, this time using two-point perspective. Again imagine you are going to draw a cylinder that will fit snugly inside that box.

This time you need two vanishing points. As the cylinder is going to be drawn just slightly off-centre, your vanishing point on the right will be off the page, unless you use a very large sheet of paper.

Repeat the process as in the previous exercise and you will notice that your ellipses are now a slightly different shape, but they look correct.

If you want to draw a much taller cylinder, simply continue the vertical lines to a point above your eyeline and repeat the process, rubbing out all unnecessary lines as you go.

This method can be adapted to enable you to draw jam jars, glasses, cups, plates, flower pots, and so on.

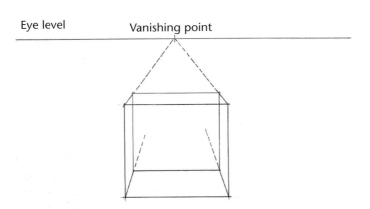

To draw a cylindrical shape immediately in front of you, first draw a transparent box.

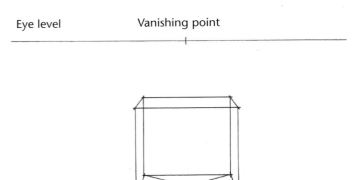

Draw two diagonal lines across the base of the box, connecting all four corners. Where they cross is the centre of the base of the box, as seen in perspective.

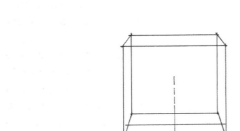

Draw a horizontal line across the base, passing through its centre. Draw another line from the vanishing point through the centre of the base. Rub out your diagonal lines and you now have a cross at the centre of the box.

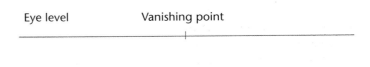
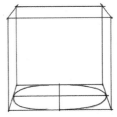

Now connect each of the points with a smooth curve that has to be drawn freehand. Rub out the cross at the bottom of the box and you will be left with an ellipse.

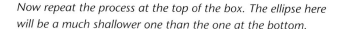

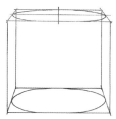
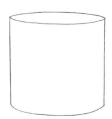

Now repeat the process at the top of the box. The ellipse here will be a much shallower one than the one at the bottom.

Connect the two ellipses at their outer extremities with vertical lines and remove all other construction lines. You now have a cylinder. If you wanted to draw a cylinder off-centre, you simply go through the same process, but this time using two-point perspective instead of one-point.

Creating Atmosphere with Lighting

Lighting is something you will certainly have to give some thought to. One of the problems encountered when painting directly from life is shadows. While shadows can add atmosphere and drama to a picture, they can also be a hindrance. Anyone who has painted a landscape *en plein air* will have experienced the frustration of beginning a painting in beautiful sunshine when the highlights are sharp and bright and the shadows deep and rich, only to watch the sun disappear leaving the whole scene in a monotonous mid-tone.

There is nothing that can be done with the natural elements when painting outside, but lighting can be regulated when you are painting inside. If you have more than one light source, you will find your still life set-up will have shadows falling in different directions. This can be confusing to the eye and brain and gives a rather uneasy and disjointed overall effect. There are ways to establish a constant light source and so create the same shadows in the same place over an indefinite period of time. If there is just one window in the room in which you paint, set up your still life in front of it, with a board large enough to create a backdrop behind it; this will block out most of the light filtering onto your objects. You can then add a light source to the front or side of your set-up. An Anglepoise lamp or spotlight can be positioned to create the effect required. Most of the paintings in this book have been produced under these conditions. Alternatively you can always close the curtains or blinds if you don't mind spending your daylight hours in semi-darkness. It will then of course be necessary to have another light source

directed onto your painting, so that you can see what you're doing.

Your lamps should be fitted with 'daylight' bulbs, which produce a more natural lighting effect. Ordinary tungsten, household bulbs give off a rather golden glow. An excellent choice would be a spiral, florescent bulb using about 18 watts of power.

A piece of equipment that has been used for centuries by still life painters is a 'shadow box'. This is like a miniature stage set into which you place your objects. This is usually a homemade construction that forms a box, open at the front. Light is provided through holes at the top or sides of the box. Traditionally, the inside of the box was painted black and was sometimes covered in drapes to form an atmospheric backdrop to the objects. A simple version of this can be made by taking a reasonably large cardboard or wooden box and sticking black mount board to the insides.

Using a shadow box is perhaps more appropriate for those who like to paint still life pictures with rather dark, rich backgrounds in the traditional style of oil painting. Nevertheless, it may be worth experimenting with. Try limiting the infiltration of unwanted light by arranging your objects in front of a construction with just two pieces of board attached at right angles, or a box that is open at the top as well as the front. To give your paintings a more contemporary look, you might try painting the inside of a box white, or pinning fabric to its walls. The simplest way to block out unwanted light is to prop up a board on one side of your set-up, to restrict any unwanted light coming in from that side.

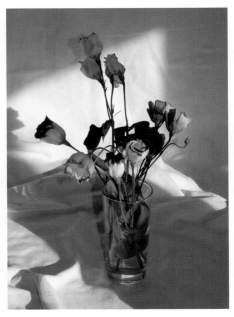
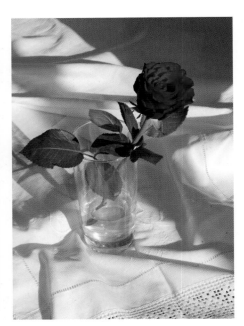

Each of these compositions was set up with natural daylight shining into the room through a window. In some cases shadows have appeared in the foreground because other objects have been placed between the composition and the light source. Making use of these shadows can sometimes add a touch of drama to an otherwise mundane painting.

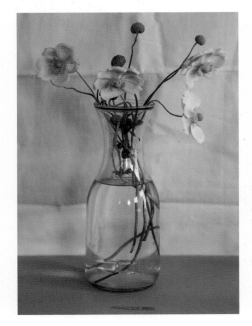
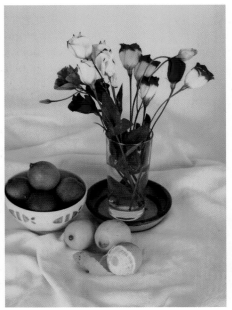

This image shows an object lit by natural daylight from several different directions. The result of this is that there are no strong shadows, as the different light sources tend to cancel each other out.

Tungsten bulbs produce a golden glow to objects, as can be seen in this composition, which has been lit from two sides.

A composition lit by daylight bulbs creates a more natural atmosphere. There are no harsh shadows present, as the objects have been lit from both sides. They also receive a certain amount of light shining in from windows immediately in front of them, as can be seen from the reflections on the glass.

Lighting a subject from top left seems to be an instinctive thing to do. As we in the Western world begin writing from top left, perhaps this is why this lighting arrangement seems most natural. By all means do this, but also experiment with lighting from different directions: top, bottom, straight ahead, back or even with diffused lighting, which will create a subdued effect with no harsh shadows at all.

You might try placing your objects on a sheet of glass or shiny metal, which will create interesting reflections.

There is much merit in spontaneity, and occasionally a single object on a plain background, painted with no thought given to contrived lighting, can be the subject of a simple, charming picture.

A few objects on a sunlit window ledge can produce a beautiful set-up, with the intense shadows providing dramatic impact within a strong design element.

Object Selection: Combining Natural Materials with Manmade Objects

While it is possible to paint a composition made up of either entirely manmade or natural objects, try combining the two. The contrast between the shapes and textures of rigid man-

A sunlit window ledge can be the ideal spot for an arrangement that offers a great variety of shadows and reflections. But bear in mind the fact that their positions will alter as the sun moves across the sky.

A, B and C: *Whilst working on an idea for a painting, several different jackets were hung from a hook on this old wooden panel, and photographs were taken of them in slightly different positions. A comparison of the photographs helped in deciding which one would work best as a painting.*

made objects and much looser natural forms gives unlimited scope for some interesting pairings. Even a single flower in a glass of water can be all that is needed to make a great painting.

The uniform shapes of manmade objects have to be painted more judiciously, particularly when ellipses and perspective are involved, whereas natural forms can be painted in a freer, more creative way to suggest their form and texture. The complex highlights, shadows and reflections on a stainless steel or copper saucepan have to be studied very intensely and painted with care to suggest their shiny surfaces.

Using Sketches and Photography for Inspiration

Use a sketchbook to try out different combinations and compositions of your chosen objects. By drawing them you will be familiarizing yourself with their shape and volume. You can also photograph different arrangements and viewpoints for comparison, before finally deciding on the most satisfactory set-up.

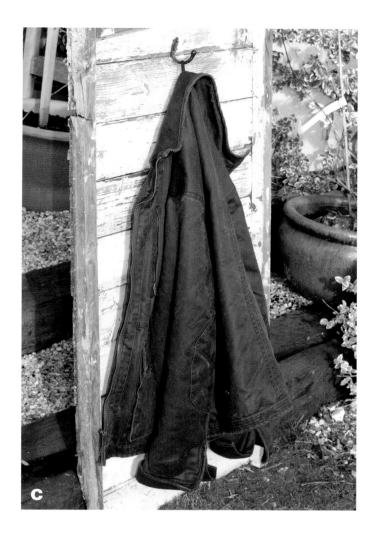

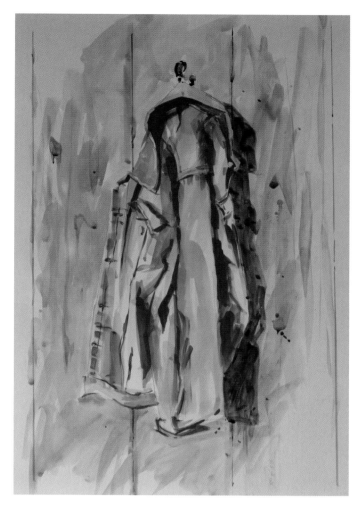

A preliminary sketch in gouache on Bristol Board, for a proposed painting of a jacket hanging on a door. In this sketch the wooden panel was substituted for a door on which the denim jacket hung. It was felt that the plain, vertical boards of a brown timber door would provide a better contrast to the blue jacket.

Unusual Combinations and Subject Matter

It is not necessary to restrict yourself to flowers, vases, fruit and vegetables, although grouping together objects sharing a common theme will give your painting a certain cohesion. Try to think of slightly unusual things that you would not readily put together: driftwood and roses, a bouquet hanging upside down from a hook on an old door, a toy boat floating in a tin bath, a wooden mallet and a basket of eggs, a selection of berries arranged on an artist's palette with a paintbrush in a yoghurt pot. Such combinations may be meaningful or meaningless, real or surreal, but could still work well visually.

COLOUR AND TECHNIQUES

'Have no fear of perfection, you'll never reach it.'

Salvador Dali

Do's and Don'ts and Common Mistakes

If you are new to painting it is inevitable that you will make mistakes, so it's worth remembering that even experienced artists make mistakes too. I have heard professional watercolour painters admit to throwing away 20 per cent or more of pictures that they weren't happy with. Perhaps a wash had gone wrong, the colours had become muddy, the paper hadn't stretched properly and had cockled when dry, the detail was overworked, the composition wasn't really quite right, and so on. There are many things that can go wrong. But remember, every mistake is something learned, even though you may make the same mistake again!

The advantage of still life painting is the ability to work at your own pace under controlled light in the comfort of your own workspace. And with gouache you also have the luxury of time. There is no need to rush a painting. You don't have to worry about leaving white spaces within washes or fiddle about with masking fluid. You don't have to be vigilant with a

OPPOSITE: Blue Vase and Toy Boat, *Kevin Scully. Here is a painting that works on several layers of visual interest. Your eye is led first to the toy boat on the window ledge in the centre of the picture, and then to the group of objects in the foreground. You then notice the paintings on the wall and the window blind with its pull string, which leads your eye back down again to the boat and sea, and the hills beyond. The sash windows create a frame within a frame.*

wash that may run into another but you do have to think a few steps ahead, just as with any other form of painting. Planning is important, so a few basic do's and don'ts have to be considered.

Don't expect the first painting you do to be a masterpiece; in fact, don't think of it as a finished painting at all, but merely the first stage in the learning process. There will probably be many failures on the road to competence. It takes time to feel entirely comfortable with any painting medium and gouache is no exception.

Don't be too ambitious with your first efforts. Keep the subject matter simple and the number of colours in the picture down to a minimum.

A common mistake when painting in any water-based medium is to be too frugal when mixing paint, particularly for washes. Work out how much paint you think you are going to need and then mix up at least 50 per cent more. There is nothing more frustrating than running out of paint halfway through applying a wash. This extra paint will rarely be wasted, as it can be added to and adjusted either for subsequent washes or for different colours within the painting.

Unless you have your heart set on painting miniatures, buy a large palette. There are large circular ones available that have plenty of wells deep enough to hold paint for washes.

If you leave the tops off your tubes of paint for too long they will begin to solidify and you won't be able to get the colour out, so it's good practice to screw the tops back on as soon as you have squeezed some paint onto your palette.

Don't build up your painting with layers of thick paint, as there is a danger that it will crack. If you like to work in this way then gouache is probably the wrong medium for you.

Initially, it's advisable to ignore all the gimmicky accessories on the market, as brushes, paper, paint, a palette and water are all you really need. Similarly, while it's easy to be seduced by the various paint additives that speed things up or slow things down, these too are best avoided. If you want to experiment with these products, do so later on, but in the early stages of learning to paint they are more of a hindrance than a help.

I would also recommend not indulging in any of the 'quick effect' techniques too early on, as these are often used to

disguise the fact that a painting has been poorly executed. These techniques include masking, wax resist, spattering, flicking, scratching, sponging and scraping, amongst others. By all means try them later on, but they have a novelty value and their appeal that can soon wane.

Always make sure that you're happy with your composition before you begin painting. A strong vertical object positioned in the middle of a picture always looks uncomfortable, so it should be moved off-centre; this produces a better-balanced arrangement. Make sure vertical objects are actually vertical and not leaning over to one side. Likewise, a strong horizontal line across the centre of your painting doesn't normally make for a good composition.

As with watercolour, when overlaying one thin wash over another make sure this is executed fairly swiftly. Any scrubbing and fussing around will cause the colour to lift and mix, often producing a muddy result.

Don't regard the background as an afterthought, as it is an integral part of a painting and should not be considered unimportant. It shouldn't overpower or detract from your painting but should be included as an important element within it, adding balance and variation. As a general rule the background should be kept fairly simple so as not to overpower the objects in the foreground.

While you are painting, don't forget to change your water often. Failing to do so will result in muddy paintings.

Although it's possible to build up a gouache painting by starting from a thin watery wash and then progressing to an opaque matt finish using thicker paint, there is a limit to how many layers you can apply. If the paint becomes too thick, there is a

danger of it cracking, and if you apply a thin glaze over paint that has been built up in opaque layers, the paint underneath may lift and discolour your glaze. When painting one layer over another, it's important that the first layer is dry otherwise the first layer will affect the next. However, if you like to work in a more painterly way, as with oil painting, this might not necessarily be something to get too worried about and indeed the effect might be just what you're after.

The best approach is to begin your painting with thin washes and, as the work progresses, use the gouache more thickly. The paint should have the consistency of single cream or perhaps slightly thicker.

Having a sheet of paper handy to test your paint on will allow you to see the effect when dry. Make sure this test paper is the same as the one you will be painting on because the colour and texture of a dissimilar paper will produce a different result. If you intend painting one colour over another in your painting, it's also a good idea to have some of the first colour on your test sheet so that you can then overlay the second colour, which will allow you to see the result of this over-layering when dry.

If the paint is too thick, particularly in the early stages of a painting, the brush will drag over the surface of the paper and not deposit enough paint where it is needed. As the paint becomes opaque, it's best to apply the finishing touches with a fairly dry brush. As with oil painting, you should work from thin to thick, not the other way around.

It's possible to blend colours together on your picture by using two or more different brushes loaded with paint. The paint will stay manageable for long enough to achieve this, but should you be dissatisfied with the smoothness of your blend,

Keep a scrap piece of watercolour paper handy when you are mixing colours for a painting. Any colours that you use in the painting, particularly washes, can also be painted on your scrap piece. The effects of overlaying one colour on top of another can be tested before adding it to your painting.

you will be able to make adjustments by using a clean, damp brush to soften it even when it has dried. Unlike acrylic paint, which undergoes a chemical change when dry, gouache can be reworked over and over again providing the paint doesn't become too thick.

One peculiarity to be aware of when using gouache is that it tends to dry at a different value to how it appears when wet. Lighter colours dry slightly darker, while darker colours dry slightly lighter. This is caused by the presence of the white pigment in the paint that gives gouache its opacity. This effect is more noticeable as you build up subsequent layers of paint. Again, this can be tested first so that you can see the outcome.

Initial Drawing

If you have a still life set up and are ready to start painting, you will need to draw out your image first. You may have already decided exactly where everything is to be positioned by doing some initial compositional sketches. If you feel confident in drawing directly onto the paper that you are going to use for your painting, then do so. If not, there are other ways whereby you can transfer your original composition onto your paper.

If you plan to make your painting bigger than your sketch, it will have to be enlarged onto your watercolour paper. To do this, take a sheet of watercolour paper and lay your sketch on it, lined up with the bottom left corner. Lay a ruler diagonally across your sketch and lightly draw a line from the top right

hand corner of your sketch to the edge of your watercolour paper.

From this point, draw a line horizontally across your watercolour paper parallel with the top, using a set-square. If you don't have a set-square, simply transfer the measurement at the top of the paper to the other side.

Erase the diagonal line you had previously drawn and cut off the excess paper at the top. The rectangle or square that you now have is in direct proportion to the size of your original sketch, only larger.

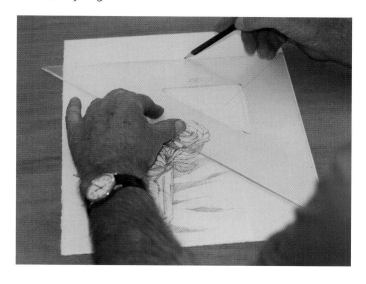

From this point, draw a line at right angles across your watercolour paper, parallel with the top of the sketch.

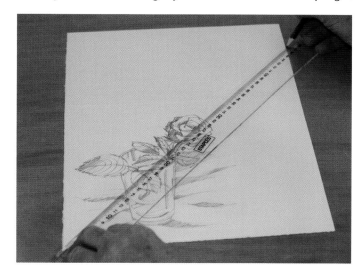

Lay a ruler diagonally across your existing sketch and draw a line from the top right hand corner across to the edge of your watercolour paper.

Cut off the top of your watercolour paper and rub out the diagonal line. You now have a piece of paper that has exactly the same proportions as your sketch, only larger.

If you want to reproduce your sketch more accurately at a larger size, you can do so by this method. Divide your sketch into half, quarters or eighths, or into as many sections as you like, both horizontally and vertically, depending on how detailed the drawing is. Do the same on your watercolour paper, drawing the lines lightly so that they can be rubbed out when the drawing is finished. You will have corresponding rectangular sections of the same ratio. These will only be squares if you opted for a square format for your drawing in the first place. You can now transfer your sketch onto your watercolour paper by copying what is in each rectangle.

In this example, certain reference points in the rectangles have been located and a faint line has been drawn to indicate where a certain part of an object touches that line.

If you want your painting to be the same size as your sketch, you can also do it by this method, or you can use 'tracedown paper', which is sometimes known as 'tracing down' or 'transfer

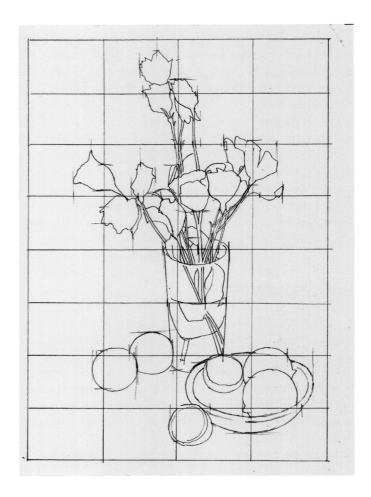

Now draw the same grid on your watercolour paper and copy across the detail in each rectangle. If you want to enlarge the sketch, simply double the size of your new rectangles.

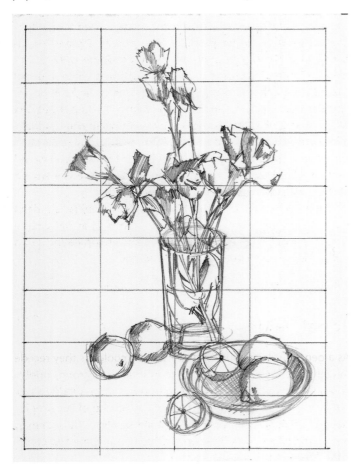

Draw a grid on your sketch by dividing it into half, both vertically and horizontally. You can then continue dividing it by half again. Depending on how much detail is in the drawing, you can continue dividing for as long as is necessary.

paper'. This is a quick and easy way to transfer an image onto your paper: place a sheet of wax-free paper between your sketch and the watercolour paper and simply trace over the lines. If you want a bigger image, you can have your sketch enlarged on a photocopier. Tracedown paper comes in a variety of colours, including white. It is relatively expensive but can be used over and over again.

Colour Mixing

Here is a brief description of the terminology used in colour mixing:

- Primary Colours: red, yellow, blue.

Make sure you have the tracedown paper the right way round. The dark side should face down.

Secure the sketch to the watercolour paper to prevent the image moving. Draw over the sketch with a fairly hard, sharp pencil, taking care not to tear the paper.

Keep checking to make sure the image is being transferred onto the watercolour paper.

times when these are exactly the colours you need to counter-balance brighter, richer passages in a picture. Pigments contained in paint vary in intensity. There are some colours that have a high tinting strength, which means that when you mix them with another colour in equal proportions they overpower and dominate. Winsor Blue is such a colour. If you want to mix a fairly pale blue with this colour, start with white and gradually add small amounts of Winsor Blue into the mix until you obtain the desired colour. If you were to start with the Blue, you would probably need to use a whole tube of white before you arrived at the colour you wanted.

Whole books can be written about colour theory (and indeed many have been), but the best way of arriving at satisfactory colour mixing is by experimentation, and if something looks right, it is right, regardless of colour theory.

- Secondary Colours: green, orange, purple. Secondary colours are the result of mixing two primary colours together.
- Complementary Colour: the complementary colour of a primary colour is the combination of the other two primaries mixed together. For example: blue and yellow mixed together produces green, which is the complementary of red.
- Tertiary Colours: these are formed by mixing a primary colour with a secondary colour: yellow–orange, red–orange, red–purple, blue–purple, blue–green and yellow–green.

As a general rule, the more colours you mix together, the muddier and less intense they become. Of course, there are often

Tonal Value

As a general rule, colours become slightly cooler as they recede into the distance and they reduce in intensity. Strong, bright, warm colours appear closer to the viewer than subdued colours. This is perhaps more relevant to the painter of landscapes, but the principle still applies to still life painting. By squinting at a composition, it will become evident which are the cooler colours and which are the warmer ones.

Tonal value is the degree by which colour can be assessed in terms of lightness and darkness. A pale green grape placed on a white cloth will appear darker in tone than the cloth. If you were then to place a red grape next to it, the green grape would appear lighter in tone than the red one. It's this comparison in

strength of tone that it is important to understand, regardless of the actual colour of the object. To produce a dramatic painting, it's important to have a mixture of dark and light tones, not forgetting that a range of middle tones are also required to hold the whole thing together.

By analysing the range of tones in your composition you will be able to replicate them in your painting to suggest the illusion of three-dimensional volume. If you intend to paint in a fairly realistic way, an understanding of this is essential. The way in which these tones are gradated will suggest whether or not an object is round, solid or transparent.

Sometimes when two objects are side-by-side their tones can appear exactly the same. That is, neither one is darker than the other. The difference between them will only be established by their colour.

Sometimes it can be very difficult to assess relative tones as we tend to be more aware of colour than the lightness or darkness of things. For example, Cobalt Blue and Cadmium Red are two distinctly different colours, but if they are sufficiently diluted in varying degrees they can be produced in exactly the same tone. That is, if you were to take a black and white picture of them side-by-side, they would be indistinguishable, being the same tone. Judging tone can be practised by placing two objects next to each other, perhaps a green pen on a red book, and squinting at them with half-closed eyes; you will soon be able to tell which one is darker than the other.

Each time you add a colour to a painting it affects the colours already there, so a certain amount of adjustment sometimes has to be made. A shadow that you initially thought of as being strong enough may have to be given a bit more punch, and similarly with a highlight.

By building up your picture with the addition of colour over the whole image, rather than trying to finish in detail certain elements of the picture, you will find it easier to assess the strength of dark, light and intermediate tones. It's very easy to get engrossed in one section of a painting just because it's the nicest or easiest bit to paint. Always treat the painting as a whole and not as separate entities within it.

Colour Temperature

Unless you wish to dissect colour in a scientific manner, it is really a subjective matter as to whether a colour is warm or cool. It is generally accepted that blues, greens and violets are cool, and that yellows, reds and oranges are warm, but there are a million intermediate colours that can appear either warm or cool depending on which colour they are placed next to. There are also degrees of warmth or coolness within individual colours. For instance, Cadmium Yellow comes in a range of colour temperatures: depending on which brand you use, there is Cadmium Lemon, Cadmium Yellow and Cadmium Yellow Warm. Placing Cadmium Yellow next to Cerulean Blue will make it appear quite warm, although it is generally perceived as a cool colour. The temperature of a colour will also be altered by light shining upon it.

If you want to make a bright colour really stand out and to give it extra richness, this can be achieved by placing a fairly subdued neutral colour next to it. Very light colours will only appear light if they are placed next to darker ones, and vice versa.

> 'Colour is my day-long obsession, joy and torment.'
>
> Claude Monet

Harmonious Colours

A painting that has been executed by including a common base colour will produce a harmonious effect. For example, if you chose blue as the base colour, then by using blue–grey, blue–green and blue–violet, you will be creating a visually harmonious painting by using a cool set of colours.

This harmonious effect doesn't necessarily need to have a primary colour as its base. A similarly pleasing painting could be created by choosing a colour such as Raw Sienna as its base. Red, yellow, brown and perhaps any of the earth colours could be added to produce a warm tonal range.

First Steps in Applying Paint

The colours used in this painting were:

Permanent Green
Cadmium Red
Burnt Sienna
Permanent White

Although you may never have used gouache before, you will no doubt have used some form of water-based paint, probably watercolour. A basic method of painting in gouache can be approached in the same way as you would begin a watercolour painting.

Start with a simple composition, in this case an apple on a white cloth that has been lit from the top left. Look at the lightest tones of the apple and, using the green and red, mix up a couple of pale colours of a thin consistency that, when dry, will suggest the overall tones of the apple. These will be the 'local colours' of the apple. That is, the colour of the apple as it appears under a white light, devoid of shadows, highlights and reflections. Try these colours out on a piece of scrap paper, cut or torn from the same paper you'll be working on. This will show you how the colours will appear when dry.

Two brushes were used for this painting: a No. 8 and a No. 3, but use whatever size you are comfortable with. Don't use too small a brush though, especially for the initial washes as this will result in a rather fiddly-looking painting. Keep everything as simple as possible.

More opaque colour is added to the apple.

The initial washes of diluted watercolour, including the shadow of the apple.

The shadow immediately under the apple is painted in a stronger colour, but the more diffused shadow is left in the original wash.

At the same time, look at the shadow that has been cast by the apple onto the cloth. Depending upon surrounding objects and lighting, the shadow may contain hints of other colours, other than that which is reflected into the shadow by the apple itself. Remember that shadows are very rarely just grey.

At this stage, try to paint what you see and think in terms of patches of colour, rather than painting what you think an apple and its shadow should look like.

Paint the apple, including the stem and the shadow, without trying to blend the colours too carefully, but rather letting the colours run into each other slightly. The shadow on the cloth can be softened if necessary by painting a narrow band along its edge with a fairly dry brush containing clear water, while the wash is still damp.

For the next stage of the painting, the paint can be of a slightly thicker consistency. Now look at the local colours of the apple.

There are patches of green and patches of red. Mix the colours that you see and paint in these areas as patches of colour. Again, you can try the colours out on top of the samples of the washes that you first made. At this stage don't try to blend the colours together, but keep them as simple patches of colour. Leave the highlight area in its initial wash colour.

The shadow on the apple was painted using a mixture of the green and red. The roundness of the apple is defined by not painting this shadow right up to the very edge but instead leaving a certain amount of the original wash uncovered. When this is dry, mix a colour to match the shadow on the cloth. This can be painted with a mixture of the green, red and a little white. Don't add too much white as this may result in a rather chalky colour. Retain all of the colours that you have mixed during the painting, as these can sometimes be used as little patches of

colour here and there, giving the painting more interest and cohesion.

Again, depending on the surrounding light, a certain amount of the white in the cloth may be reflected back onto the apple, creating a slightly lighter area on its underside. When painting the stem, a little Burnt Sienna was added to a green/red mix.

If the highlight on the apple now appears too dark, it can be adjusted by adding a little white to the green you have mixed. There may be a small highlight on the stem and this can be painted by adding a little white to the colour used to paint it previously.

To finish the painting, note any small blemishes on the apple; these can be added using the paint on a fairly dry, small brush.

The finishing touches applied to the apple include highlights on the stalk and small blemishes on the skin.

A Still Life Composition Using Just One Colour

In the following exercise just one colour has been used. The composition is a little more complex than the single apple of the previous painting, and the purpose of this is to get you thinking about tone – that is, the darkness or lightness of one object or area in relation to another.

To help you understand the tonal value in a painting, take an image in colour from a magazine or book and make a black and white copy of it. Now make yourself a 'value scale'.

Draw about eight squares, each approximately 40mm ×40mm, along the edge of a piece of paper. With a dark colour

(even black), fill in each of the squares with paint. Start with solid colour at one end and gradually dilute the colour evenly in each box until you have an empty box at the end. This box represents white. You will then have a scale ranging from dark to light. By holding this scale up to your photocopy, you can roughly match the differences in tone. If you then relate this to the original colour image, you will notice that some of the colours that you thought were lighter than others are in reality darker.

There are some colours that are lighter in tone than others. For instance, in its primary state yellow is lighter than blue. This can be demonstrated by photocopying squares of the two colours side-by-side. You will see immediately that the yellow square is lighter than the blue square. Repeat this experiment with other pairs of colours, for instance green and red, and depending upon which red and which green you have used, their tone might be almost the same. Or perhaps the colour you thought would be the darkest is actually the lightest in tone.

A total scale, showing how differing degrees of light and dark can be assessed by relating them to those in a black and white photocopy of an image.

Obviously you don't need to do this with everything you're painting, as it's only an experiment to demonstrate the subtleties created by light and shade. But when you start painting, you should bear in mind that a certain deep yellow may actually be darker in tone than a light blue and a particular green darker than a light brown. Don't just paint a pile of strawberries bright red because you know strawberries are red, without thinking about whether they are lighter or darker in tone than the green bowl they may be sitting in.

UNDERSTANDING TONE

A good way of distinguishing the lightest and darkest tones in a picture is to squint at it with your eyes half open. This eliminates most of the areas of intermediate tones. You might also experiment with tone by taking a photograph and printing it out in black and white instead of colour. You will then be able to distinguish between the varying areas of dark and light.

Demonstration: Painting a Composition in One Colour

The colour used in this painting was Raw Umber. As well as an exercise in tone, this is also an exercise in deciding which parts of the painting to leave in a watercolour-like wash and selecting those parts where the paint could be used more opaquely.

In this set-up a number of objects of varying tones have been assembled together. Having drawn them out on paper, it was decided that the mushroom in the foreground was the lightest part of the arrangement. Although the tablecloth is actually white, it appears darker than the mushroom. This is because the mushroom is angled more towards the light source and the light falling on the cloth is at a more oblique angle. A decision was made early on to leave out the cut marks on the breadboard, and to suggest the grain of the wood instead.

In the palette, five different tones of the same colour, Raw Umber, were mixed up separately.

Begin by mixing a large amount of colour at full strength. Add some of this colour to the four other wells in your palette.

This shows the watercolour paper taped to the drawing board with Gumstrip. A wash is laid over the whole painting apart from one mushroom, which, being the lightest part of the picture, is left as white paper.

Add water to these wells individually in increasing amounts until you have the palest wash in the last well.

The mushroom was left as white paper and the rest of the paper was given a pale wash of colour approximating the next tone up from white in the scale.

Each area was looked at and those parts that were slightly darker in tone were painted in the next tone. This procedure was repeated throughout the painting until the darkest tone, which was that on the handle of the knife, was painted in Raw

Another wash has been painted over the background to suggest the folds in the cloth and subsequent washes establish some of the initial tonal contrasts.

More washes are overlaid on the darker passages in the painting, while in places some of the underlying colour is left unpainted. This helps to retain the freshness of the painting and prevents it from looking too flat. No detail has yet been added to any one area.

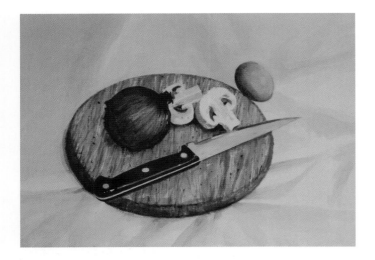

Some of the lighter areas in the painting have been left in a thin wash, while others have been painted in various degrees of opaque and semi-opaque colour. The lightest tone in the painting is that of the mushroom on the right, whose colour mostly consists of just white paper. The handle of the knife is the darkest tone, and this has been painted in opaque Raw Umber.

Umber in its pure opaque form. A certain amount of adjustment was then made to the various areas that required a little more detail.

As with watercolour, it's possible to keep adding thin layers of the same colour one on top of the other to achieve a progressively darker tone. However, when using just one colour, there is a limit to the darkest tone achievable. The handle of the knife in the photograph is black and is the darkest part of the composition, but this can only be suggested in the painting by the relative tones of the other objects around it.

Demonstration: Creating a Painting Using a Limited Colour Range

The colours used in this painting were:

Cadmium Yellow Light
Yellow Ochre
Burnt Sienna
Permanent White
Lamp Black

The paper used was Daler-Rowney Saunders Waterford 190gsm Not watercolour paper

This simple still life arrangement is a fairly traditional set-up and was created by placing three lemons in a line on a white table-cloth over a white plinth. The backdrop was a sheet of plywood. There is very little colour in this painting, so the interest has to be established by suggesting the texture of the different elements.

It was decided to place the objects high up in the painting to create a slightly unusual viewpoint. The composition was drawn onto the paper very simply, by just indicating the outlines of the plinth, cloth and lemons. There was little point in drawing the detail of the folds in the cloth, as this could be simply painted with a brush.

As with the previous exercise, some of the colours were mixed up in the palette in preparation for applying the initial wash-

This shows the initial stages of the painting, having been laid-in with just a few simple washes. In the top left hand corner work has begun by adding more opaque colour in loose brushstrokes, allowing some of the underlying wash to show through.

es. This time, to create a little visual interest, a thin wash was placed over the background that wasn't a true representation of the actual colour of the wood. Instead, a greyish colour wash was placed underneath, with a richer colour on top, allowing some of the grey to show through; the juxtaposition of the two colours produces a livelier, textured background rather than a flat colour. The thin wash, a mixture of white and black, was applied with brushstrokes at varying angles to provide a livelier texture. This is achieved without the necessity of having to go into any detail and there was no intention here to try to replicate the appearance of plywood, as a fairly plain, nondescript background was wanted.

The same greyish wash was used as an underpainting on the white tablecloth, thinned with water in some areas where the cloth appeared whiter. In contrast to the different surfaces of the plywood and lemons, the brushstrokes here were mainly vertical to indicate the direction of the folds. The same grey wash with the addition of a little Yellow Ochre was used for the shadows under the lemons.

The main focus of the painting is the lemons, so these were eventually painted more carefully, with just enough detail in the tablecloth to create a variation in colour and texture, without it overpowering the lemons.

A very pale wash of Yellow Ochre was painted over the white plinth to distinguish this white from the white of the tablecloth. When the final, thicker, white paint is used on both of these elements, they will appear as different whites due to the contrasting under-painting that will to some extent show through.

A pale mixture of Yellow Ochre with a little Cadmium Yellow Light was washed over the lemons. More opaque colour was added to the background using a mixture of Yellow Ochre, Burnt Sienna and a little Permanent White in varying quantities, again to create texture. These brushstrokes were also applied at different angles. Some thicker, pure white was painted roughly on the plinth with some of the grey underlying colour being allowed to show through.

Three or four different shades of a more opaque grey were then painted onto the tablecloth to establish the different strengths of shadow and highlight in the folds. The lemons were painted with a mixture of Cadmium Yellow Light, Yellow Ochre, Burnt Sienna and Permanent White, with more Burnt Sienna

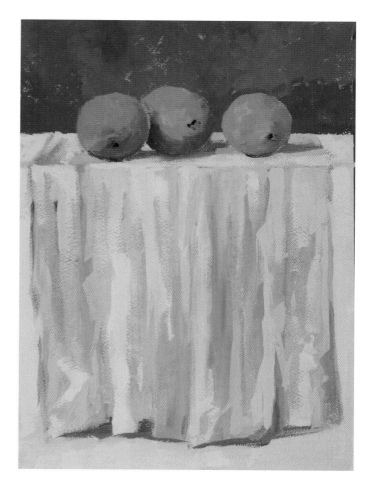

Semi-opaque colour has been added to all the elements in the painting. The varied, atmospheric treatment of the lemons and the background contrasts with the broader, vertical brushstrokes of the cloth.

added to the shadow side of the fruit. The shadows made by the lemons on the tablecloth did appear to be rather grey, and because their colour was reflected onto the cloth, these shadows absorbed a certain amount of the lemon colour. However, when you add yellow to grey, the resulting colour can appear to be too green, so a little Yellow Ochre and Burnt Sienna were added to counteract this.

HOW TO DARKEN YELLOW

Making a darker version of yellow when you want to create a shadow on a yellow object can be a tricky business. So instead of reaching for a dark brown or even black, add a touch of Raw Sienna or Cadmium Red. If you want to make it really dark, try including a little Burnt Sienna in the mix. Although a shadow on a yellow object can sometimes appear a little green, more often than not it doesn't look quite right in a painting.

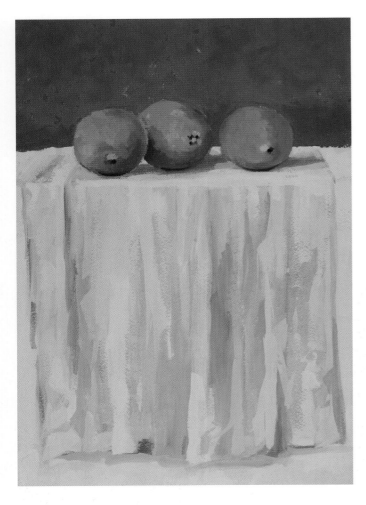

More colour and detail have been added to the background and the lemons, and the shadows under the cloth have been softened so that they are less dominant.

Because the background was now thought to be a bit too dark and rich, a slightly lighter, more subdued colour was over-painted, leaving some of the original colour to peep through. This second colour was made up by adding a little black and white to the original mixture. The advantages of mixing generous amounts of colour in the initial stages of the painting will now be obvious, as it can be added to and tweaked throughout the painting process. Doing this will save you having to keep remixing colours, and a certain unity in the picture will be attained.

The addition of a little more black to the area where the background meets the plinth helped to create a feeling of a space between the plywood and the plinth.

The lemons were painted with more patches of colour juxtaposed to suggest texture. More detail was added to the highlights and shadows, the final touches being the ends of the fruit.

The harsh shadows under the lemons were painted with Burnt Sienna, their edges softened with a fairly dry brush containing clean water. A loose, painterly feeling was achieved by leaving a rough, ragged edge to the different elements, rather than having a harsh and abrupt outline.

The darker shadows of the tablecloth were strengthened, as were the highlights, particularly where the cloth rests along the foremost edge of the plinth.

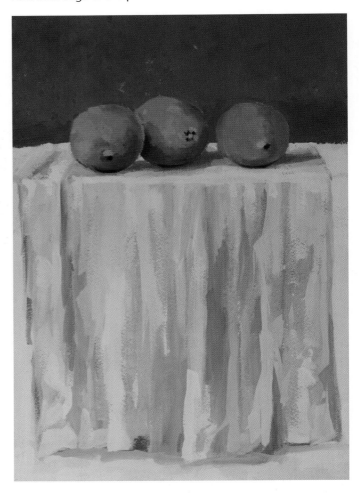

The background has been made slightly darker, to give greater emphasis to the lemons.

Demonstration: Creating a Painting Using a Wider Colour Range

The colours used in this painting were:

Permanent White
Cadmium Orange

Cadmium Yellow
Pine Green
Burnt Sienna
Cerulean Blue
Brilliant Violet

The paper used was Daler-Rowney Langton 140lb Not water-colour paper

Here is an uncomplicated painting of a simple Moroccan dish containing some Seville oranges still retaining their stalks and leaves, viewed from directly above in strong sunlight. The dish is sitting on a crisp, white napkin that has just been unfolded. Some of the colours seen in the napkin's creases are those that have been reflected in part from the sky and also from the sides of the dish itself.

Because they were perfectly round, the dish and its rim were drawn with a compass. Although it might be a good exercise to draw this freehand, I'm sure even Leonardo da Vinci would also have drawn it with a compass, as he would have wanted to get on with the actual painting as soon as possible.

The colours in the folds were drawn straight in with a brush, and the oranges, leaves and dish were painted in a thin wash of their respective colours. The crudely made, rough-textured edges of the dish were a darker colour in places than the rest of it, so these were painted with a fine brush in a darker wash of Burnt Sienna. This would also assist in retaining a definite, circular edge throughout the painting.

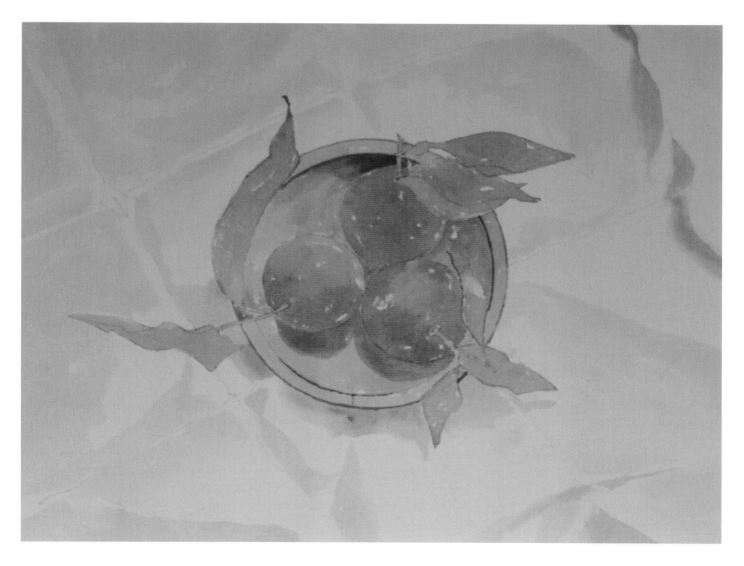

The bowl has been drawn in pencil with a compass, and its outer edge painted with a dark colour so that the circular shape is not lost during work on the painting. The first washes have been laid-in, and small specks of white paper have been left unpainted.

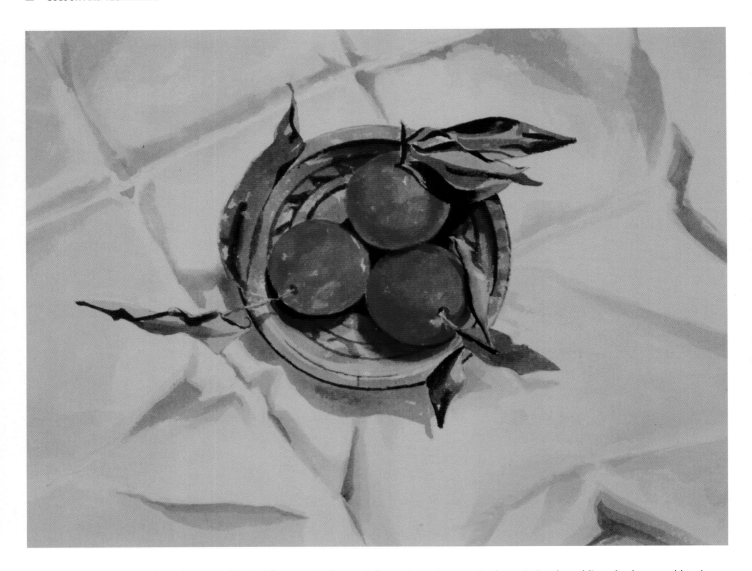

Further washes of colour have been used in building up the forms of the various elements in the painting by adding shadows and leaving the lighter parts in the first washes. The inner bands of colour were also drawn with a compass.

A thin wash of pure Cadmium Orange was painted over the fruit, leaving a few pale specks, possibly to be used as highlights later. The leaves were beginning to turn crispy and were curling as they dried. Two different tones of thin Pine Green were used to show the way in which this created some sharp, dark shadows. The inner rings on the dish were now drawn, again with a compass, and painted in Burnt Sienna. With this same colour, the shadows under the oranges and the pattern on the dish were painted in their various tones.

A wash of Cadmium Orange was brushed over the shadows under the oranges, and on the napkin under the shaded side of the dish. A slightly stronger wash of Cadmium Orange was added to the shadow side of the oranges and under the leaves where they touched. As some of the leaves were still glossy, a few small highlights could be seen. A touch of blue was added to this colour, which reflected the colour of the sky. More detail was painted on the stalks where they joined the fruit and at the point where the leaves joined the stalks. A semi-opaque pale blue colour was dragged over parts of the dish where a bloom had formed on the clay during the firing process. Some of the very dark shadows cast by the oranges were strengthened and enriched by dragging a dry brush of pure Brilliant Violet over them.

Finally, the highlights on the oranges were painted. A small area of pale orange was painted on the tops of the oranges where the light struck them. On top of this, a further highlight was added in pure white to complete the painting.

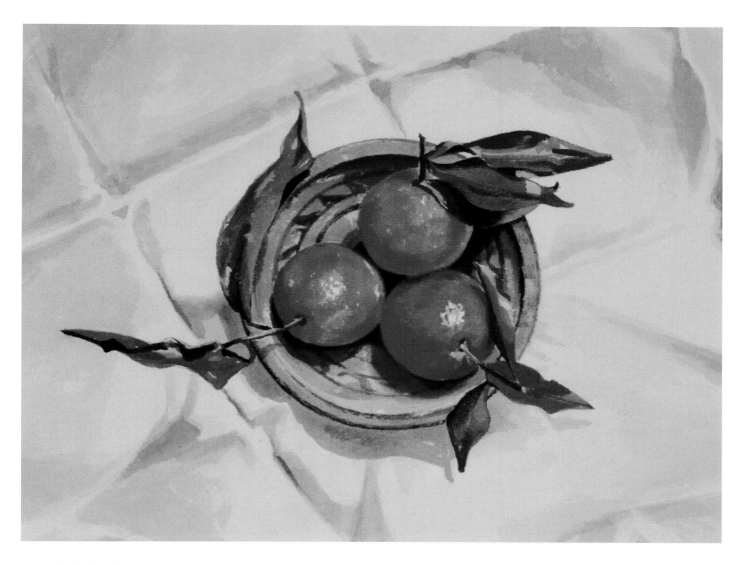

More solid colour has now been introduced into the painting and this has been used to intensify shadows and has added richness and solidity to the oranges.

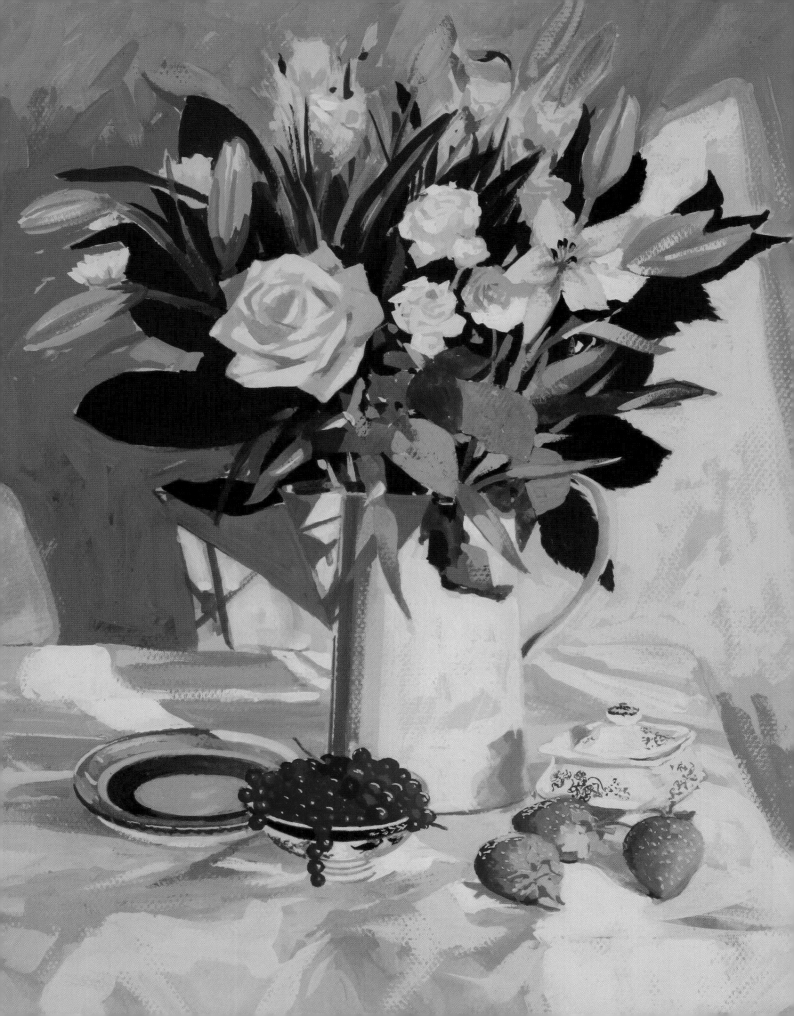

PAINTING FLOWERS

'Great things are done by a series of small things brought together.'
Vincent van Gogh

A beautiful flower arrangement doesn't necessarily make an ideal composition for a good painting. In fact, it can be quite boring. An arrangement of flowers and a composition for a painting are entirely different. A good composition can be many things: dynamic, unexpected, provocative, evocative, subtle or just pleasing to the eye for no immediately apparent reason. A flower painting in still life is not a botanical illustration. The latter is a detailed study of the plant, including all possible information ranging from the number of petals, stamens, anthers and sepals to the plant's particular leaf structure. Your aim should be to suggest the flower in a fairly descriptive yet economical way. It should be a part of the overall painting and not solely the object of it. While it

OPPOSITE: Redcurrants and Strawberries, *Kevin Scully. This painting was inspired by the strong, natural sunlight casting dramatic shadows on the wall, and illuminating everything in the composition in golden light. The geometric shapes of the shadows and leaves are in contrast with the rounded shapes of the flowers and the objects in the foreground.*

Pink Flowers on a Red Background, *Clare Wake. The differences of scale and shape of the clematis, rhododendron and daisies make this quite an exciting bouquet. The bright, singing colours create a jazz-like feeling to the painting, which is enhanced by the clashing red panel. Much of the painting has been executed in lively, thin washes with touches of opaque colour added here and there.*

The lighting in this image has been created by blocking off direct light from one window, which allows other natural light sources to produce this rather quiet, diffused atmosphere.

The natural light source has been altered here, which has resulted in most of the tumbler and the flowers being cast in shade.

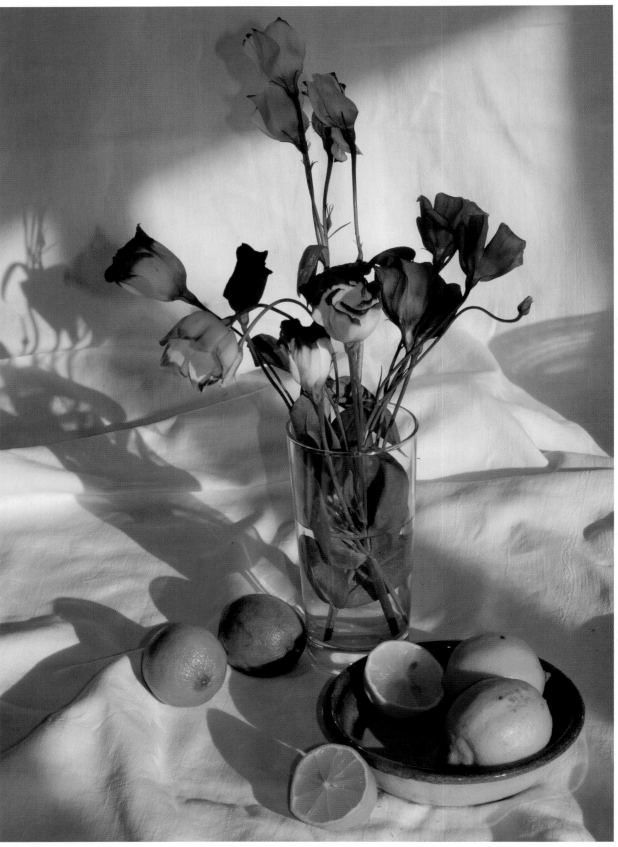

Some more objects have been introduced into the composition, and sunlight from a window has cast some intriguing shadows across the draped cloth.

will certainly pay to observe and identify the specific character-istics of the flowers you have chosen to paint, you shouldn't be a slave to perfect accuracy. A lightness of touch is often all that is required to suggest the characteristics of most flowers. Where possible, a thin, transparent wash should be the method em-ployed for painting the petals, saving the more opaque colour for sharpening the edges here and there where necessary.

The scale and proportion of any object, including flowers, and how they are positioned on the page are crucial to a good com-position, and good composition provides the foundation for a successful painting. It is something that is a natural instinct in some people, a kind of intuitive desire to arrange things in a way that is pleasing to the eye. A good photographer automati-cally frames a shot in a satisfactory manner, either instinctively or through experiencing what works and what doesn't. It's per-haps a little easier for photographers in that they have a frame within which to work. Looking at a scene through a viewfinder allows them to move the camera from side to side or up and down. By using a zoom lens, the scene can also be reduced or enlarged within the frame. Having taken the shot and decided that it isn't quite right, it can then be doctored or cropped digit-ally.

As much time as possible spent in composing a picture is time well spent. If you intend to create a finished painting rather than just a sketch, you must decide early on how you want your painting to look. Do you want your focal point to be directly in the centre of the picture, or would it be more interesting to have it in one of the sections previously described. You may want a particular flower to be the focal point or you may want the viewer's gaze to wander in one particular direction around the painting, before finally settling on the main point of interest. You can experiment with this by making yourself a simple view-finder from card or by taking several shots with a digital camera before deciding upon the most satisfactory composition. When using a viewfinder, remember to move it towards you and also away from you and not just from side to side.

If you like to paint in a decorative style, you may want to include a busy, patterned background. Here you will have to consider scale. If the elements in the background are too large in proportion to your flowers, they will be too dominant and will detract from the main focus of your painting. Similarly if you have a few small flowers in a huge vase, they will be over-whelmed by the vase. As a general rule, it's best to keep back-grounds fairly simple.

If you are embarking on a large painting, you must be aware of the scale of your flowers in relation to the area within which you will be working. At some stage you will certainly be includ-ing foliage in your paintings. Again, you must think of the rela-tive scale between flowers and foliage. Huge leaves will domi-nate small flowers and may result in a boring picture.

If you are including other objects in your picture, make sure their proportions in relation to each other and to the flowers are correct. If you are painting a small flower, such as an aubretia, it should look small in relation to an apple or a teapot. If the pro-portions are wrong, there will be no disguising them and they will be picked up on immediately! The eye and brain instantly detect these things and if your scale or proportions are wrong it will be obvious. So it is always worth spending some time fine-tuning your initial drawing.

Demonstration: Flowers

The colours used in this painting were:

Permanent White
Brilliant Violet
Raw Sienna
Permanent Light Green
Pine Green
Ultramarine
Cobalt Blue
Cadmium Yellow Pale
Cadmium Red
Brilliant Yellow
Indian Red
Magenta

The paper used was Daler-Rowney Saunders Waterford 90lb Not watercolour paper

Before this painting was started, many different arrangements of the objects were considered before settling on this composi-tion. The object of this painting was to produce one that con-tained a strong design element, harmonious colours, a pleasing balance of texture and form, and enough interest to keep the viewer's eye moving around the picture before finally resting on the tumbler of flowers.

This is probably a painting that could have been exe-cuted in watercolour, and indeed its early stages very much resemble one. But the exercise was intended to show how the painting could be taken a stage further with the addition of gouache.

The composition was drawn very lightly onto the paper with an HB pencil, taking care with the drawing so that mistakes were kept to minimum. Using a rubber on watercolour paper can ruin the surface and make it very difficult to obtain a smooth wash. The aim at the outset was to keep the painting light and delicate for as long as possible, before embellishing it with some final touches of more solid colour in the finishing stages.

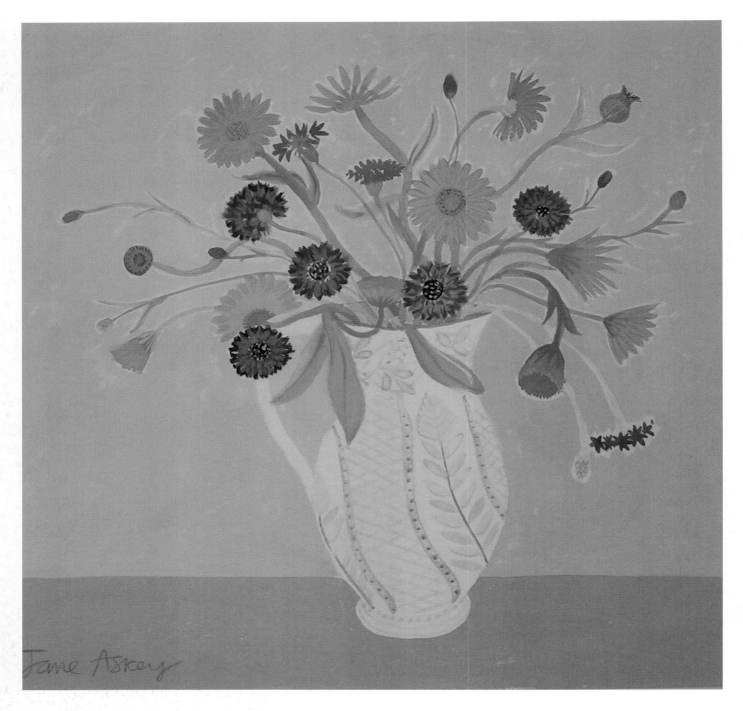

Calendula and Cornflowers, *Jane Askey. This simple painting involves a combination of the contrasting oranges and blues of the calendula and cornflowers. The background is just two blocks of colour, which ensures the focus is on the detail of the flowers and vase. The artist grows a vibrant mix of calendula and cornflowers in her garden every year; they are one of her favourite combinations, which she has interpreted in many different ways throughout her career. When planning a painting, the artist often works directly without any sketched guidelines. Occasionally initial sketches of key information are outlined in either Caran d'Ache crayon or painted using a pale colour. No detail is drawn at this stage, and only basic shapes are established. Opaque gouache is largely used but occasionally transparent washes are layered and built up. Initial brushwork is carefully considered and very often no further painting occurs; the approach is direct and decisive at the early stages. If extra definition is required then details of petals and leaves are added using finer brushwork in the later stages of the painting process.*

The background was painted with two washes, the first a diluted mixture of Ultramarine and Indian Red, and the second the same mixture with a little less water added. The first wash was laid-in as quickly as possible, taking care to paint around the objects and the tablecloth. A few areas of paper were left unpainted, which always gives a painting a certain sparkle. It was left to dry before applying the second colour, again leaving some of the under-painting untouched. The two colours used in these washes tend to granulate, leaving specks of pigment on the surface of the paper. This reaction is more pronounced with watercolours, but can also be used to good effect when using gouache.

The folds in the tablecloth were painted in the same way,

with the same colours. The lisianthus flowers were painted in a way often used in watercolour paintings. Starting with the one on the far left, each flower was first painted very carefully with a small brush containing clear water, which was left to soak into the paper until it was just damp. Care was taken so that this water didn't stray into the background colour. Before the paper became too dry, a strong mix of Brilliant Violet was painted into the top part of the flower and the stem, leaving a few specks of white paper untouched. The pale colour on the underside of the flower, which was left unpainted, was created by the colour creeping into the damp paper. Happy accidents can occur when doing this and they are best left untouched. The top of the flower needed to be a bit darker, so some stronger colour

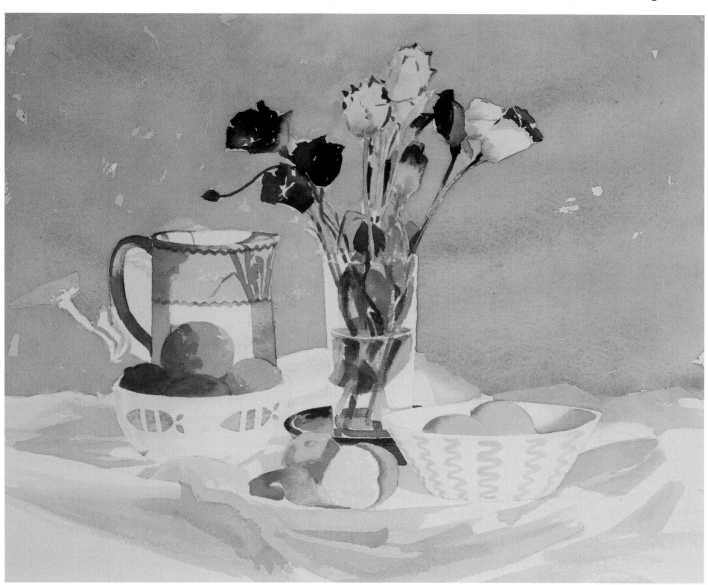

The first stages of this painting have the appearance of a watercolour painting, illustrating just how similar the two media are.

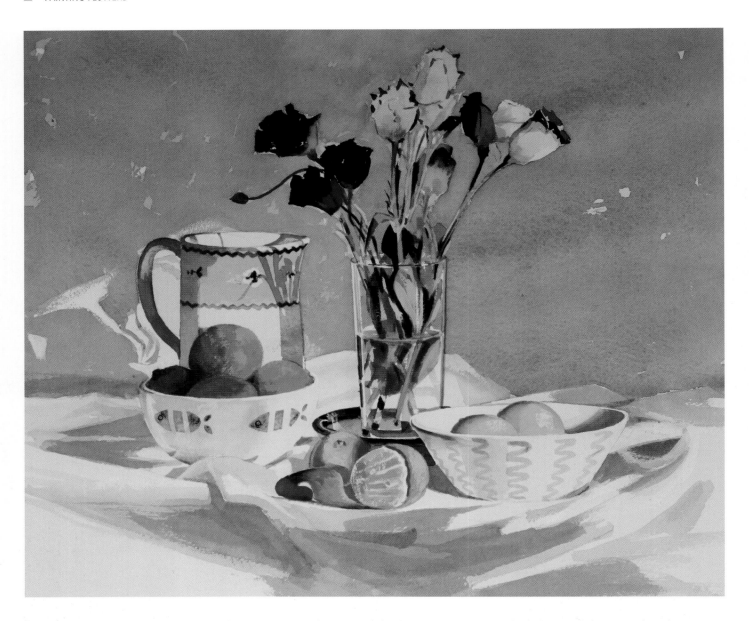

The addition of some solid colour gives the painting more impact and depth while still retaining the lightness of the original washes.

was dropped in before the paper dried completely. This process was repeated for all the flowers, some of which contained patches of Brilliant Yellow.

The two bowls were painted in the same way, each having a delicate reflection on the left hand side that was brushed into damp paper, creating a soft blend. This process was later repeated using some stronger tones, as the colour, once dry, looked far too pale. The bowls were allowed to dry before the patterns were painted on their sides. Cobalt Blue was used for the fish, which was then blotted with kitchen towel to emulate the way it appeared on the bowl, as if it had been stencilled.

The squiggles on the other bowl were painted with the same colour used for the first background wash. The stems and leaves were painted with a mixture of Permanent Light Green and Brilliant Yellow in various degrees of dilution, leaving some white paper on the water line. The same colour was used on the limes.

The dish under the tumbler was painted using Indian Red, and the band around the rim was Ultramarine with a little Brilliant Violet added to darken it; a white highlight was left along its edge. There was a slight distortion of the dish as seen through the tumbler, and these areas were painted with a more muted

colour. The oranges and lemons were both painted first with diluted Cadmium Yellow Pale, and then the darker parts with Raw Sienna added to the original colour. The top part of the jug was also painted with Cadmium Yellow Pale, and the handle with a mixture of Raw Sienna and Brilliant Violet. When the yellow was dry, the zig-zag pattern was painted with Cobalt Blue, and, when this was dry, the shadows were painted with a mixture of Raw Sienna and Brilliant Violet.

The next stage involved the introduction of some slightly more opaque colour. Some Magenta was added to the flowers and some darker green to the shadows in the foliage and stems. A few fine lines were painted along the edges of the tumbler, carefully leaving some white highlights that suggested the thickness of the glass, as did the curved reflection at the bottom. The dish was painted in more detail, leaving its reflection in the original wash. The limes were painted with small patches of various green tones, and Pine Green was added to the deep shadow. The fish's eyes were drawn with a fine pigment-based technical pen. The darker parts of the oranges and lemons, and their reflection in the bowl, were painted with a mixture of Cadmium Yellow Pale and Cadmium Red. Some darker colour was added to the tablecloth, and this colour was also used for the shadows under the top edges of the bowls. Some dirty yellow that had appeared on the palette was the perfect colour for the peeled orange. On the jug, a darker blue was added to the pattern where it was in shade, and was also used for the small motif on the side. The shadow on the handle was a stronger mixture of Raw Sienna and Brilliant Violet, as used previously.

Some opaque colour was used on the fruit, adding to its sense of solidity. The only place in this painting where a white highlight was used was on the reflection of the glass onto the inside of the shallow dish.

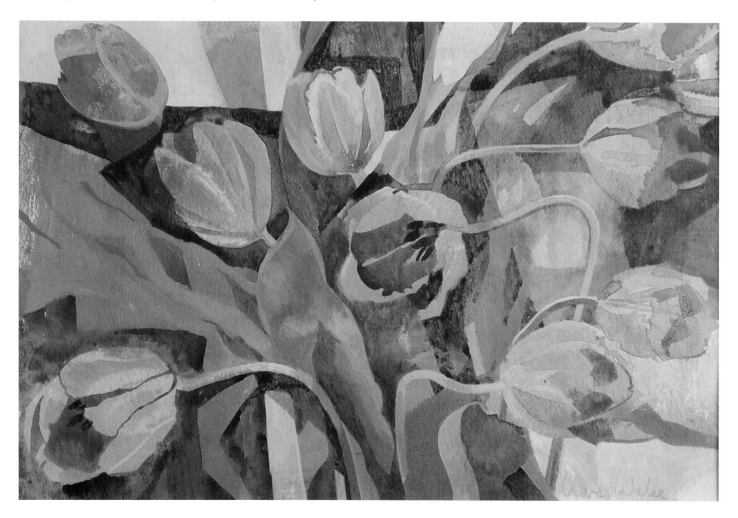

Tulip Composition, *Clare Wake, watercolour and gouache. When painting this, the movement of the stems and leaves became as important as the yellow tulips. The painting began with lots of colour flowing all over wet paper to try to achieve a glowing effect. Details were added later, with gouache used extensively to establish and define the paler abstract shapes.*

Cropping

Your composition doesn't have to sit comfortably within the confines of the page. Many excellent flower paintings have been created by allowing the flowers and foliage to disappear off the page, but careful consideration should be given to where this cropping takes place.

By using a combination of transparent washes and solid colour, the essence and beauty of flowers can be expressed to the full using gouache, and painting flowers is an excellent way to discover the possibilities of this versatile medium. Although you will need to employ a certain degree of observational drawing, accuracy isn't critical. Therefore you are given more of a free rein to experiment with technique. Unless you want to paint in a decorative, illustrative style using flat areas of colour, the following exercise will allow you to use gouache in a similar way to watercolour, with only the final touches being applied in opaque paint.

Demonstration: an Exercise in Simplicity

The colours used in this painting were:

Permanent White
Lemon Yellow
Permanent Green
French Ultramarine
Indian Red
Raw Sienna

The paper used was Bockingford 190gsm Not watercolour paper

Begin with a simple composition of some daisies in a glass tumbler. The background used here was a white cloth. Although the daisies were rather pale, making the background darker than

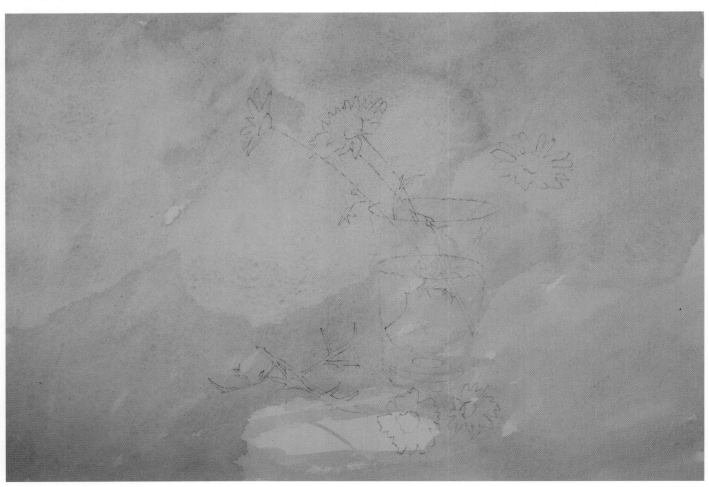

This painting began with a rather sombre wash over the whole image, leaving just a few traces of white paper where the light struck the tablecloth. When this was dry, a further wash of a slightly different colour was added to suggest some shadow behind the objects.

it really was prevented them from disappearing into the background. Because of the way in which the composition was lit, enough shadow was created on the flowers to enable the petals to show up, and this was also exaggerated slightly. By overlaying delicate washes of slightly differing colours in the background, the pale yellow petals of the daisies stand out. They were painted in a solid, opaque colour and their three-dimensional form is described by the shadow colour of the flower where the light hasn't struck it.

Attempting to paint a transparent glass containing transparent water against a pale background might also pose a problem. But the glass and the surface of the water both have edges and these will be seen as a tone either slightly lighter or darker than the background. The glass has been positioned slightly off-centre with the curve of the daisy stems giving the composition balance. A flower placed in the foreground adds further interest and gives the arrangement a sense of perspective and depth.

The painting was started by mixing up the two colours that were to be used for the initial wash. One was Ultramarine with a touch of Indian Red added, and the other was Indian Red diluted with plenty of water. To add some atmosphere to the background, the right hand side of the painting was left as a very slightly lighter shade than the left. The washes were taken straight over the daisies and the glass and then left to dry. A further thin wash of Ultramarine was then overlaid, leaving some of the original colour untouched. The stems of the daisies, including the calyxes (the bulbous part of the plant at the junction between the stem and the flower) were painted with a mixture of Pine Green with a touch of Raw Sienna added. The stems were painted in various strengths of this mix where some were in shade and others were paler where the light fell on them. Notice how, where the stems enter the water, they appear not as a continuous line but seem to change direction slightly. This is due to the phenomenon known as refraction, which occurs when an object enters water at an oblique angle and appears to bend.

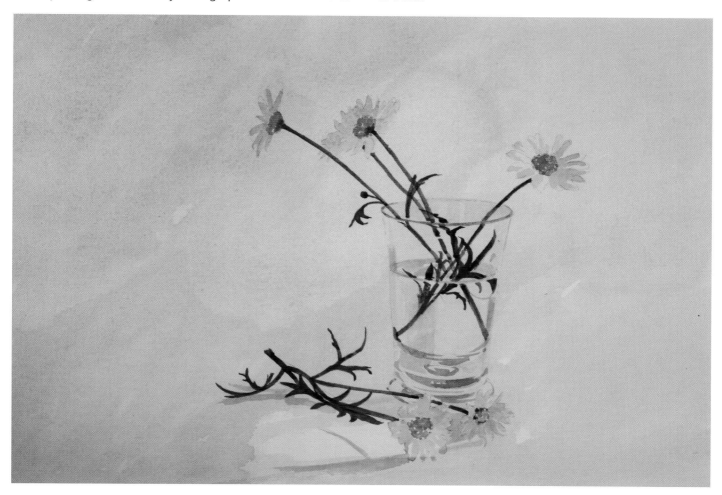

The glass and daisies were painted in diluted colour, and a shadow was added under the daisy in the foreground.

To indicate the thickness of the glass, a diluted mix of Ultramarine and Indian Red was painted in a 'lost and found' line on its vertical edges. A slightly darker version of the same colour describes the ellipse at the top of the glass. The bottom of the glass has a greater thickness and some of the colours used in the stems are reflected here. You will notice that at the point where the stems touch the bottom of the glass there is a slight curve to the glass, and the line of this curve doesn't quite touch the vertical sides. Again, this helps to show the thickness of the glass.

The shadows on the cloth were painted with a stronger mix of Ultramarine and Indian Red. The daisy in the foreground was painted in the same way as those in the glass, leaving the brightest pale yellow petals to be painted at the very end.

Even the simplest of arrangements can be full of subtle balances of colour, light and dark, reflections and shadows, and passages both cool and warm. The beauty of transparent glass and water contrasting with the solid forms of foliage, sharp edges and blurred edges makes for a simple but pleasing painting.

Problems

Painting flowers is not without its problems. Time is the great enemy: if you start off trying to paint a massive bouquet of dazzling blooms with an inexperienced eye, the flowerheads and leaves will begin to droop before you have finished your picture. It is therefore best to work loosely over the whole painting before trying to finish any areas in great detail too early on. Even when confronted with a simple grouping, your beautiful composition may have drooped and faded and tilted out of balance. It is better to either leave everything as it is or make adjustments as you go along. Another solution is to take a photograph of the arrangement as soon as you have set it up, and you can then refer to this for positioning if things have moved around a bit or taken a turn for the worse. One other problem that may arise is that having carefully drawn in or loosely painted your composition, you wake the next morning to find that several of the beautiful, delicate buds have turned into

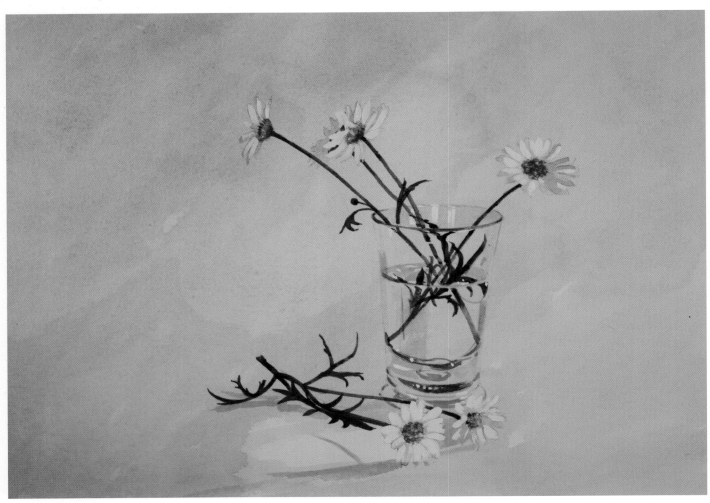

The painting is finished with just a few simple shadows and highlights in solid colour.

huge flowerheads. It's at moments like these that you may curse nature and its unpredictability. If possible, aim to finish a flower painting in one sitting, although in the real world this quite often cannot be done.

Your arrangement may also be spoilt by the flowers dropping some of their petals. If this happens you may choose to either leave them out of the picture altogether, or include them anyway if you feel they add something to the composition.

Demonstration: Flowers and Shadows

'I perhaps owe having become a painter to flowers.'

Claude Monet

The colours used in this painting were:

Permanent White
Cadmium Red
Alizarin Crimson
Burnt Sienna
Raw Sienna
Viridian
Pine Green
Ultramarine
Lamp Black
Yellow Ochre

The pastel paper used was Canson 'Mi-Teintes' Sand

This was painted on a summer's day with strong sunlight streaming in through the window. The objects in this set-up are not especially connected in any way, but when carefully arranged they made a pleasing composition.

A large sheet of golden brown paper that had been lying around the studio for some time, waiting to be used, was pinned to the wall and a white cloth was draped over the end of a table. The other objects in the picture were moved around a few times until a satisfactory composition had been decided upon.

The appeal of this arrangement lay in the way in which the rather angular leaves and flower shapes were echoed in the geometric patterns created by the shadows on the wall. Similar colours appear in both the shallow dish and the two bowls, while the whole picture is balanced by the curves of all of the objects

on the table. It was decided to paint the background, flowers and white cloth in a fairly loose, painterly fashion, while the objects in the foreground were afforded a bit more detail.

A sheet of pastel paper was chosen for this painting as it was just about the right colour for the basis of this richly coloured arrangement. It was only lightly dampened before stretching, to prevent it from tearing. The composition was drawn directly onto the paper.

All of the items in the picture were painted with a thin wash of their local colour, without worrying too much about accuracy at this stage. The strong shadow on the wall was painted with a large brush loaded with diluted Burnt Sienna and this established its strong shape. A line was painted in Pine Green around the roses to establish their shape and position. Because they were fairly pale in colour, this line was painted to prevent the staining effect of the green colour straying onto the petals. It is very easy to get lost when painting a mass of tightly packed foliage and flowers.

The background was painted using Permanent White, Burnt Sienna and Raw Sienna. The first shape to be painted was the shadow on the wall behind the flowers. This was first painted with a mixture of Burnt Sienna and Raw Sienna and then overpainted with the same colour with some Permanent White added. The rest of the background was painted at speed using a mixture of these colours wet-in-wet. Quite a lot of the original pastel paper can still be seen in this painting, particularly on the wall and tablecloth.

No more was added to the background and the position of the shadows reflected the direction of the lighting. This was important, as the light would alter while the rest of the painting was done during the morning and consequently the position of the shadows would change. Using the background as the key to the direction of light, some of the shadows were painted from imagination. However, the sun shone again the following day and adjustments could be made where necessary.

For the next stage of the painting, more solid colour was used in defining the shapes of the objects and indicating areas in shade, particularly where a lot of the foliage in the jug was very dark. Here, some Lamp Black was added to the Pine Green. This was accentuated slightly, so that the flowers could appear more dominant. The lilies at the back were painted very simply, while the flowers nearer the front were treated to a little more detail. The petals of the rose and the buds of the lilies were painted with a mixture of Permanent White, Pine Green and Yellow Ochre.

On the shadow side of the jug, a certain amount of the foliage colour was reflected onto it, so a little Pine Green was included here. This vertical line of shadow wasn't taken right up to the edge of the jug, but instead a lighter colour left along this edge suggests the roundness of the object.

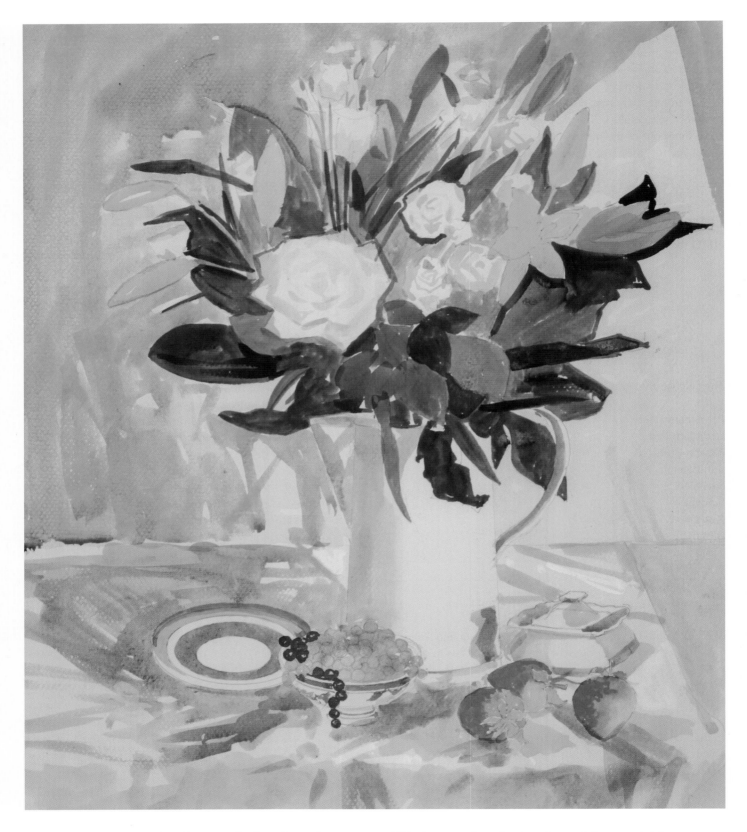

The composition is painted swiftly on sand-coloured pastel paper, to establish the general tonal values. Some of the paper is left untouched to retain the painting's unified, golden glow.

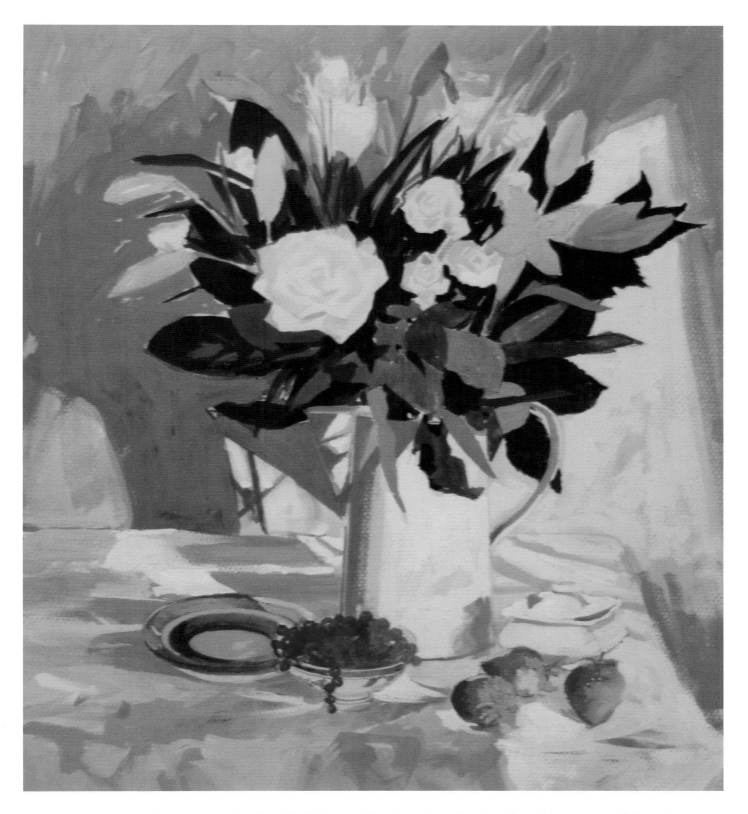

Some semi-transparent white was painted on the tablecloth, jug and background to allow the colour of the paper to still show through. The shadows on the wall and the tablecloth were painted with loose brushstrokes in contrast with the more careful treatment of the bowls and fruit.

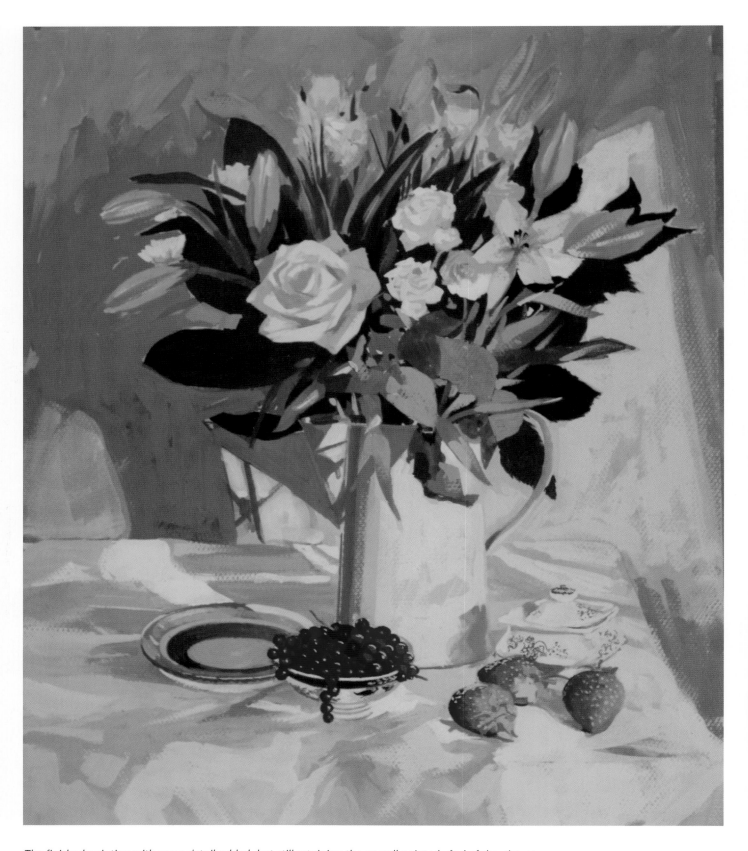

The finished painting with more detail added, but still retaining the overall painterly feel of the picture.

CREATING THE ILLUSION OF A ROUND OBJECT

When painting round or curved objects, they can be made to appear round by painting a shadow on one side that stops just short of their edge. Sometimes a shadow painted right up to the edge can make the object look rather flat.

An even greater amount of care was given to the shallow dish on the left of the picture, as it was quite tricky getting the ellipses created by the two bands of colour to look convincing. The blackcurrants were defined a little more carefully by painting those in shade with a semi-opaque Crimson wash. The delicate pattern on the bowl was indicated with a thin wash of Ultramarine.

The strawberries were painted with three colours: Alizarin Crimson on the shadow side; Cadmium Red to which a little white was added on the lighter side in half-shade; and a mixture of Pine Green, Permanent White and Yellow Ochre for their stalks.

The painting was resumed the following day and a few adjustments were made to some of the shadows. Some of the buds had opened and a few of the leaves had drooped. These changes were ignored, so some of the detail in the flower arrangement had to be invented.

While the light was at a similar angle to the previous day, the shadows on the sugar bowl were painted in. This again was a bit tricky, because of the rather strange shape of the curly lip around its top. The flowery pattern was painted in Ultramarine.

The flowers and foliage were now painted in greater detail to give the arrangement a more three-dimensional appearance. Highlights painted on some of the leaves indicate those that are closer to the front, while the plainer, darker leaves now appear further back. Sometimes, however, this technique can have the opposite effect. Occasionally when drawing or painting very dark areas, they can look closer to the viewer than those that are less dominant, but in this instance it seems to work well.

The roses were painted very carefully, because the way that the petals wrap around each other can be quite difficult to work out when drawn or painted. The loose brushwork on the jug and tablecloth was deemed adequate and tied in with the way in which the background had been painted.

Highlights on the blackcurrants were painted in keeping with their scale and on some of them there are highlights on top of slightly paler highlights.

On the shadow side of the strawberries it was noticed that there was some light reflected off the cream jug, so this was added before the tiny pale dimples peculiar to the fruit were painted with a small sable with a Permanent White and Yellow Ochre mix.

The stems were then given some highlights and shadows and, apart from a few areas elsewhere on the painting where a little 'sharpening-up' was performed, the painting was finished.

Dried Flowers and Artificial Flowers

The pleasure derived from painting fresh flowers is unquestionably one of the reasons why you would choose to do it in the first place, but perhaps you might consider not so fresh ones: in other words, dried ones. This can be a challenge. In addition, you might like to try your hand at flowers that aren't flowers at all: artificial flowers.

This probably conjures up images of lurid plastic flowers dropped into perforated metal domes on an untended and long-forgotten grave. However, there are now some beautiful artificial flowers available intended for indoor display. They are made from linen, and from a distance can be mistaken for the real thing. They do, of course, have the distinct advantage of not drooping or fading overnight. In the depths of winter, when your favourite blooms are unavailable, they're a pretty good substitute and are excellent for practising your painting techniques.

Ready-made arrangements of plants still with their roots in soil offer further possibilities for a prolonged plant life. These are very often attractive pairings of flowers in terracotta or ceramic pots or baskets lined with plastic.

Backgrounds

Contrary to many claims, it is not that easy to paint a truly flat background in gouache, particularly when you have to negotiate your brushstrokes around delicate flower petals and thin stems. It is much better to keep backgrounds simple, but not, of course, to the extent of them appearing boring. By overlaying a number of delicate washes, the variation in colour and tone creates an atmospheric and moody backdrop, while not distracting from what is going on centre-stage. By keeping the washes thin, the drying process is slowed down and this allows you precious thinking time as the painting slowly evolves. If you are painting very pale flowers you will need to paint them against a fairly dark background so that the contrast of light and dark enables you to depict their shape.

The thicker the paint, the quicker it starts to dry on the sur-

face, and where the brushstrokes overlap an unwanted and unlovely slight change in colour can occur.

It is, of course, possible to create a painting entirely in washes of gouache, but quite honestly, if you want your picture to look exactly like a watercolour then use watercolour. The beauty of gouache is that you can produce rich and sumptuous effects by combining both transparent and solid colour.

Using solid colour should be avoided too early on in a painting, especially the darker tones. Once you have painted an opaque dark colour it can be very difficult to do anything with it later on in the painting process. It is always advisable

to leave the solid highlights and darkest passages until the end.

A soft, graded wash can often enhance a flower painting by providing a subdued backdrop for the main event. A series of washes can be overlaid using slightly different colours, creating just the right atmosphere and a foil for a bolder arrangement in the foreground. If you attempt this, be sure that the first wash is bone-dry before overlaying subsequent washes, otherwise you may end up with a rather muddy background. These washes should be executed as swiftly as possible to prevent stirring up the colour underneath. Make sure you mix up

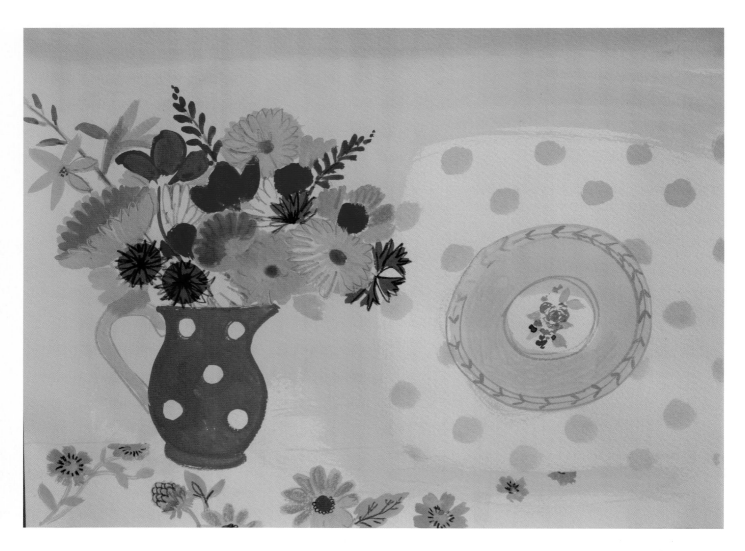

Sunny Room and Orange Jug, *Jane Askey. The fragility and transience of flowers can create a sense of urgency when painting fresh flowers. The artist works quickly to explore the vibrancy of the colour and to capture the freshness of the subject. The oranges, pinks and blues of a late summer garden come together in the bunch of picked flowers. The yellow ground is a large sweeping wash of colour like light flooding into a room. Fragments of pattern echo the colour of the flowers and the blue polka dots add to the happy mood. The dotty pattern also mirrors the spots on the jug and helps connect the two halves of the painting. There is very little over painting, the approach involves fast, direct brushwork and accurate colour mixing.*

Very tall flowers can sometimes look rather uncomfortable in a composition. With a group of objects like this, a painting of them would perhaps benefit from being cropped at the top of the picture.

plenty of colour so that you don't run out halfway across the page, thus avoiding a hard line that forms where the paint has dried while you're mixing up more paint. The aim of these watercolour-like background washes is for them to appear as fresh as possible.

A common mistake when painting a background wash is to start in the middle of the page, which means you have to work in both directions, left and right, to prevent a hard edge appearing. If you are right-handed, start from the top left-hand corner of the painting, working as quickly as you can across to the right. If you are left-handed you will probably want to start from the right-hand side. If your background goes down to the bottom corners of the painting, you should start painting it there, working your way up and then across.

There will inevitably be times when you will have to paint around flowers or leaves, but try not to leave any edges to dry when doing this. Any areas that are isolated, in other words a shape that is not attached to the main background can be left until later. These shapes will be those in between flowers or stems. If you are using a fairly big brush for your background, which I would recommend, you might want to have a smaller brush to hand for painting around intricate areas, using the same colour.

If you want your background washes to be fairly dark, mixing the paint to the right consistency is a little trickier and requires a bit of practice. The strength of colour can, of course, be tried out on a piece of test paper first. Remember that, because gouache can be used opaquely, any small indiscretions can usually be rectified later on.

Different Types of Flowers in a Composition

Flowerheads can be very complicated, so when looking at them individually, half-close your eyes. This will eliminate the half-tones that can be distracting, and you will be able to distinguish

between the lighter and darker areas. This is a good starting point for laying-in your initial washes. When these are dry you can overlay more subtle colour washes to define the various changes in tone.

Care should be taken when choosing which flowers to include in your painting. There are some that, although beautiful in their own right, look decidedly uncomfortable in a vase or a pot. Very tall, upright and spiky ones are very difficult to deal with, as are those with stiff, sword-like leaves.

Round flowerheads can be very distracting, particularly if there are too many of them in one group. You can't really go that far wrong with those flowers that have a looser, straggly nature, as they sit more comfortably in a variety of contain-

ers. A bowl of tulips on their last legs, with fallen petals in the foreground, has a look of charming abandonment. But you will have to work quickly!

Don't treat leaves as an afterthought, as they are an integral part of the whole picture. Their positioning, both in front of and behind the flowerheads, is crucial to the overall balance of colour and shape. It is also essential that the leaves look as though they are attached to the stems and that the flowers actually emerge from those stems. It is wise to remove most of the lower leaves from the stems, as you would when arranging a vase of flowers, particularly when painting a grouping in a glass container. A tangled mass of leaves in water isn't all that attractive, and is also rather difficult to paint!

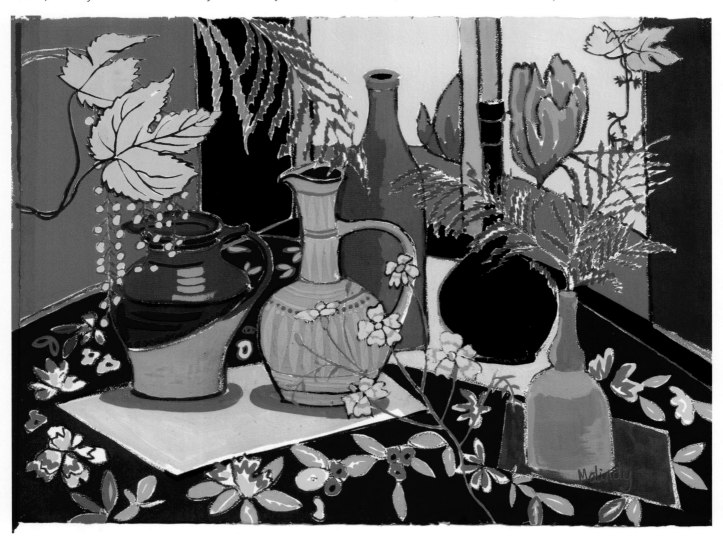

Still Life with Vases, *Malindy Argyle. This still life was painted with the table and vases placed in front of the window in the artist's studio. Two trees (which are no longer there) are visible in an abstracted yellow patch of sunlight. A golden hop, which had started to take over the veranda, is featured in two corners, and a tagetes occupies the foreground. The artist enjoyed the spontaneity of working on a large scale, and the ease with which the composition simply fell into place. Her love of Cadmium Red is very evident in this colourful painting.*

Choosing Containers: Vases, Opaque and Transparent

To display the beauty of flowers properly it is necessary to arrange them in containers. When choosing your container, think about its shape and proportion in relation to the flowers themselves. Also consider any pattern that may be on the vase and whether or not it complements or jars the arrangement. It helps if you choose a container that you like the shape of, and not just one that happens to be the right size. If a vase is too brightly coloured it probably wouldn't be suitable for an arrangement of the pastel shades of anemones. The possibilities of flower and vase combinations are endless, but if you have a love for flowers you will without doubt have spent a fair amount of time arranging them in vases. A painting of a huge pot containing tiny flowers is doomed to failure and conversely a tiny container

Here the effects of distortion can be seen as stems enter the water, emerging below the water line at a different angle.

When seen from a higher viewpoint, the angle of distortion is even greater.

with a huge display of large blooms is not a recipe for a winning picture.

Glass vases can add another dimension to a composition by creating reflections and highlights, as well as possessing a three-dimensional form. Their transparency is a great contrast to the solid forms of flowers. Simple, plain glass vases perhaps make the best containers, but you should also consider round bowls, glass jugs and fluted glasses. A glass bowl filled with roses is a classic combination and never fails to please the eye. A square glass vase also makes an excellent container, its geometric form contrasting well with the organic shapes of flowers. Even the humble jam jar can be the perfect vessel for a simple arrangement of just a stem or two of roses. Drinking glasses in various shapes and sizes are also worthy of consideration. Bottles are another possibility, but these are of limited use due to their narrow necks.

If you have room, build up a collection of containers, as you will soon tire of painting the same ones over and over again.

Pots

Ceramic and terracotta pots intended for outdoor use can be adapted to hold flowers by inserting a suitable watertight container inside them. The bottom of a plastic water or lemonade bottle cut off at the appropriate height will do the job perfectly.

Choosing Flowers

The scope for painting flowers is endless. A small grouping of woodland flowers with delicate petals can be cosy, calm and evocative, while a painting of exuberant flowers such as camellias and cannas will, with a blast of colour, generate a feeling of excitement and elation. The overall effect may be reminiscent of a woodland spring walk or a hot, tropical holiday. There is probably no flower in existence that hasn't been painted at some time or other, but that doesn't mean that you can't paint it in a way that is particular to you. No flower is worthy of dismissal when it comes to choosing subjects for a painting, but for it to be successful you must begin your picture with some sort of emotion.

It may be tranquil or poignant, sensitive or fiery, but the feeling you had when you were first inspired to embark on the piece can be expressed by the way the flowers and their colour are interpreted. Certain flowers suggest particular ways of going about painting them: bluebells, wood anemones, campion and speedwell are fairly small in scale and lend themselves to delicate washes rather than bold slabs of solid colour.

Painting Water

Painting water in a glass container can be problematic for the inexperienced painter, but the challenge of producing a convincing rendition of a transparent liquid in a transparent glass or vase will have to be confronted at some stage.

By careful observation, there is no reason why you shouldn't be able to tackle water successfully. First thoughts might lead you to mix a grey wash and indeed sometimes this is a good starting point, but the more closely you study flower stems in water the more quickly you will realize that there will probably be several different hues of grey present. Depending on the background colour, the surface on which the container is sitting, the flowers themselves and any other objects surrounding them, there may be green-greys, blue-greys and also touches of warmer tints present. You will be able to utilize reflections and highlights on the glass's surface and with just a few brushstrokes you can give the impression of transparency.

Close observation will reveal that where the stems enter the water, their angle changes depending upon your viewpoint. The higher your viewpoint, the greater the angle of distortion. By painting this change of direction above and below the water level, and the distortion of objects in the background, the highlights and perhaps shadow on the water's surface, you'll find that there is very little else to paint to create the illusion of water in two dimensions. Look at the vertical edges of the glass. Where there is a light colour in the background there will probably be a subtle dark edge to the glass, and where there is a dark background there will probably be a highlight somewhere along its edge. This counter-balance of light and dark tones is an essential tool when painting water in a glass container.

Look for reflections in the base of the container where the glass is usually thicker. Some of the stem colour may appear here, or perhaps some of the colour of the material on which the glass has been placed.

Common Mistakes

A common mistake when painting water is to overcomplicate the brushstrokes. Try to keep the washes thin and the shapes

simple, and don't paint any strong shadows or highlights until your picture is almost complete. Look out for areas where there are actually two highlights. In other words, a small, precise highlight on top of, or next to, another more subtle highlight of a slightly larger shape. This can occur anywhere, particularly on glass.

It is very easy to forget that some flowers and leaves can be translucent. The surface may be one colour, but if there is light shining upon that surface there will probably be subtle differences in the colour, particularly if the petals or leaves are turned at different angles. There may also be light or reflected light shining through them from below, which also creates a difference in colour between the top and bottom surfaces. Such subtle nuances invariably add another dimension to your paintings.

Unless you are setting out to produce a purely decorative flower painting, don't bombard your picture with too much bright colour. Remember that passages of subdued colour will enhance those areas where all the action is taking place.

Don't be too ambitious with your subject matter or the scale of your paintings too early on, as flowers can be quite complicated subjects to tackle. Gain confidence by beginning with simple compositions and slowly ease your way into more complex arrangements.

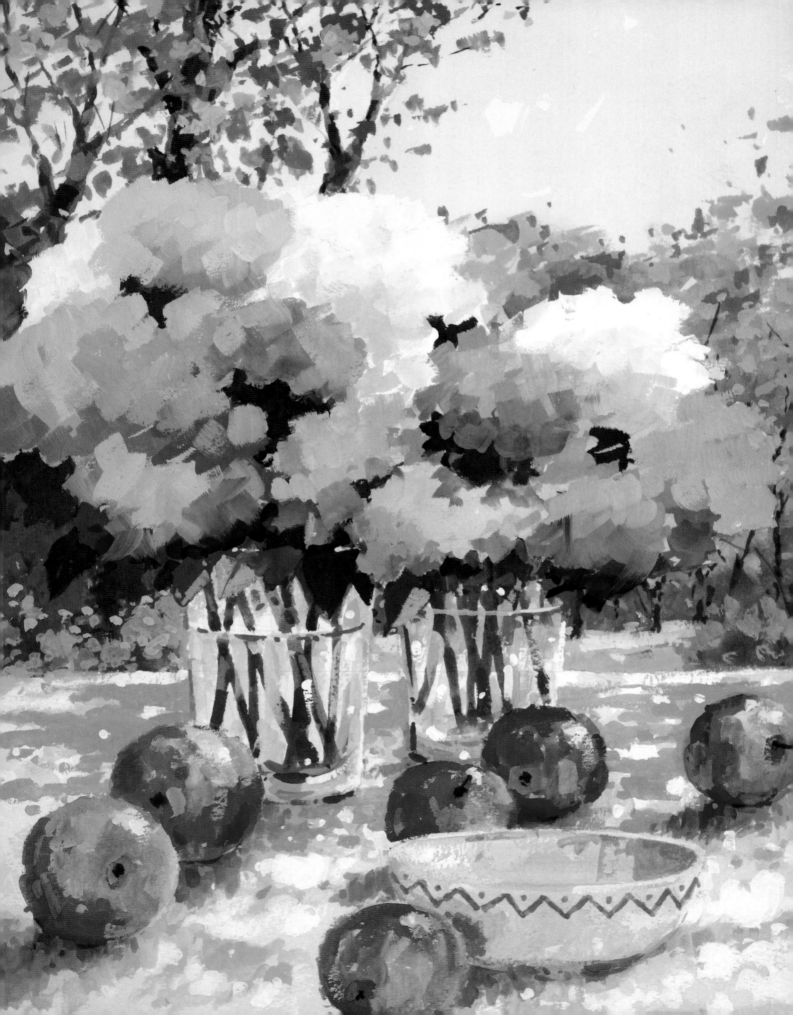

OBJECTS AND BACKGROUNDS

By setting your still life objects in a room, you can add an extra dimension to your compositions without actually creating an 'interior painting'. Your own home may be a treasure trove of interesting backdrops, from curtains and carpets to furniture and windows. By simply moving a piece of furniture under a window and placing a few objects upon it, you can create some interesting arrangements. An open window or door, perhaps with a coat hanging on a peg, will give a sense of scale and perspective to what may seem a fairly mundane composition, particularly if there is a view to be glimpsed through the opening. Light from outside reflected on shiny surfaces, and shadows cast within, also add an extra dimension to the image. You might also consider a simple item of clothing draped over a shiny table bathed in shafts of sunlight through half-closed venetian blinds. You may also like to examine the possibilities of a view from outside looking into a room, framed by a window or doorway. The sensation of peeping into a room can create a feeling of intrigue and curiosity.

A garden building or conservatory may also have potential. The rustic simplicity of some battered tools leaning against the interior of a weatherboard shed, a few pot plants on a tiled garden room floor or even the contents of a greenhouse are all valuable sources of inspiration.

Reversing the focus of attention can create a rewarding composition. A simple bowl on a table, placed in front of an intricately patterned curtain, or a pair of weather-beaten boots casually discarded on a brightly coloured, striped rug by an open door can provide great possibilities and endless variation. You may have an interesting staircase, one that turns or winds, so placing a few objects on the landing, or perhaps on a window ledge could give a sense of movement and of something happening beyond the picture.

OPPOSITE: *Summer Flowers and Fruit*, Kevin Scully. Reflections and highlights on the tablecloth help to create the illusion of dappled sunlight filtering through the branches of an overhanging tree.

A moody and melancholy atmosphere can be created by placing a simple object on a bare wooden floor in an otherwise empty room. A cardboard box or a few discarded items propped up against a wall could suggest a story untold, a sense of something that may have just happened or someone having just left. Here, some empty space within the painting could add drama to the enigmatic scene, and direct the viewer's eye to focus on the objects.

Demonstration: Bringing out the Background

The colours used in this painting were:

Permanent White
Raw Sienna
Raw Umber
Brilliant Green
Cobalt Blue
Lamp Black
Ultramarine

The paper used was Daler-Rowney Saunders Waterford 90lb Not watercolour paper

This quiet painting, with its subdued colour scheme, was painted in rather dull daylight and is lacking in any strong shadows other than the dark area at the bottom of the picture. The dark, vertical band at the top of the picture didn't actually exist but was added to counter-balance the strong horizontal shape at the bottom and the water pipe on the wall to the right of the jug. Some sheets of tinted paper were pinned to the wall at a jaunty angle to give a vaguely abstract look to the background. The objects were chosen for their similarity in colour and these colours are echoed throughout the painting. By contrast, the flowers in the jug are bright and colourful

Moonlit Tulip, *Liz Venn. This is one of a series of paintings of flowers against a starry sky. The artist liked the idea of closeness and infinity alluded to in the painting, and the way that the dark sky intensifies the colour of the tulip. This painting is on Fabriano 5 hot press paper, which gives a lovely smooth finish. Normally she uses Winsor & Newton Designer's Gouache. The colour for the dark sky was mixed with Ultramarine, Magenta and Black, which produces a rich, soft black. She often paints the background underneath the main subject as she finds that gouache can quite happily be painted over dark colours, though several coats may be needed. If she needs to draw the subject over a dark background she uses a light-coloured watercolour pencil. Some colours have been blended together by placing two colours next to each other and softening the join with a damp brush. Highlights and shadows were painted with a dry brush technique. The additional colours used in this painting were Permanent White, Permanent Yellow Deep, Flame Red, Light Green, Linden Green and Forest Green. She first used gouache at art college and loves the way in which it can be manipulated. Care has to be taken with the finished painting though, as any careless splashes of water or scratches will mark the surface. As soon as she is happy with her painting, it goes into a portfolio for safekeeping.*

without being overpowering and their scale is pleasingly small.

The initial drawing was in simple line, and some areas were left without any indication of what was there. Decisions regarding how these areas were going to be tackled were made during the course of the painting. Sometimes a painting will take its own course, with amendments made along the way, and this was such a painting. The jug was 'drawn through' the mortar and pestle in front of it, to establish the correct ellipse at its base and the flowers were indicated very loosely.

The painting began with the minimum of drawing, but a certain amount of care was taken in establishing the correct ellipses on the jug and mortar.

Thin washes of various tones were laid-in as a preliminary base for the different objects. The area beneath the table was left unpainted, as the decision regarding what to include here was yet to be resolved.

Once the various base colours and their tonal relationship had been established, work was begun on the next stage: painting the background. Several different colours were mixed in the palette, all of them containing more or less the same colours but in varying quantities. The colours used were Permanent White, Raw Sienna, Raw Umber, Cobalt Blue and Lamp Black. These

The first washes created the basis for the subdued atmosphere of the painting.

areas were painted very loosely, with blocks of colour being applied in a rather random manner, with some of the colour from one area being introduced into another to establish a certain atmospheric cohesion. In some areas colours were blended together, but this was done in a patchy way that added to the rather enigmatic mood of the painting.

Paint was then applied to the objects themselves, creating a subtle counter-balance of light against dark and dark against light. Keeping the brushstrokes fairly small makes it easier to describe the various forms and colour changes of each individual object, while at the same time creating a unified composition.

Although the objects were actually set up on an old chest, it

To continue the muted colour range, the same colours were introduced into several sections of the painting.

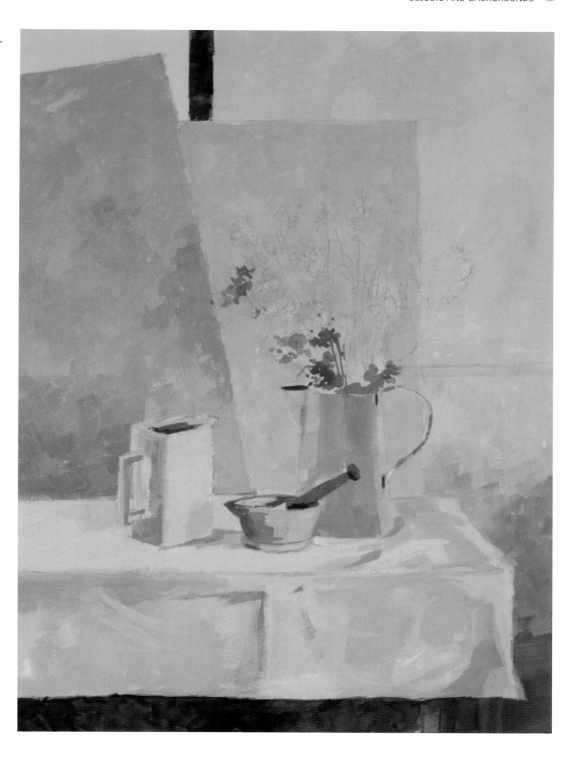

was decided to paint this as a table instead, so some legs were added at the bottom of the painting. Folds were painted on the tablecloth and the addition of some darker shadows throughout the painting began to establish a more solid look to the composition. At this point it was decided to strengthen the tone of the vertical band in the background at the top of the picture, adding more interest in an area that otherwise might be a bit dull.

Some of the foliage was painted in the jug in order to establish how strong it needed to be tonally. Two or three different shades of this colour were then used to paint the stems and leaves. The flowers were painted with a mixture of Cobalt

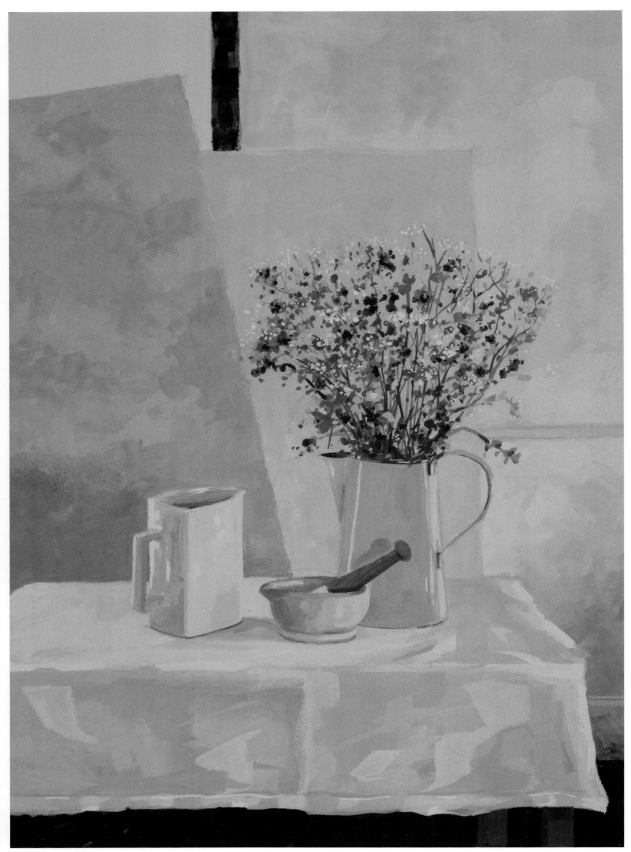

Some subtle shades in the flower arrangement add a colourful passage to the low-key colour scheme.

and Ultramarine Blue, and the background colour was just dark enough for the tiny white gypsophila flowerheads to be seen.

Sometimes quite a dramatic colour transition occurs during the process of executing a painting, but in this case very little changed, and much of the initial painting was left as it was. The objects were painted a little more carefully to describe their differing surfaces, and in particular more detail was applied to the handle, rim and spout of the metal jug. A skirting board was added to the wall and, apart from a few more highlights and shadows, the painting was complete.

There is nothing in this picture that is going to set the world on fire, but the mood and atmosphere of the finished painting are exactly as was intended at the outset.

Using Natural and Artificial Light

Following on from this theme of 'a story untold', a sense of drama can be added to a painting by experimenting with lighting. Any natural lighting should be incorporated wherever possible, especially strong sunlight. A sense of peace and tranquillity can be suggested by the play of light from a window onto a wall or floor. If diffused by a net curtain, sunlight creates softer, more subdued shadows, and if there are trees outside the window the shadows will be dappled, producing a more abstract pattern.

Daylight on a cool day casts a cool, blue light, whereas strong, warm sunlight bathes objects in warm yellow light. Normal electric light also produces a warm colour. By combining two different light sources, one cool from a window and the other warm from an interior light, you can create a very interesting interplay between the two different tones.

Demonstration: Adopting an Unusual Perspective

The colours used in this painting were:

Permanent White
Turquoise
Helio Blue
Scarlet
Brilliant Violet
Raw Sienna
Lamp Black
Burnt Umber

The paper used was Daler-Rowney Saunders Waterford 90lb Not watercolour paper

In this painting all the objects are leaning slightly over to the right. This is the product of a viewpoint taken from the left of the set-up. By keeping one's head facing forward, the objects seen in peripheral vision, or by just turning one's head a little, appear tilted. Without going into a scientific explanation for this, it is simply the result of the way in which our eyes focus. It was painted this way as an exercise in creating a painting with this concept as its basis. The unusual viewpoint is emphasized by the coloured paper pinned at an angle to the wall in the background.

While drawing these objects, the ellipses were drawn through each other so that they could be established with greater accuracy. As the eye travels over to the right hand side of the drawing, the ellipses also lean further in that direction. The intention of this painting was to create as much visual interest as possible using some very mundane objects, by treating them in a loose painterly manner.

The first stage of the painting required a wash of dilute Burnt Umber to cover the paper. Any lighter areas required later on would be painted in opaque or semi-opaque colour, so there was no need to retain the pristine white paper.

Semi-opaque colour was washed over the various elements in the composition, leaving patches of the initial wash peeping through here and there. Highlighted areas were left untouched so that the tonal balance of the painting could be immediately established. Tweaks can be made to this at a later stage, but this is an important guide to refer to as the painting progresses.

Even at this early stage, care was taken when painting the reflections seen through the transparent objects in the foreground, because once these are lost, it is more difficult to paint them convincingly later on, as these areas can be very confusing.

The set-up was lit by a spotlight positioned at the top left, which further exaggerated the unusual perspective by casting long shadows to the right, as well as providing a constant light source that makes painting them a lot easier.

Beginning with the background, some semi-opaque colours were tentatively introduced, working over the whole painting to maintain progress at an even pace, without concentrating on any one part. A hint of blue, reflected from another painting in the studio was picked up on and exaggerated slightly in intensity and dotted-in here and there in the painting, particularly along the edge of the tablecloth and in places on the bottles. This was a mixture of Helio Blue and Permanent White.

With the paintbrush held at various angles, patches of colour

A slightly unusual composition, based on one of the peculiarities of perspective. The ellipses have been 'drawn through' each other to ensure their correct shape.

The first wash was painted very briskly, with broad brushstrokes, leaving patches of white paper.

RIGHT AND BELOW RIGHT: *Local colour was added to the various objects, with the highlights left unpainted at this early stage. Shadows were painted loosely to establish the light source.*

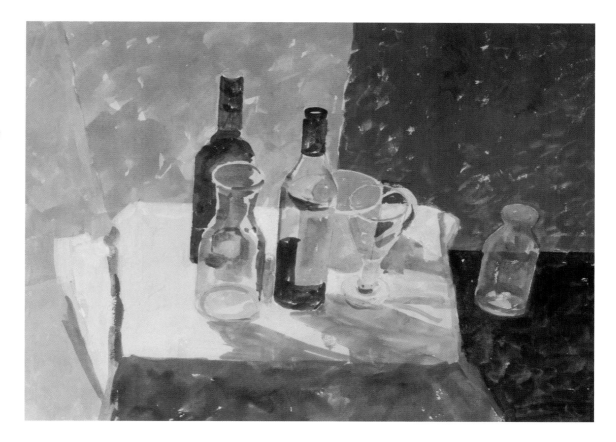

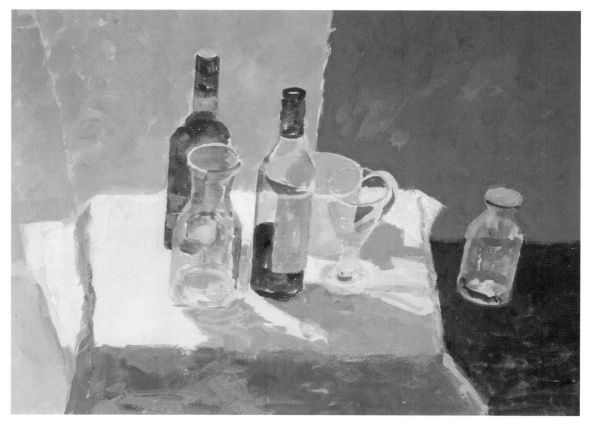

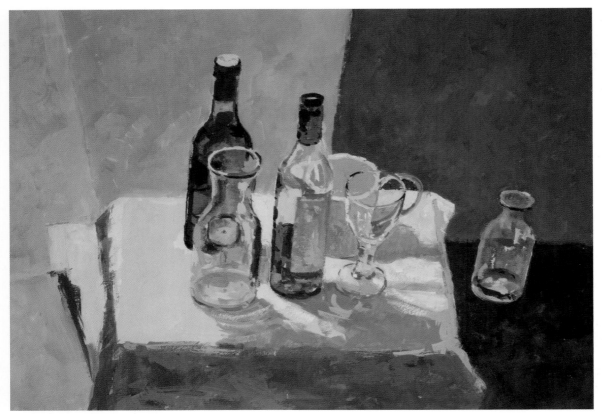

The addition of stronger colour gives the painting more substance and form.

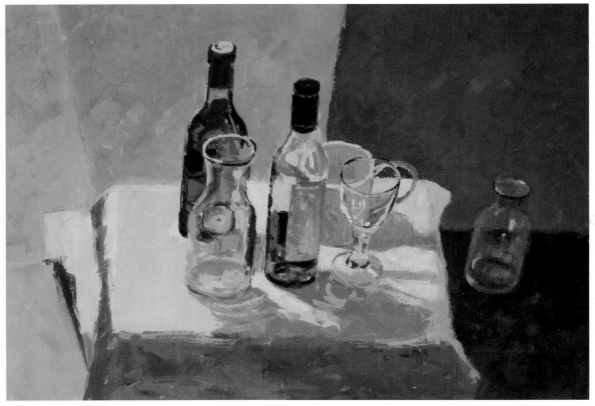

The carafe on the far right of the picture has now been painted in a lower key to give more emphasis to the objects on the table.

were added to the shadows on the tablecloth. A more interesting shadow colour can achieved by placing one colour on top of, and adjacent to, another colour of a different hue. The resulting colour, when viewed from a distance, has a richness that is difficult to attain by using just one colour. Over the lighter areas some semi-opaque white was painted loosely, allowing some of the underlying tones to show through in places. These spontaneous, rapid brushstrokes are often more effective than those executed with too much thought and precision.

In the next stage, dabs of more opaque colour were added liberally around the painting, intentionally avoiding any harsh edges. The paint being used now had less water added, and in some places was applied with a very dry brush, which keeps the brushstrokes suitably rough.

The small carafe on the far right appeared a little too dominant in comparison with the main focus of the painting, so this was knocked back with some darker colour and a dry brush. There were now many different colours on the palette, and most of them were simply a mixture of the colours previously listed. The temptation to clean the palette constantly should always be resisted, as these colours when distributed throughout the painting can help to tie the whole image together. In a painting of this style, too many different strong colours can cause visual confusion.

As a general rule, an object reflected through glass should be painted in a colour that is in a lower key tonally than the object itself. By painting it in this way, it will appear to be behind the glass rather than patches of colour on the glass itself. Reflections and highlights on the glass objects have been painted here as stronger colours with a dry brush.

A few adjustments were made in the final stage of the painting, with some areas receiving stronger colour and a few of the edges being 'roughed-up' a bit, in keeping with the general feel of the picture. The background has been left in its semi-abstract state.

Still Life Outdoors

Don't dismiss the possibilities of painting still life subjects outdoors. You may, of course, encounter some of the difficulties that landscape artists and *en plein air* painters have to cope with, but don't let this deter you!

If you can find a sheltered spot in the garden or on a patio or roof terrace, set up a still life arrangement on a table or bench. If the sun is out (and likely to stay out), spread a rug or tablecloth on the lawn and add some appropriate paraphernalia: a picnic basket, a cushion or two, a bottle and some glasses and perhaps a parasol. You will be rewarded with some interesting shadows and textures, particularly in dappled sunlight. On a white cloth you will notice a myriad of colours in the shadows cast by the objects.

Here also, you will be able to paint flowers in their natural environment. Don't be too ambitious with this as subject matter, as a mass of flowers in ever-changing light conditions can be rather daunting. Try to focus on a small grouping of blooms in front of a fairly dark, nondescript background, as this will enable you to define the shapes of the flowers. It is all too easy to get lost in a mass of flowers and green foliage. Seek out an area where there is a variety of flower and leaf forms, a combination of tall and spiky architectural plants softened in the foreground perhaps with some more gentle flower shapes. A shady corner will provide a cosy, evocative scene that won't be achievable if you try to paint a panoramic view of your garden. This will also be more of a landscape painting than a still life.

You may have a rusty old wheelbarrow or garden roller propped up against a garden wall, and don't be afraid to move things around to create an interesting composition. In the shed you may have a trug, terracotta pots, a trowel and fork, hurricane lamps and a watering can. Add to these some flowers in a terracotta pot and you will have the perfect set-up for a painting. A still life painted outdoors with a combination of man-made and organic objects will have an immediate, natural cohesion.

Demonstration: Garland

The colours used in this painting were:

Raw Umber
Lamp Black
Brilliant Violet
Cadmium Yellow Light
Cobalt Blue
Raw Sienna
Pine Green
Permanent White

The paper used was Fabriano Artistico 200gsm HP watercolour paper

The subject matter for this painting was spotted on the side of a shed onto which someone had attached a planter made from reconstituted stone. Both the timber of the shed and the planter were rather weather-beaten and thus supplied a perfect contrast to the pretty campanula spilling from the girl's hair.

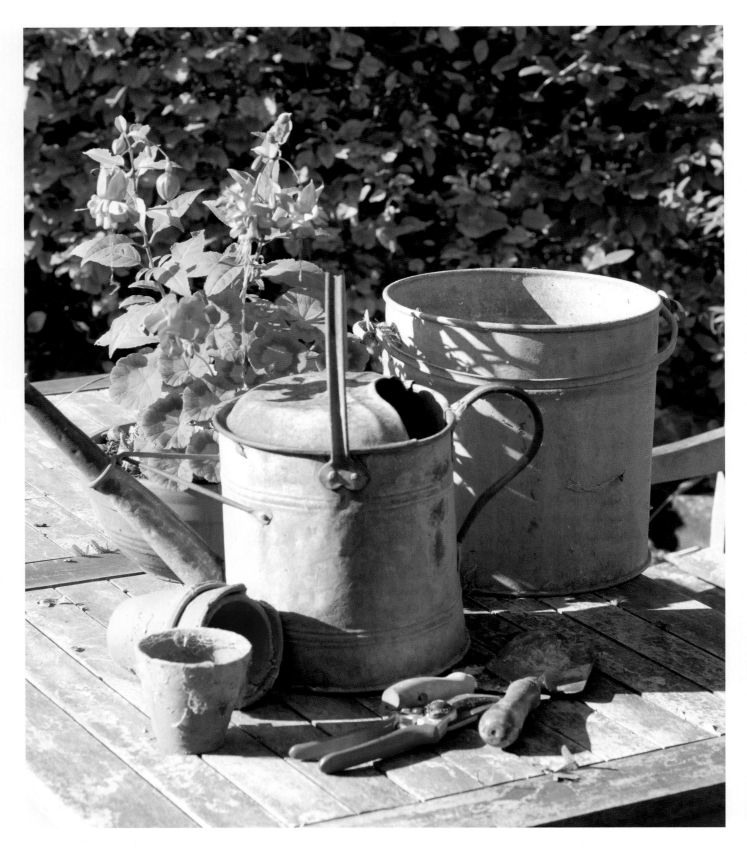

A group of objects retrieved from the garden shed can be the subject of a great picture, combining a variety of colour, shape and texture.

Both the shed and the planter were of a similar colour, the original colour of the wood having turned to an ash-grey over time, and the planter was stained by the elements. This combination of man-made and natural objects never fails to supply great material for a painting. The strong horizontals of the wooden boards and their grain contrasted beautifully with the soft curves of the girl's face, hair and garland, and her expression added a touch of serenity to the composition. The muted colours were accentuated by the delicate, vivid flowers of the campanula. Strong sunlight filtered through an overhanging tree, and a gentle breeze created fluttering shadows and highlights.

The composition was drawn out on a sheet of Fabriano Artistico 200gm HP watercolour paper that had already been stretched in preparation for a painting. After a few simple, compositional sketches, it was decided that there was no particular reason for the planter and flowers to be placed anywhere other than in the centre of the picture.

After the image was drawn out, a pale wash of Raw Umber with a touch of Lamp Black added was brushed over the background, leaving some of the white paper showing through in a few places. The wash was cut in around the flowers and leaves which remained white. As the flowers were a clean, crisp mauve-blue they would be painted initially with a transparent, delicate wash and this would be better painted on white paper rather than grey.

A faint golden glow could be detected around the lighter parts of the wood and the girl's face where the sun was striking it. These were added with a pale wash of Cadmium Yellow Light that was dropped in and left to blend in with the grey wash. The girl's face and garland were given a paler grey wash with a little of the yellow dropped into it. There was just enough brown in

The same wash has been applied over the background and the planter, which were both of a similar colour, but the flowers were left as white paper for the time being.

The shadows on the wood have been painted in a stronger wash, and the planter's three-dimensional form has been modelled with some darker colour. The flowers have been painted in a delicate, pale wash.

The foliage has been added using several different tones of green. Some of the shadows have been strengthened and a little more detail introduced ito the grain of the wood.

The planter and the grain of the wood have both been painted with more detail, and the flowers with some opaque colour.

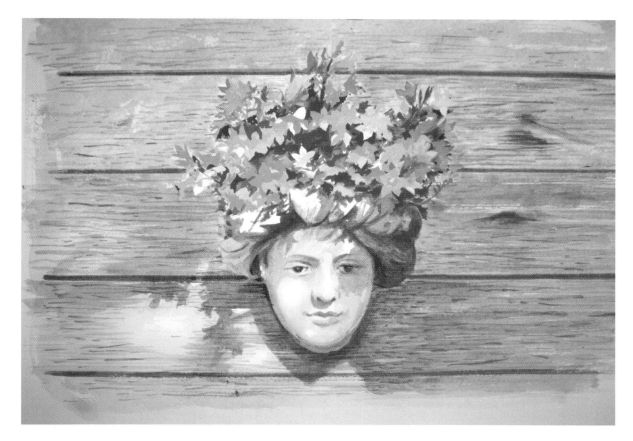

The finished painting, in a mixture of thin washes and opaque colour.

the grey colour to prevent the grey-yellow blend from turning a dirty green, which is what happens when you mix black and yellow together.

In the next stage the flowers were painted in a wash of Cobalt Blue with a small amount of Brilliant Violet added. They were painted fairly carefully with a small sable brush to establish the shape of the petals. Details were added to the girl's face, hair and garland with a stronger version of the first wash. The cast shadows on and between the boards were painted with the same colour. At the same time some horizontal brushstrokes were introduced onto the boards to suggest the grain of the wood. A few more brushstrokes hinted at some knots in the wood. These were smudged with a thumb before they dried, to soften their edges. They would be painted in a bit more detail later on.

The foliage was painted initially with a thin wash of neat Pine Green and the darker shadow areas were added with a slightly more opaque colour, taking care to retain the shape of the petals. More detail was added to the wooden boards and planter. At this stage no part of the painting was finished in any detail, as this allows for any corrections or additions to be made as you feel your way around the picture. In particular, none of the shadows were as yet defined, as the breeze made it a bit difficult to pin down their exact location. This was a decision to be made later on, when the picture neared completion.

Three separate shades of the same colour were then mixed up for painting the campanulas. These were for the local colour, the highlight and the shadow. It was decided that the initial wash on the petals was too weak and that they needed a stronger, opaque body colour to make them stand out. They were then painted fairly loosely, as no decision had yet been made on whether or not to execute this part of the composition in great detail. Some darker colour was introduced into the shadow areas of the foliage that helped define the shape of the leaves.

More detail was added to the grain of the wood and a few patches of pure white now defined the highlights here and on the planter.

Detail showing the opaque highlights added at the last stage of the painting.

98

In the final stages of the painting, there was almost no point in referring to the ready-made composition, as the shadows had already changed position with the movement of the sun, so the painting was completed in the studio. Where the initial shadows and highlights had been painted in loosely, they were now defined with stronger colour. Although the campanulas were the brightest part of the composition, it was felt that the planter, and in particular the girl's face, should be given more emphasis, so this part of the painting was taken to a greater degree of finish than the flowers, which were left in their looser, freer state of completion.

The grain and knots in the wood were painted in a bit more detail and the shadow between the boards was darkened. Overall, it was felt that the finished painting conveyed just about the right amount of detail, atmosphere and sense of serenity that had inspired the painting at the outset.

Common Mistakes

Time will become the enemy if you overcomplicate your arrangements. The weather may change abruptly and all of your carefully arranged objects may become wet and shiny with rainwater after a sudden shower. If the sun goes in, the shadows will disappear, and if it comes out again a couple of hours later, the angle and position of them will have altered. If you have all the time in the world, you can, of course, spend an hour or two painting at the same time each day so that the light source is in the same place. The time in between could be spent in carefully drawing in the composition or readjusting it if necessary, so that no time is wasted. It may be a good idea to have another painting on the go inside your home or studio, so that when your creative forces are in full flow you can simply switch to another subject that you may have already begun painting.

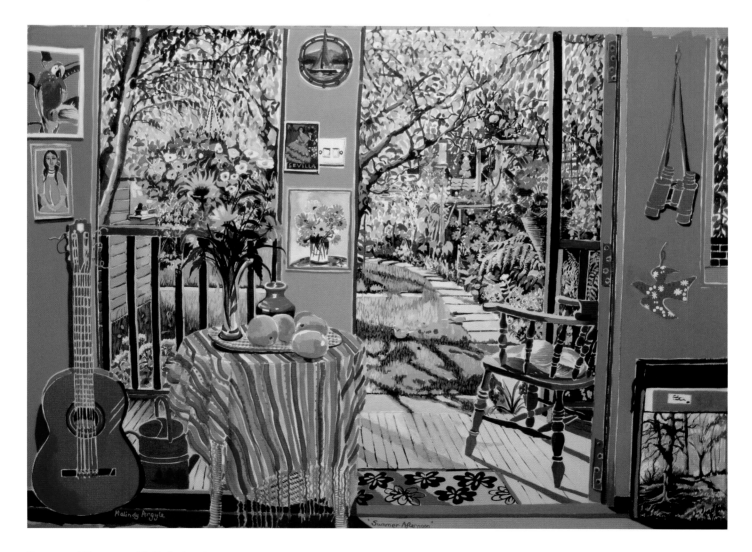

Summer Afternoon, *Malindy Argyle.*

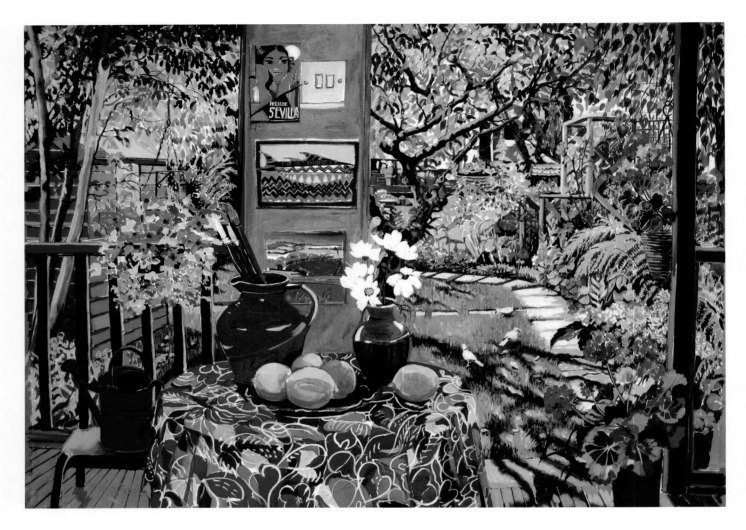

View from a Room, *Malindy Argyle. These two paintings were commissioned by Frimley Park Hospital for their Isolation Unit, where patients can sometimes have to stay on their own for many weeks. Each single room has a window, which looks out onto a brick wall. This bleak outlook did nothing for morale, so the artist decided to create pictures with plenty of detail and interest, using a palette of heightened colours to lift the spirits and give emotional depth. The view from her studio in the height of summer provided the perfect subject matter; it is a view she has painted many times, sitting in the open doorway looking through to the garden. Each of these large gouache paintings hangs opposite a hospital bed so that it can be seen by the bed-bound patient. Much positive feedback has been passed on to her by staff and patients, so it seems that her garden has been enjoyed by many unknown people!*

As with a still life set-up indoors, things outdoors can be shifted around. Don't just paint things because they are there. Here is a perfect opportunity to rearrange nature to your advantage. If a plant in a pot is looking a bit sad, get the secateurs out and snip the offending bits off. If that rose on the trellis has some faded blooms, perform a bit of dead-heading. If the delphiniums are leaning over at an awkward angle, give them some support.

It may take time, but move things around until you are entirely happy with your composition. Don't suddenly leap into a painting only to wish halfway through it that the watering can should have been pointing in the other direction.

You will undoubtedly be confronted by the elements, so be prepared for a sudden gust of wind or a downpour. Make yourself comfortable and have all your painting materials to hand. You might like to paint at an easel, in which case, whether you are standing or sitting, you will need your paints and water pot at a convenient height and immediately accessible. So that you don't have to keep going into the house to continually replenish your clean water, keep a large water

container handy. A bucket of water on the ground is useful for swilling your brushes in when you want to clean them. You may be able to move a table and chair into your chosen painting location, in which case everything can be placed on the table.

An umbrella or parasol shading your painting is invaluable, both to create some shade and to eliminate the dazzle caused by sunlight reflecting off your white paper. It can also help to eliminate any shadows.

Insects can also be a problem. Don't be tempted to flick an ant or a spider from your painting, as many a half-finished picture has been ruined by a streak of blood across the page. If it can't be persuaded to move, it's much better to shake it off or remove it by blowing it from close range at full throttle.

I suppose there is a point at which a painting ceases to become a still life in the strict sense, and this is perhaps a matter for individual interpretation. It could be argued that one inanimate object placed in front of a flower-filled border with acres of landscape in the distance, doesn't constitute a still life painting, but it is a matter of personal choice.

ADVANCED TECHNIQUES

'Art is not what you see, but what you make others see.'

Edgar Degas

Reflections and Shiny Objects

Detecting reflected light in a composition, and understanding how to capture it, will charge your paintings with greater realism and energy as well as adding a degree of vibrancy and luminosity. A collection of bright, shiny objects grouped together will produce a myriad of colourful reflections that bounce off each other. These reflections can be very complex and can be seen to behave in different ways. Many things have to be taken into consideration. Depending upon how shiny the object is, whether it has a rounded or angular form, the direction of the light source and the colour of the surface on which the object has been placed, the reflections may be subtle, luminous or even semi-transparent. Where these reflections are is merely a question of close observation, and the closer you look, the more colours you will see. Objects of a lighter, brighter colour can be seen to reflect light more than darker, duller ones which tend to absorb light.

OPPOSITE: **Panama Hat**, *Kevin Scully. A rather enigmatic still life painting, containing just one simple object on a background rich in colour and detail. The strong shadow suggests the hat is either hanging on a hook on the side of a building, or just lying on a boarded floor in bright sunshine.*

Although it is not always obvious why reflections appear to be the colours they are, it is certainly beneficial to make the most of them in your paintings. Occasionally, however, a very prominent reflection may confuse the eye, and although in reality it is present, it may be judicious to ignore it if it adds nothing to the picture. If it looks strange in real life, it will inevitably look wrong in your painting, so ignore it and leave it out!

An orange placed next to a shiny white vase will undoubtedly reflect some of its colour onto the vase, but there may also be touches of other colours reflected from other objects that may not even be in the picture.

Rays of light passing through transparent, shiny objects produce some scintillating, kaleidoscopic reflections, and by utilizing these dazzling colours you can inject a sense of dynamism into your paintings. Depending on the material that an object is made from, it will reflect different amounts of light. A silver teapot, for instance, will produce mirror-like reflections, while a wicker basket will reflect very little light at all.

Even with super-shiny objects, the amount of detail in the reflections on their surfaces will vary. The colours and detail of the light reflected onto a glazed ceramic vase will vary greatly from those reflected onto a polished metal container. On a round pot the reflections will usually be distorted and elongated. On a shiny flat-sided surface the object next to it will be reflected in a more realistic manner.

Copper containers throw up some fantastic reflections, so if you can lay your hands on a copper jug or kettle, and place a few flowers in it and some other objects around it, you will be rewarded with some beautiful colours to paint. Consider also containers made of other metals, such as pewter, zinc, tin and steel. Each of them has its own unique reflective properties.

Reflections can become rather complicated when they appear on the shadow side of an object, where you may be trying to paint both the shadow and something else reflected onto it at the same time. Unless you want to go in for ultra photo-realism, you sometimes need to simplify these complexities with a combination of thin washes and opaque colour.

Reflections on glass can be equally challenging because here

you are attempting to paint both the colours seen through the transparent material and the reflections on its surface. The highlights and reflections on glass can be subtle and elusive, as shifting your viewpoint by just a few inches in either direction will alter their positions. A satisfactory way of tackling this problem is to keep the colours and reflections within the glass as fairly thin washes and to paint the reflections in the surface in a more opaque colour. Looking at the glass with half-closed eyes will help you to determine and simplify the patches of colour, thereby eliminating most of the more subtle intermediate tones. If the reflections are still too baffling for you to sort out, you might try moving the light source to create a more straightforward arrangement of shapes.

When painting transparent glass, it has to be remembered that it too has a three-dimensional structure, so that its edges have to be defined in some way. You may be able to define this by strengthening the tone of the colour immediately adjacent to the edge, rather than painting a line around it. Too many reflections and highlights can be confusing and may add nothing to your attempt to render the glass in a satisfactory way. If you find that you have overcomplicated the reflections and highlights, they can be softened with a wet-in-wet wash or by simply washing some clean water over the glass, which will have

the effect of blending the pigments together and producing a more muted image.

Demonstration: Reflections

The colours used in this painting were:

Permanent White
Cadmium Orange
Cadmium Yellow Light
Pine Green
Cobalt Blue
Brilliant Violet
Burnt Umber
Burnt Sienna
Raw Sienna
Lamp Black

The paper used was Fabriano Artistico 200gsm Not watercolour paper

The initial washes for a painting that is an exercise in depicting reflections.

The reflections are beginning to be more defined with the addition of stronger, more opaque colour.

At the outset of this painting, it was intended to leave the background as a watercolour-style wash. Although there is an even number of objects here, their varying sizes and proportions seem to work well in the composition. The shiny reflections on the stainless steel coffee pot and glazed cup, saucer and sugar bowl present a bit of a challenge, but with careful observation they can be reproduced in a convincing enough manner.

The background was first painted with a very pale mixture of Raw Sienna and Brilliant Violet. This was left to dry before another wash consisting of the same two colours was laid over the initial wash. On the left hand side of the painting more Brilliant Violet was added to the mixture and on the right hand side more Raw Sienna was added. The two separate colours were allowed to bleed into each other to create a smooth blend. A thinner wash of Brilliant Violet was used for the shadows on the tablecloth.

The coffee pot was painted with a mixture of Lamp Black and Brilliant Violet, leaving some of the paper showing where the highlights were to go. So that they could be kept neat at this early stage, a ruler was used to help paint some of the crisp, sharp edges. A couple of reflections from the cup and saucer were added to the side of the coffee pot.

The green was painted with a Pine Green and Lamp Black mix, with the shadows and fluting on the sides added in a stronger version of the same colour. The gold edging was painted with washes of Raw and Burnt Sienna and the coffee pot in a thin wash of Burnt Umber. Cobalt Blue was used for the napkin.

The colour of the coffee pot was changed to one that contained more grey, which seemed to work better than the previous colour, and the spoon was painted using the same colours. The reflections here were elusive and changed with just a slight movement of the head. It is not always easy to work out why reflections appear as they do, but it is enough to just view them as simply another shape on the surface and paint them as such.

Reflections from other objects in the room were added to the cup, saucer and sugar bowl, and detail was added to the fluted sides. The napkin was painted carefully to suggest the weight of the material and the way in which the shadows were cast in the folds. More opaque colour was added to the tablecloth, but a mental note was made to adjust this colour at a later stage as it was now too vibrant and not in keeping with the rest of the painting.

The reflections on the teapot were altered once again as they were becoming too fussy, so the shapes were simplified into

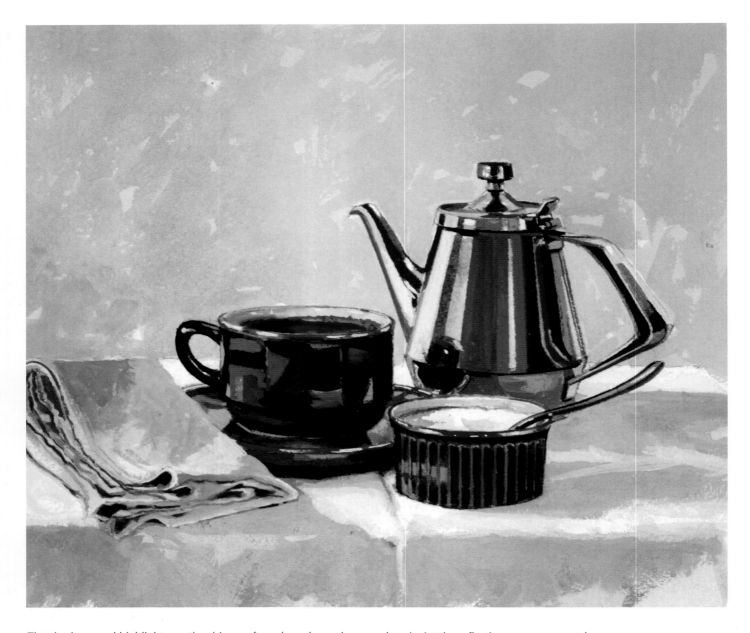

The shadows and highlights on the shiny surfaces have been sharpened to depict the reflections more accurately.

broader bands of colour. A strong yellow highlight on one side helped to create the illusion of its shiny surface. Some darker green shapes on the cup and saucer and a few more reflections eventually gave them a much more solid appearance. The reflections were also simplified on the sugar bowl and the highlights on the fluting were painted in a much more subtle colour. The rich gold was finished with some highlights upon highlights, leaving the lightest and brightest until last.

The shadows on the tablecloth were revisited and the colour toned down to one that was more appropriate.

'A man without a shadow is but half a man.'

Anon

The Colour of Shadows

In essence, shadows are the absence of light and are usually perceived as areas without colour. However, this doesn't mean that

there is necessarily always a total absence of colour. Shadows can be used effectively to embellish the sensation of light and to determine the space between objects and also as a means of connecting objects in a composition.

If you look very closely, you can usually detect colour in shadows. A good example is the shadow cast by a tree or building across a road. More often than not this will contain a certain amount of blue or mauve-blue. It will be more evident in warm, golden sunlight. This colour will also be affected by the colour of the sky, and will alter as the sky changes colour. So although the shadow has been created by less light reaching that part of the road because of something getting in the way of the light source, in this case the tree or building, light is being reflected onto the road from the sky and sometimes from other things nearby. This shadow must begin its work by starting immediately below the object in question. The length of the shadow is dependent on the angle of the sun or light source. A light source immediately above an object creates a small, often diffused shadow, whereas a low lighting angle will create a long shadow, as created in a landscape scene with low evening sunlight. The length of a shadow can be determined by observation but, as a rough guide, if the light source is at 45 degrees to your eye level, the shadow created by an object will be the same length as the object itself. If there are two light sources there will be two shadows, but they will not be sharp-edged, as the light from one direction will cast some light into the other shadow. A more satisfactory composition will have just one light source, giving sharper, more intense shadows.

The effect of the sky in relation to shadows is best demonstrated by the colour created in the shadows of a sunlit snow scene. Warm sunlight shining onto a white snowy surface creates a blue shadow. If the sky is grey or pink, then the shadows have these colours in them.

If you are painting shadows on an uneven surface, such as a crumpled piece of material, they will travel up, over and across that surface and not just in a straight line. In these instances the shadow plays an important role in describing the terrain over which it travels, and the direction in which they are painted will help to define the form and volume of objects.

A good way to begin to understand the colour in shadows is to place a coloured object onto a white surface and study the shadows that it creates when a light source is directed at it from different directions. Now transfer the object onto a coloured surface and observe the colour of the shadow. This colour may sometimes be difficult to pin down, but will usually contain some of the colours in both the object and the surface on which it is sitting. Cut a hole in a piece of white card and look at the shadow in isolation through the hole. This will usually give you a

clue as to the colours contained within the shadow. You can also study shadows by simply holding your hand over a surface at varying distances and angles from it, creating shadows of differing shapes and intensity. You will notice that the colour changes depending on how far away from the surface your hand is held. The closer it is to the surface, the greater the amount of your hand colour will be reflected into the shadow. Don't just paint a shadow as a darker version of that which it has been cast across, as it will be influenced by many other things around it. A diffused shadow will often have a slightly different hue around its outer edge.

It isn't necessary to analyse everything in this way, but by having a basic understanding of the way in which certain colours appear the way they are, it will help you to look for colour in shadows and use them to your best advantage.

It was perhaps the Impressionist painters who first started adding vibrant colour in their shadows, and this was created by applying touches of several different hues usually present elsewhere in the picture, thereby suggesting an overall colour without actually painting it simply in one colour.

There is nothing worse than a painting that is littered with grey and even black shadows. So even if you can't always see any colour in the shadows that you're painting, introduce a little, and this will inject life into them. Add some colour, perhaps blue, purple or magenta, to even the deepest, darkest recesses of your paintings. These shadows may be warm or cool, depending on the lighting conditions.

The shadows of these objects on a white surface can be seen to contain a certain amount of their own colour close to the objects themselves, as well as a bluer colour further away. Note that the shadows behind, which are from objects further back on a window ledge, are distinctly blue. This is the effect of bright sunlight on a white surface.

The same objects on a white surface, this time with natural daylight from above, appear to cast very little shadow, but a certain amount of blue is still evident.

This time the objects are placed on a cream surface and lit with artificial lighting from above. This has created two distinct shadows on each object. One is very dark directly beneath the orange and apple, and the other is a more diffused shadow containing some of the colour of each fruit.

The shadows in a painting can perform many functions. They help us to determine the strength and direction of a light source, describe the surface texture of a material, create atmosphere and mood, and can be a substantial element in the overall composition. The shape of a shadow is important, as it helps to describe the form of an object. Shadows should never be considered as an afterthought, but must be treated with great respect. There are even occasions when the intricate

'Shadow is the obstruction of light. Shadows appear to me to be of supreme importance in perspective, because without them opaque and solid bodies will be ill defined; that which is contained within their outlines and their boundaries themselves will be ill-understood unless they are shown against a background of a different tone from themselves.'

Leonardo da Vinci

shadows can be the most important part of a picture, with the objects within playing second fiddle. The way in which they are painted can suggest mood and atmosphere, either calm or dramatic.

Shadows follow the rules of perspective illustrated in an earlier chapter. These rules apply no matter where the light source is located, and by following these rules you will create a credible image.

Step-by-Step Demonstration: Painting Shadows

The colours used in this painting were:

Permanent White
Lamp Black
Helio Blue
Cadmium Red
Burnt Sienna
Ultramarine
Lemon Yellow
Pine Green

The paper used in this painting was Daler Rowney Saunders Waterford 90lb Not watercolour paper.

The inspiration for this painting was a note in an envelope left on a table. This rather enigmatic composition could allude to several situations that might have taken place, or were about to take place. There was a danger that there may be something sinister involved, so it was intentionally painted in a fairly gentle manner. Does the envelope contain a love letter, a goodbye letter, or perhaps something else? The answer to that is left up to the viewer to decide.

The simple drawing was painted with a thin wash of Burnt Sienna on the walls, windowsill and eggshells. The window frame was painted with a mixture of Burnt Sienna, Ultramarine and Lamp Black. The envelope, letter, tablecloth and plate were painted with a thin wash of Ultramarine and Lamp Black. Pine Green and Lemon Yellow were used for the flowers. Initially, a shadow from one of the glazing bars of the window was added to the tablecloth, but this was later removed, as it was felt that it added nothing to the painting.

In the second stage of the painting some more opaque colour was introduced into the tablecloth and the cup and saucer. While painting this area, some thought was being given to how the finished painting was going to look. Was it to be highly detailed or was it to be executed in a looser way? When tackling areas where there isn't very much going on, in this case the shadows created by the various objects, it gives you the opportunity to experiment with different brushstrokes and colour combinations. By keeping the marks simple and diverse, you can ease yourself into a picture, without making too many definite decisions too early on. As the painting evolves, these patches of colour can be amended and tweaked, to tie the whole composition together.

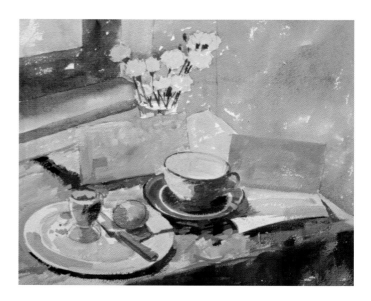

Some solid colour has been added to part of the tablecloth.

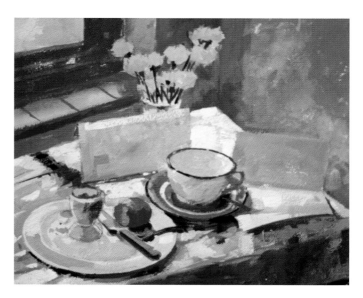

The same treatment has been continued over the rest of the painting in loose, lively brushstrokes.

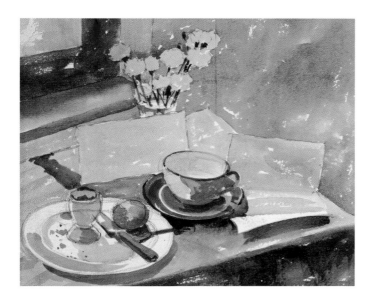

Initial washes over the simple drawing, showing how the ellipses have been drawn through the objects in front of them.

By overlaying colours of slightly differing tones to the walls, a sense of atmosphere began to develop. These brushstrokes were kept fairly simple and unfussy, not wishing to detract from the main focus of the painting. The objects on the table were treated in the same loose way, the erratic brushstrokes giving the painting a degree of vitality.

Once the tonal arrangement had been established, the next process involved softening some of the harsh areas of colour with intermediate tones. The white envelope and notepaper were painted several times until a satisfactory result was achieved. Although they were both in shadow, a certain amount of light

shone through the thin paper, which made the exact strength of colour and tone quite difficult to pin down. By squinting at them, and relating their tones to surrounding objects, their tone was finally established.

One of the advantages of gouache is that alterations can be made without too much trouble. It was noticed that the general perspective of the table wasn't quite right, so this was adjusted. During the initial laying-in and subsequent additions of colour, some of the ellipses had become a little distorted, so these were also corrected. Although it had been decided to apply the colour in a painterly way, there is a point at which things can just look wrong, and no matter how many times you try to persuade yourself that they are OK, they're not! This is particularly true of perspective and ellipses.

The carnations were painted with a square-edged brush, turning it constantly to create random shapes that merely suggest the structure of the petals. The stems were painted with the brush on edge. This same brush was also used in painting

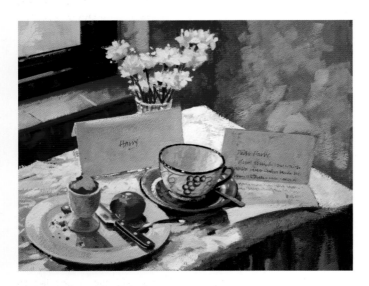

Final details have been added and amendments made to the perspective and ellipses. The handwriting was added using a fibre-tipped pen.

the larger areas of the walls, tablecloth, envelope and note-paper. More detail was added to the objects on the plate and the pattern on the cup and saucer. The shadow from the window's glazing bar was painted out, as it looked rather confusing, particularly as no detail had been suggested on the window. Finally, the handwriting was added using a fine, fibre-tipped blue pen.

Sharp and Diffused Shadows

A sharp, hard-edged shadow can be painted in gouache by simply painting it with a brush loaded with plenty of colour. This will prevent you from producing a fuzzy edge. If you want a softer shadow, it could be painted with a thin wash of one or two colours wet-in-wet. There are two ways of creating a very subtle edge. While the wash is still wet, run a clean damp brush around its outer edge. This will have the effect of diffusing the colour and creating a soft, delicate blend. Another method is to paint the edge of where you want the shadow to end with clean water. Let this soak into the paper for a while until the paper is just damp, and then paint your shadow up to this area and you will achieve the same diffused edge as the colour seeps into the damp paper.

Even within a shadow, there may be areas where other colours have crept in. This is particularly noticeable where the shadow stretches across a large area. It may have a cool, bluer tint to one section, leading into a warm redder area elsewhere.

When painting a shadow in a thin wash, aim to get the correct strength of tone in one hit, as subsequent washes will render the colour muddy, particularly if you are painting over an area that has already been painted more than once. You can test the colour beforehand on a scrap piece of watercolour paper to see if it will dry to the strength and colour you require. Be sure to mix up enough colour, as it will be very difficult to match it if you run out half-way through applying it. This is less of a problem if you are using opaque colour, as you can adjust the tones with further applications and tweaks.

It is often best to refrain from painting a shadow across an

COMPLEMENTARY COLOURS IN SHADOWS

You will notice that shadows get cooler and lighter as they recede into the distance. A warm light source casts a shadow that is cool, whereas a cool light produces a warm shadow. Very careful observation may detect its complementary colour in the shadow of an object. For instance, the shadow cast by a red cricket ball may include a suggestion of its complementary colour, green. This isn't necessarily always the case, as various other factors have to be taken into consideration, including the colour of surrounding objects reflected into the shadow and the type and colour of the light source.

object that has a detailed patterned surface until you have nearly finished the picture. If you apply the shadow with a thin wash of the correct strength, the tones of the detail will appear slightly darker in the shadow area than they will in any un-shaded passages, and this is what you should be aiming for. This thin wash should be applied with a single brushstroke, as any fiddling around will disturb the pigment beneath and your detail will become blurred.

Demonstration: Painting Types of Shadow

The colours used in this painting were:

Permanent White
Cerulean Blue
Raw Sienna
Raw Umber
Pine Green
Brilliant Violet
Alizarin Crimson
Brilliant Yellow

The paper used was Daler-Rowney Saunders Waterford 190gsm Not watercolour paper

The initial appeal of this composition was the contrast between the circular shape of the hat and the horizontal boards on which it was hung. The possibilities for a painting presented themselves when the side panels of an old shed that was being demolished were stacked up against a wall in strong sunlight. The inside of the shed had been painted many times, which was evident from the multitude of colours that were visible as the wood had become damp and the paint was flaking off. One particular panel was more colourful than the others, so this was taken to one side. A large nail was banged into the wood and several different objects were hung from it, including jackets, an apron, a garden rake, a saucepan, a framed painting, a clock and finally the hat. The clock was a strong possibility and may appear in a future painting. The charm of this combination was the concept of passing time as the connection between the age-old rotting wood and the clock.

However, the simplicity of the hat's shape, and its dissimilarity to the complex patterns and colours of the wood, won through in the end. Both the hat and the panel were turned around several times, until a satisfactory composition was arrived at. A certain appealing ambiguity also presented itself: was the hat hanging on a wall, or had it just been dropped onto a wooden floor?

The boards were marked on the paper and drawn with a ruler, and the hat was drawn-in freehand. The paper was given a wash of thinly diluted Raw Umber and left to dry. The dark horizontal lines were painted in Raw Umber with the aid of a ruler. They were not painted as continuous lines, but in a hit-and-miss fashion, because in some places they were covered by layers of paint.

A few different washes were ready-mixed in the palette and quickly laid-in over the background. The colours used were Cerulean Blue mixed with Raw Sienna, Brilliant Violet mixed with Raw Umber and Raw Umber on its own. Not all of the paper was covered with these washes and they were allowed to run into each other in various places. Some white was added to the Brilliant Violet and Raw Umber mix, and this was used for the initial wash on the hat.

While the initial washes were still damp, some stronger Raw Umber was dragged into the background where the wood was showing through the many layers of paint. The shadow on the hat was painted with a diluted mixture of Cerulean Blue, Brilliant Violet and Raw Umber. The hatband and dark shadow beneath the hat were painted in a mixture of Brilliant Violet and Raw Umber.

More detail was added to the background with subsequent layers of thin colour. In places where the paint had flaked off, the wood was painted with Raw Umber, sometimes with other colours added to it, where they were evident. Where bare wood was showing, this was painted carefully, still using fairly thin paint, and occasionally wiped with a finger to imitate the grain and an occasional knot.

The texture of the Panama hat was brought out by painting it in the circular direction of the weave, and several layers of semi-opaque and opaque paint in slightly different colours were overlaid to show its shape and form. To give depth to the cast shadow, a wash of Raw Sienna was laid over it and left to dry. Then another, more opaque colour was painted on top of this, allowing some of the underlying colour to show through, particularly along its edge. This juxtaposition of colours gave the shadow a richness and depth that are difficult to obtain when using just one colour.

The three stripes in the hatband were painted with neat Pine Green, Brilliant Yellow with Raw Sienna added and Alizarin Crimson with Raw Sienna added. Where they disappear into shade, Brilliant Violet was added to all of the colours.

The horizontal lines were darkened in places with a mixture of Raw Umber and Brilliant Violet. This same colour was also used for the shadow under the hat. Although some of the colours in this painting are very dark, it should be noted that no black was used anywhere.

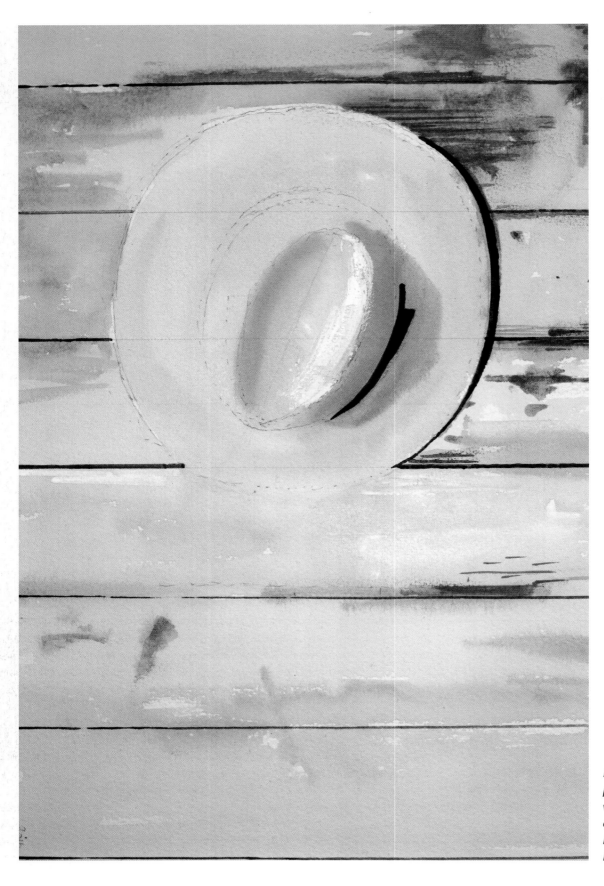

First stages of the painting in wash, with the beginnings of opaque colour being added to the hat.

The horizontal lines were painted with the aid of a ruler. The ruler is kept well clear of the painting by the fingers of the left hand, which are tilting it forward and holding it steady. The paintbrush is run along the ruler with its ferrule held tight against the ruler. This is a skill that, with a little practice, will come in very useful.

Finally, some highlights were painted on the hat, although none was especially bright, because the hat itself was very pale in colour and almost white.

Highlights

Highlights are those areas in a painting where the light strikes the edge of an object and produces a tone in the highest key on the edge or top of it where it faces the light source. These highlights can be created by retaining the white of the paper, by using opaque colour, or by applying masking fluid to cover those areas that you wish to keep as pristine paper and thus unpainted.

Unless there is a particular reason for using masking fluid to retain your white paper to create highlights, these can be painted with opaque gouache. You can, of course, preserve the white paper for your lightest areas by simply painting around them as you would in a watercolour; this can be quite effective, but it requires careful planning at an early stage of the operation.

Masking fluid can be tricky to apply and you will have to wait for it to dry before you are able to remove it to reveal the white paper. In many cases it adds an unnecessary complication to painting in gouache.

Highlights add the finishing touches to a painting and are the icing on the cake. Executed correctly, they will give your painting added sparkle and life, but if overdone they will have the effect of confusing the eye and actually detracting from the

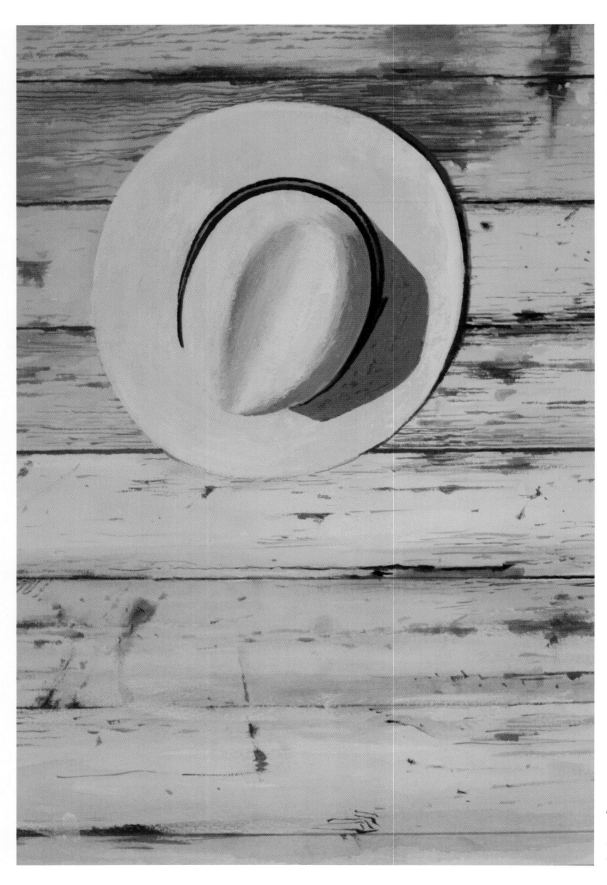

The hat in the finished picture has now been painted entirely in opaque paint, whereas thin washes make up most of the detail on the boards.

painting. As with reflections, highlights usually contain a certain amount of the local colour of the object on which the highlight occurs. Even on really pale objects the highlight might not be pure white. Sometimes there will be a highlight upon a highlight, with one colour being in a higher key than the one below it.

Painting from the Imagination

There may be occasions when you feel there is something absent from your composition, or a lack of interest in the objects that you have selected. Perhaps that jug would benefit from some motif to complement the colours of the flowers you have arranged in it, or the background might need a piece of patterned fabric and you just can't find the kind of thing you're looking for. In these instances you can use your imagination and create something that doesn't actually exist.

To be able to do this, and to produce a convincing picture, you need to understand how shadows, highlights and reflections work, as well as having an appreciation of perspective. In your observation of the objects when working from life, you should be able to incorporate details from your imagination in a realistic way by working out from the light source where the shadows, highlights and reflections should be.

Common Mistakes

It is very easy to overcomplicate reflections and highlights, particularly when painting water in a glass container. Keep them simple and they will be just as effective.

WHAT NEXT?

Combining with Other Media

If you're feeling adventurous, you might like to experiment by mixing gouache with other media. As with all mixed media, the possibilities are endless. When you feel more confident with the way that gouache behaves as a medium, try painting some still life pictures in a freer, looser style.

Combining gouache with watercolour is an obvious choice, as both are water-based, but as the two media are in essence so similar, there seems little point. We have already seen how gouache can be used in a similar way to watercolour and when painted in thin washes it is almost indistinguishable from watercolour. The main difference between the two when applied thinly is that watercolour pigments granulate more readily, so you can perhaps experiment by mixing the two media, if only to see how differently they behave. Other water-based possibilities are watercolour pencils, markers, inks and acrylic paints and inks.

Try incorporating some dry media into your pictures. Mixing gouache with coloured pencils, pastels and chalk can produce some exciting results.

Masking fluid forms a rubber-like substance when dry, and can be used to preserve areas of white paper. It can be removed by gently rubbing it with your finger. When using masking fluid be sure not to use a brush, as this will be rendered useless – it is impossible to remove the dried rubber from the hairs. Alternatively, there are special applicators on the market that do the job well, or you could try using a sharpened stick. The surface of metal dip-pens or ruling pens has the advantage of being impervious to masking fluid, which can easily be peeled off when dry. When the masking fluid has been removed, the bare paper can be painted with a further colour. You can even apply more masking fluid over some of this colour before repeating the process with a further wash.

Other materials that will resist gouache are oil pastels, wax crayons and, to a certain degree, waterproof inks. A great range of exciting effects can be achieved by drawing into a damp wash of gouache with watercolour pencils. If you want to go really wild, there are texture media available that leave a raised surface on the paper when dry. You can also paint into this medium while it is still wet.

Demonstration: Combining Gouache with Other Media

The colours used in this painting were:

Permanent White
Raw Sienna
Burnt Sienna
Tyrien Rose
Scarlet
Cadmium Red
Sap Green
Brilliant Yellow
Lamp Black

The paper used was Bockingford 190gsm Not watercolour paper

Other materials used were: spirit-based markers, a fibre-tipped pen, pastels and pastel pencils

OPPOSITE: Jenny's Boots, *Kevin Scully. This is a simple composition of a pair of wellington boots apparently discarded on the floor. The background colour is made up of hundreds of small impressionistic brushstrokes, whilst the boots have been painted in a more realistic way.*

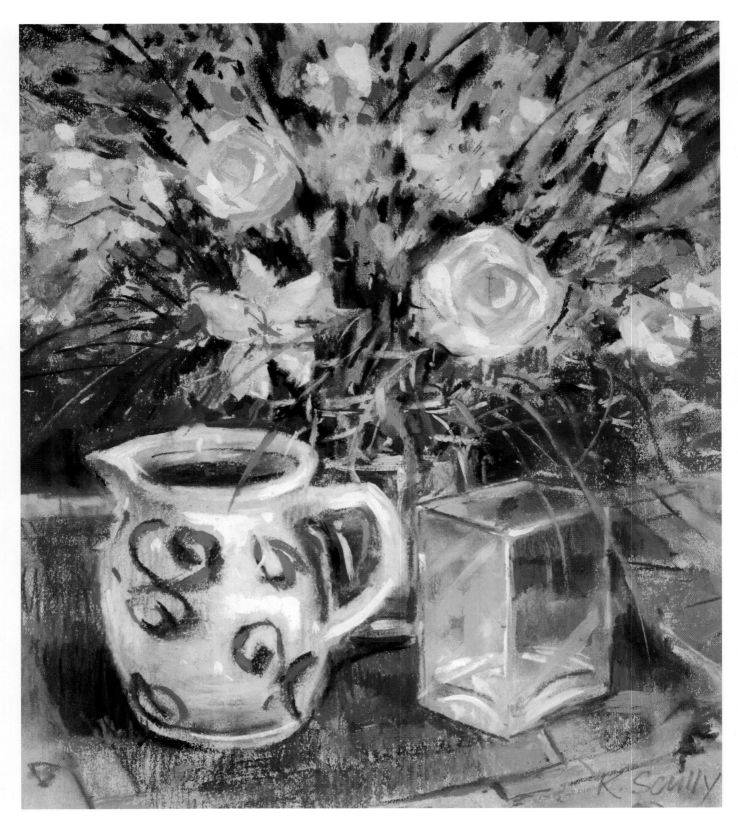

Italian Jug. *A vibrant painting combining both gouache and pastel. The huge flower display has been cropped to afford more dominance to the jug.*

The objects were assembled on a chest of drawers, in front of a painting hanging on the wall. The composition was lit from the left by an ordinary household lamp that emitted a diffused, golden glow.

After the image was drawn out, a wash of Raw Sienna was applied over the whole sheet of paper with bold sweeps of a large brush.

The pencil drawing was then outlined with a range of markers, with each part of the image outlined in its relevant colour. Thin washes of gouache were painted over all areas, and some solid colour was painted onto the pink tulips. Solid colour continued to be added in a loose way to the vase of flowers and the bowl of fruit, but the background, including the painting on the wall, was left as thin washes, which helped to make it less dominant. Some pastel pencils were drawn into and around the flowers, and in some sections more semi-opaque gouache was painted over these marks.

Sticks of soft pastels were used to make larger marks on the vase of flowers and the fruit, and they were also dragged over areas of the background and picture frame. Some of this colour was softened by rubbing it with a finger, and in some areas water was brushed over the pastel, which has the effect of mixing it with the gouache and creating different colours. Where the pastel and gouache were applied more liberally on the flowers, this produced some rich colours and textures. The area on the wall to the right of the flowers was darkened slightly with a pastel on edge, to accentuate the rich glow from the left hand side.

One of the advantages of using a large palette is that generous amounts of colour can be mixed for washes, leaving plenty to spare.

After the composition was drawn in, a large brush was used to apply a wash of Raw Sienna.

Different colour markers were used to outline the drawing.

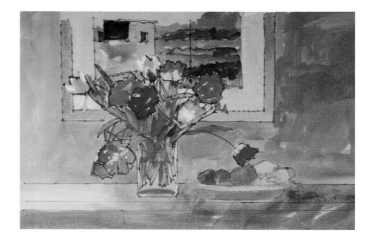

Some very loose washes were painted over the drawing, and a little opaque colour was added to some of the tulips.

Pastel pencils and soft pastels were used to draw into the painting, and in some areas this was washed over with a brush in clean water.

The area to the right of the picture was darkened in contrast with the warm glow emerging from the left.

Finally, some white highlights were added to the square vase and fruit, and to the open, pink tulip.

Experimentation

A wax candle sharpened to a point and 'drawn' onto your paper has great possibilities in producing exciting effects when painted over. Unlike masking fluid though, it is very difficult to remove wax, so this should be taken into consideration.

Collage is also worthy of experimentation and lends itself to a more abstract form of picture-making. Gather together some sheets of coloured or pastel paper and tear them into random shapes. Arrange them onto a sheet of watercolour paper until you have a pleasing abstract composition. Once you are happy with the pattern, glue them down with PVA. Now paint your still life in a variety of mixed media on top of your paper arrangement, using a combination of line and solid colour. To achieve a lively picture, paint quickly without too much preparatory work and fussing around.

As an exercise, try using some decorative wrapping paper as a background for your still life painting. Painting directly onto patterned paper does have certain possibilities, but there is a danger here of wandering into the gimmicky side of art as seen in the over-use of pictures painted onto newsprint and images torn from magazines.

Rather than painting on watercolour paper, there is no reason why gouache can't be used on other surfaces. One surface that lends itself to the application of gouache is oil painting board. This is available as compressed cardboard with a canvas-like

finish, or as an MDF panel with cotton canvas glued to it. If you want to use one of these boards, those with a fine finish are probably more suitable than those with a coarser finish. These are available ready-primed, usually with white acrylic gesso.

In the demonstration shown here, an MDF panel was given two coats of acrylic gesso. Priming a board like this is necessary to prevent the paint being absorbed into the support. The primer seals the surface of the board and enables the gouache to slide over its surface more easily.

Demonstration: Gouache on MDF

The colours used in this painting were:

Permanent White
Burnt Umber
Tyrien Rose
Ultramarine
Lamp Black
Cadmium Orange
Pine Green
Raw Sienna
Burnt Sienna
Raw Umber

It was painted on MDF board primed with two coats of acrylic gesso

There is no reason why gouache can't be used on supports other than paper. By painting on a semi-porous rigid surface you can use gouache in an entirely different way. You can adopt a much more brutal, physical technique, more like that used in oil painting. Mistakes can be wiped out with a damp rag or stiff brush and then repainted. The slight texture of the gesso primer can be utilized to good effect when the paint is used in thin glazes, or when a dry brush is dragged over its surface.

After two coats of acrylic gesso, some thin, blue-grey acrylic paint was washed over the surface of the board, allowing the brushmarks to remain.

An ordinary household brush was used to paint an MDF board in acrylic gesso to prevent the paint sinking in to the surface.

This is the process by which this painting was created. The thin MDF board was given two coats of acrylic gesso primer to seal it, which prevents the gouache sinking into its porous surface. Each coat of gesso was sanded lightly to remove some of the more prominent, raised brushstrokes. In this painting, these brush strokes were going to be a visible part of the picture. If required, the gesso can also be sanded to a smooth, flat surface.

The board was then given a thin coat of blue-grey acrylic paint (as one would when preparing a canvas for an oil painting, when a white surface is seldom suitable or necessary). This colour was chosen for the overall under-painting, as it represented the general colour of the composition. No attempt was made to create a smooth surface, as the intention was to paint a loose and lively picture. Thin washes were used to lay-in the various elements of the composition and a few more slightly opaque details were suggested. The background to the left of the picture was a mirror with a pale grey-green surround, its glass reflecting other colours present in the room. This area was to remain indistinct. The frame behind the glass carafe could be seen through the water and the distorted stems of

the anemones were evident where they entered the water. In some areas the paint was smudged with a finger to achieve a soft blend.

The whole painting was given thin washes of colour with the occasional highlight and shadow added as points of reference. Starting with the teapot, patches of colour were applied and the beginning of the composition's three-dimensional forms began to emerge.

With this way of using gouache, the painting seems to emerge from the under-painting rather than be painted on it. At this stage the blue-grey colour is still evident as the basis for the colour scheme and much of it will remain.

The flowers are indicated very simply with a semi-opaque wash of Tyrien Rose and Permanent White, and the stems were painted in washes of Pine Green mixed with a little Raw Sienna. Having established the form of the teapot, the pattern was painted onto it and the handle painted in greater detail.

It was noticed that one of the flowers had been accidentally omitted in the early stages of the painting, so a bristle brush with a little water was used to remove the blue gouache wash, so that the flower could be painted in the same way as the others, in a thin wash over the blue-grey under-painting.

With solid colour being gradually added, the painting now took on the appearance of the early stages of an oil painting. Although this wasn't entirely intentional, the effect was nevertheless rather attractive, so it was decided to retain this look by not adding too much more detail in the finishing stages.

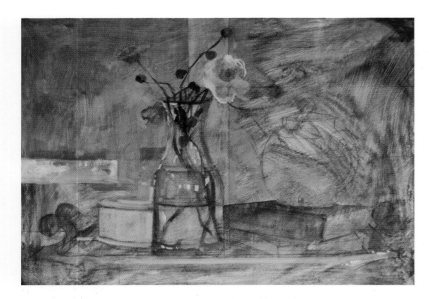

The composition was drawn directly onto the board and semi-opaque colour was used to 'tease' the painting out of the background wash.

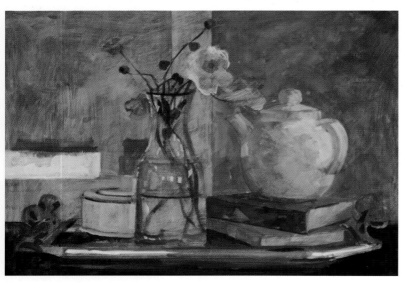

More colour was added, without paying too much attention to detail at this early stage.

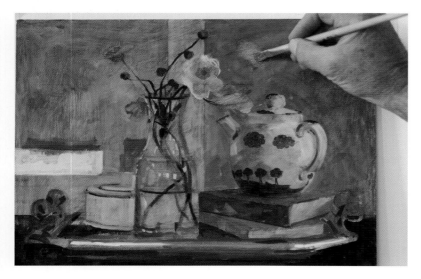

Some gouache was removed with water and a bristle brush where a flower had been omitted in the initial drawing.

The final details were added with flicks of opaque paint on highlights and shadows.

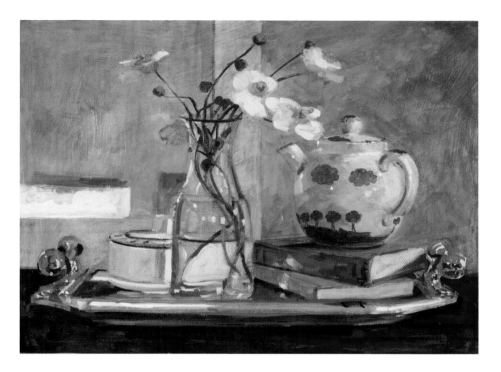

The anemones were painted with simple brushstrokes that described the flower forms, and the steel and brass tray was painted with the minimum of fuss with swift flicks of colour. The books were painted with a combination of opaque colour applied wet-in-wet and dry brushstrokes to suggest shadows and reflections. The roughly painted background was left as it was.

The distorted reflection of the cheese dish was painted as seen through the water in the carafe, and small touches of pink and orange reflections were painted where they were detected, and the picture was complete.

There is a current trend for some oil and acrylic paintings to be framed under glass with or without a mount, so as this is a slightly unusual painting, being on board and still rather vulnerable, perhaps it could be framed in a similar way. Alternatively it could be varnished and framed as a traditional oil painting in an open frame. Another possibility is to simply frame it as a watercolour with a mount and under glass.

Acrylic Gouache

There is a product available on the market that is a cross between acrylic paint and gouache. Its claims to fame are that it combines the best qualities of each of the two media and that it appears virtually the same colour once dried as it does when wet. In its simplest terms it is gouache paint with an acrylic polymer added. Another of its attractions is that once dry, it is impermeable to water, which makes it ideal for any artwork that needs to stand up to rough treatment or confront the elements. It can be used on any hard surface including wood and metal. This durability does mean, however, that it can't be re-worked once dry, whereas gouache can be re-adjusted months or even years after it has dried.

Spontaneity

'Once you know the rules of perspective, it is the painter's choice to use the techniques or disregard them as a matter of intelligent design and style, but there will be no struggle to achieve the desired effect.'

Coulter Watt

If you have reached the stage where you feel comfortable with gouache and your natural tendency is towards a much looser style of painting, you can let rip with your creative side and abandon some of the rules previously laid down. Rules are there to be broken!

Assemble some objects, including some flowers and fabrics with vibrant colours, but rather than arranging them into a traditional still life set-up, just use them as reference, as an aid

Japanese Anemones and Calla Lilies, *Clare Wake*, *watercolour, gouache, collage and coloured pencil on paper. By chance, a scrap of coloured paper landed on the picture while it was in progress, and made it look much more interesting. Working with this idea led to the collage, which emphasized the abstract wavy rhythm of the flowers that had been barely visible before. Gouache was used to make certain alterations and to paint the silhouetted area on the right of the picture.*

for an exciting, dynamic painting. To a certain degree you can disregard perspective, reflections, shadows and highlights, and instead concentrate on producing a sensational composition of varied pattern, scale and colour. Grab that gouache and perhaps some watercolour and ink. Some fantastic effects can be created by rearranging and overlapping the different elements collected, in a lost-and-found way, without totally abandoning realism just yet. Cast off any inhibitions and just let things happen.

The composition may be based on a particular theme, a garden, a room in your house, a meal, or anything close to your heart.

Here is an exercise that will get you started. The idea here is to use a small coloured sketch as the basis for a larger semi-abstract composition.

To begin with, take two colours, perhaps French Ultramarine and Indian Red, and paint some random shapes, overlapping the colours in places and letting them run into each other. Thin the colours with a little clean water and brush some further shapes onto the paper. Now, while the paint is still wet, draw into your shapes with a water-soluble, coloured pencil or marker some simple semi-abstract shapes that represent some of the objects you have chosen to paint.

You can add further passages of colour to perhaps suggest some coloured material and draw into this with your pencils or markers. When this is dry, add some solid shapes of a brighter colour, perhaps to a vase and flowers. A small sketch like this containing areas of fairly muted tones with odd spots of bright colour can have instant, dynamic impact and can be used as the basic idea for a much larger work. If you feel your sketch is worth taking to the next stage and developing further, don't copy it slavishly, as you will lose the spontaneity achieved in the original.

Try painting on a much larger scale. Throw caution to the wind and use a whole sheet of watercolour paper.

Draw with speed and ignore perspective, shadows and highlights. Concentrate on the balance of your composition, creating larger areas where there isn't much happening and counterbalance them by introducing sections of detail and colour. Make use of any happy accidents and aim to keep the image vibrant and lively throughout the whole painting process. Mistakes will occur when you are working at speed, but in this exercise don't worry too much about making them. If you can't correct them, try to incorporate them into the picture, as something that you perceive as wrong may not even be noticed by someone else.

Don't aim for accuracy as there are no strict rules to follow here, but instead adopt a more fluid, lyrical approach to your painting. This may be new and unfamiliar for you but it may lead you into exciting and exhilarating territory.

'There is in art the notion of less is more, which is to say, you don't torture a painting that has already confessed.'

Robert Brault

Thistle Composition, *Clare Wake, watercolour and gouache on paper. The sun-bleached cream and opal colours of the spiky stems and the sunburst qualities of the seeds made this thistle lying on an old baking tray into something like a firework display. The network of criss-cross lines was achieved by applying masking fluid in a ruling pen at the start of the painting before a blue and yellow wet-in-wet wash was laid down. Extra white lines were added later where necessary using white gouache. The sharp, crystalline patterns around the seed heads were patiently reclaimed from the initial chaos of the picture, each tiny shape individually painted in watercolour or gouache.*

Simplification

Your paintings don't have to be too complex, as sometimes a simple composition can have as much impact as one full of objects and incidents. There doesn't have to be layer upon layer of shape and colour. Consider a single object placed in an empty space with either subdued or dramatic lighting. Such a composition can create an evocative and enigmatic mood without having to try too hard as far as the actual painting is concerned. However, careful thought should be given to your choice of object and to its location within the composition. There is sometimes a fine line between a simple, charming painting and one that is just uninteresting.

> *'Faithfully copying every detail you see doesn't work – too much detail destroys the illusion.'*
>
> Anon.

Realism

If you like to paint in a realistic way, there are, of course, varying degrees of realism. There is a kind of naturalistic realism that follows all the rules of perspective, composition, shadows and highlights and so on, but still allows for a certain degree of artistic interpretation. The world around us is, of course, three-dimensional, and we as artists are struggling to depict it in a two-dimensional way. So our paintings can only ever be an analysis of that which we see. Illusionistic realism, photorealism and hyper-realism are a different matter. The artist's aim here is to depict as accurately as possible every single detail in rendering objects in precise detail.

Realism suggests an absence of stylization, artistic trends and conventions and attempts to represent subject matter in a truthful rather than an artificial way.

Once you veer away from the definition of realism or figurative painting you enter the world of abstraction, decorative art, fantasy art and art that falls into many other categories. Realistic art can be created in a contemporary way that doesn't venture into microscopic detail.

While there is much to be admired in the skill by which hyperrealistic paintings are created, very little is left to the imagination. There are no gaps for us to fill in for ourselves, and nothing further to be added.

Demonstration: Realism

The colours used in this painting were:

Permanent White
Pine Green
Brilliant Violet
Cadmium Red
Raw Sienna
Van Dyck Brown
Burnt Sienna
Lamp Black
Cobalt Blue

The paper used was Daler-Rowney Saunders Waterford 90lb Not watercolour paper

In the finishing stages of this painting, Brilliant Violet was used where possible to darken colours in preference to Lamp Black. Although there are quite a few colours in this painting, the overall effect is such that it seems very few colours were used.

The composition was initially set up by simply dropping the boots onto the concrete floor in an attempt to suggest that they had been casually discarded after a walk in the muddy countryside. This didn't prove entirely successful as wherever they landed they just didn't look as though they had been abandoned, so to create the desired effect they were carefully arranged in various poses before a satisfactory impression of abandonment was arrived at.

While contemplating how the finished painting should look, several possibilities presented themselves. Should the background be painted in the same way as the boots or should it be a more central feature of the composition? From which side should the painting be lit? Should the shadows be intense or muted? Where should the boots be placed on the page to create the most visual interest? How realistic should the overall effect be?

The concrete floor was actually far greyer than was depicted in the painting, but it was decided to make it slightly warmer to create a more harmonious colour scheme. Although the rough concrete was mainly grey, there were other colours present, where in places it had been mixed with varying degrees of the cement and aggregate ratio, giving some of the areas a sandy-coloured hue. It was decided early on to create this colour by juxtaposing a myriad of different colours, using small brush strokes side by side and in places one on top of another. The boots were to be painted in a flatter way to suggest the smooth rubber material.

By placing the boots at the bottom of the page a larger area of the floor remained, suggesting perhaps that something else

was going on beyond this. Although the placement of the boots was a subconscious one, the most interesting part of the boot on the left actually falls on one of the areas previously discussed in the section on the 'Rule of Thirds', that part where two of the lines cross.

A sheet of Daler-Rowney Waterford Not surface watercolour paper was chosen for the painting as it was felt that its slightly textured surface could be used to advantage in depicting the rough texture of the concrete.

A simple drawing of the composition that was finally decided upon.

The boots were drawn in pencil and the shadows were loosely indicated. The painting was started outside *in situ*, under natural light, but as the sun moved around the boots were brought into the studio, where they were worked on without attempting to finish any particular part of the painting. With the aid of a light shining from the same angle as the sun earlier, the various areas of light and shade were loosely indicated. The following day, when the sun was in approximately the same place, the painting was continued outside, adjusting the relationship between the various colours that had been used in the studio.

Because of the decision to work on the concrete floor using many different colours and many different brushstrokes, the picture was quite time-consuming, so eventually it was finished in the studio with the boots on the floor as reference. The concrete was painted largely from imagination, adjusting the colour combinations gradually while applying the brushstrokes.

In the first stage of the painting the large area of floor was painted with a thin wash of Van Dyck Brown mixed with a little Burnt Sienna. As the overall effect was to be created with many brushstrokes going in different directions, the initial wash was painted in this way with a round sable brush. Several patches of white paper were left untouched; although most of these would eventually be painted over, they would hopefully add to the rough, textured effect.

The boots were painted in a thin wash of Pine Green mixed with a touch of VanDyck Brown. The familiar logo at the top of the boot was left unpainted and the highlight on the toe of the right hand boot was painted with an even thinner wash of the mixture. The shadow on the floor was a mixture of VanDyck Brown and a little Lamp Black. The shadow between the boots

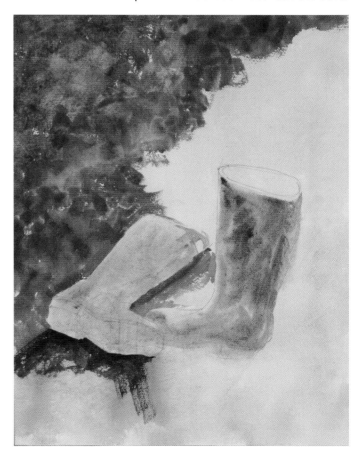

After an initial grey wash was left to dry, the background and boots were painted loosely in their respective general colours.

has a small amount of white added, for no particular reason other than to determine early on just how grey to make, or not make, the concrete. It was noticed that the reflected shadow under the top of the left hand boot was slightly lighter than that under the bottom of the boot. This was because the boot is curved and some light from it is reflected from the ground onto the boot and back into the shadow. However, the thin cast shadow here was even darker than that at the bottom of the boots.

The initial background wash was completed using various strengths of wash and constantly changing the angle of the brushstrokes. It was noticed that the shadow cast from the left hand boot was stronger than that from the right hand boot. The boots were painted with a stronger version of the Pine Green and VanDyck Brown mixture, this time holding the brush at a more horizontal angle to tie-in their treatment with that of the concrete, without suggesting too much texture. Some lighter passages were left where the highlights would eventually be painted.

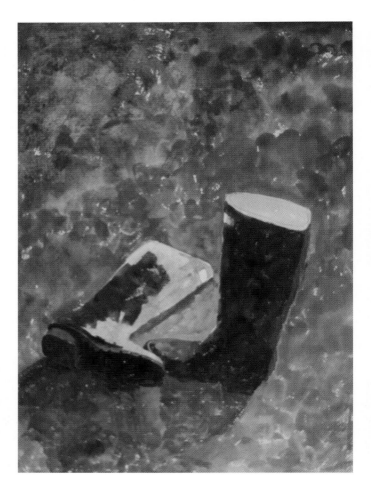

Light and dark areas were now emphasized with more intense colour.

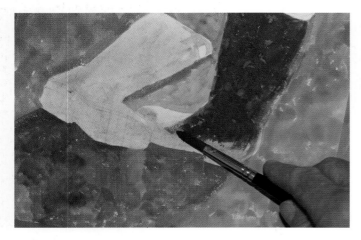

Colour was added, holding the brush horizontally at various angles, to create a textured basis for further applications of colour.

During this stage of the painting, it is always a good idea to keep everything loose while tentatively feeling your way around the picture, and not to decide too early on in the proceedings how dark or light to make the different elements.

More colour was added to the boots, and the logo which had been missed on the right hand boot was left in the colour of the initial wash. The bottom of the left hand boot was painted with a stronger mixture of Pine Green and VanDyck Brown, with the addition of a little Raw Sienna. The strong shadows on the sole of the boot had a little Lamp Black added.

The inside of the boot was painted in Raw Sienna, with a

stronger colour on the right hand side where it was in shadow. Some lighter areas on the boots were painted by adding some white to the original colour. With much eye-squinting and a little imagination, it was noticed that there was a slight blue-ish tint to the shadow cast by the right hand boot. Here a little Cobalt Blue and Permanent White were introduced by mixing a little of each of them with one of the many colours now appearing on the palette. Small brushstrokes were now introduced into the concrete floor. A crack in the concrete was suggested just to the right of the standing boot.

It was now decided to concentrate on the concrete floor and this was tackled by painting several different colours made up of varying proportions of those already on the palette. A smaller sable was used for this and the paint was dragged over the surface of the paper with a dry brush method. Several brushstrokes of one of these colours was added to the whole background, before switching to another colour. The reason for this was to give the whole area a certain cohesion, by having each colour

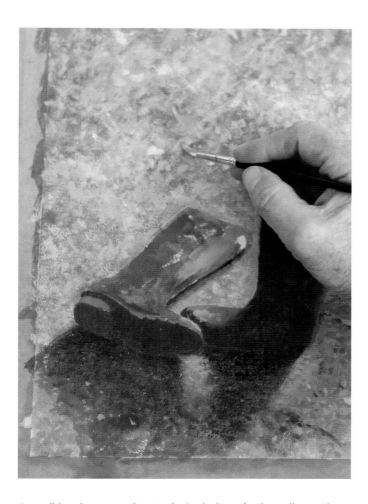

A small brush was used to stroke in dashes of colour all over the background.

The finished picture is unified by the inclusion of the various colours used in the composition, dispersed throughout the painting.

appearing everywhere. The process was repeated using several different colours, changing the angle of the brushstrokes all the time.

More detail was added to the boots by painting the seams and highlights by adding white to the base colour used in painting them. Some Lamp Black was also added to the base colour in defining the shadows on the boots.

The inside of the standing boot was painted with a stronger mixture of Raw Sienna, with a touch of VanDyck Brown added. The highlight on the outer rim was painted with a little white added. Both of these colours were used in adding the flecks of paint to the concrete floor.

For the shadows on the floor, a little Brilliant Violet was mixed with Van Dyck Brown and the colour applied with a dry brush. Some of this colour was introduced into the sole of the boot, and some of the boot colour was dragged over the shadow. This helps to connect the two while each area still retains its own general, local colour. Although the colour of the floor has

veered away from the true colour of the concrete, it was felt that this warmer colour was more acceptable. A slight concession was made to the fact that it was actually concrete by adding several flecks of grey. Eventually a very old bristle oil painting brush was used for suggesting the rough texture of the floor. The floor was now a mixture of both cool and warm colours and the individual brushstrokes made for a more interesting foil to the cold rubber of the boots than if it were painted in a flatter colour. The latter stages of the painting were invented to a certain extent, as they were added in the studio under artificial light.

The pale colour of the logo panels was painted using white, dirtied down with a little colour from the palette. The borders were painted with a small brush using Cadmium Red and the lettering was suggested by using an even smaller brush.

The dried mud on the boots was painted again with a fairly dry brush with a mixture of Raw Sienna, Pine Green and Van-Dyck Brown.

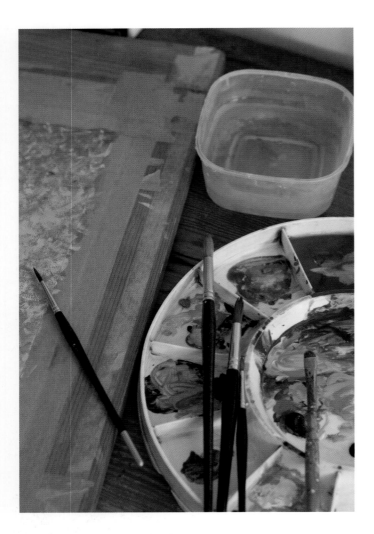

No attempt was made to clean the palette throughout the painting process.

The finished painting is fairly realistic without any attempt being made to take it any further, and there is still room left for the imagination of the viewer to finish it as they wish.

Painting Styles

A fairly detailed realistic image may be the kind of picture you want to create, in which case gouache has the edge over water-colour. It is possible to achieve a solidity of colour with gouache, giving your painting a great deal more gravitas than is possible with watercolour because of its ability to paint light colours onto dark. And by employing the dry brush method, very subtle and complex tones can be created. There may be some painters who

want to go in for photo-realism, in which case there are perhaps other media that are more sympathetic to this style of painting.

Gouache is an ideal medium if you like to paint in a rather graphic style. The apples in the following demonstration were painted in a very simple way with slabs of colour applied with a square-ended brush. Very little blending has taken place, with most of the colours being placed side-by-side or as shapes on top of one another.

Demonstration: Graphic Painting

The colours used in this painting were:

Permanent White
Ultramarine
Cadmium Red
Cadmium Yellow Light
Burnt Umber
Brilliant Green
Lamp Black

The paper used was Fabriano 5 160gsm Not watercolour paper

The apples were placed on a sheet of green card, which in turn was lying on a sheet of dark blue card. They were drawn with a simple outline and the two pieces of card were painted in a thin wash, the green with neat Brilliant Green, and the blue with a mixture of Ultramarine and a little Lamp Black.

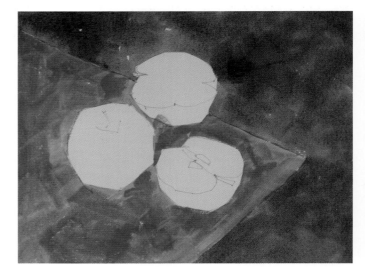

The first broad washes applied in this simple, graphic-style painting.

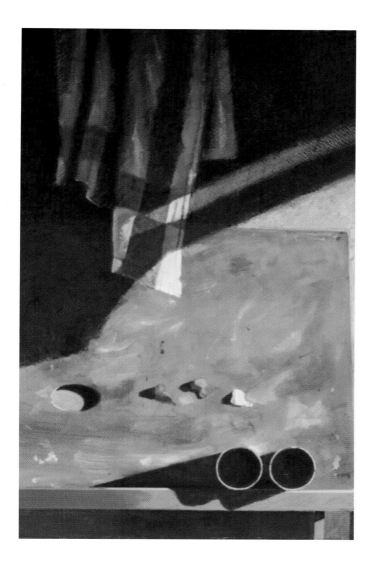

The painting included many techniques associated with gouache painting, and the end result was a semi-abstract image that required the viewer to fill in a few of the indistinct passages for themselves.

painted with mixtures of Yellow Ochre, Burnt Sienna, Lamp Black and Permanent White.

The very dark area of shadow at the top required a different treatment. Much of the work here was painted with a very dry brush and colour almost straight from the tube. It seems that when you're trying to paint very dark, rich colours, adding too much water to the paint can result in a rather chalky look. Several different layers of colour dragged over the surface of the paper eventually produced the desired effect. Ultramarine, Lamp Black and Burnt Sienna were used here. A blue-black mixture was dragged over a blue-brown mixture and vice versa until finally a deeply rich shadow was produced. The same method was eventually used on all of the shadow areas. The blobs of oil colour were given highlights and reflections and finally a dark shadow gave them a fairly realistic three-dimensional look.

With the aid of a ruler, a highlight was painted along the top edge of the easel's ledge and along the edge of the palette. With the aid of a steady hand, a few highlights were added to the rim of the dippers and the edge of the thumbhole.

Sienna and Ultramarine, as were the shadows they formed on the palette and inside the thumbhole. The rim of the dippers bore the residue of many old oil paint colours, so this was painted with little dabs of different colours.

The paint stains on the palette were suggested by scrubbing colour over different areas with an old bristle brush and wiping them with a thumb before they dried. Some areas were re-wetted and more colour was added and then wiped again. This seemed to replicate reasonably well how the palette looked.

The part of the easel seen at the bottom of the picture was

Thinking Outside the Box

Rather than arranging your objects in a traditional way – that is, lining them up to be viewed at eye level or slightly above – try thinking about more quirky viewpoints. Experiment by pushing the boundaries. If possible, view your composition from above, either directly over the objects, or at a slight angle. Even mundane objects take on an extra dimension when seen from an elevated position. A slightly more abstract painting can be produced when thinking outside the box. When setting out your objects, try to think of a way to entice the viewer's eye into the picture. Perspective will be exaggerated and there will be no conventional backdrop against which to set your arrangement. Instead, there will either be a table, fabric or perhaps a floor. This can become an important element in the painting or even possibly the focal point. Consider a group of objects on a patterned carpet or tiled floor. Try taking some photographs from above and then rotate the objects to see if there isn't a more interesting viewpoint to be had. Consider different lighting options. Think about how much of the painting you want to be dark and how much you would like to be light. Do you want a mysterious image or one that is dynamic? A spotlight shone across the image at a low angle creates strong diagonal shadows, whereas a light source directly above gives a more subdued composition. You can define your focal point by placing your objects on one or more of the cross points previously described in the 'Rule of Thirds'.

Demonstration: A View from Above

The colours used in this painting were:

Permanent White
Raw Sienna
Cadmium Red
Cadmium Yellow Light
Cadmium Orange
Burnt Sienna
Cobalt Blue
Lamp Black

The paper used was Bockingford 190gsm Not watercolour paper

Some old pine boards were laid on the floor and the objects were moved around on them until a satisfactory composition was arrived at, to create the impression that the objects had

The initial washes included the suggestion of some of the shadows.

The image was drawn in a fair amount of detail, taking care to get the perspective, and particularly the ellipses, to read in a convincing way. The plate was drawn with a compass.

been placed on a pine table for breakfast. The easel was positioned so that the viewpoint was from directly above the main focus of the picture, which was the croissant, knife and marmalade on the plate. The lighting was directed from above and slightly behind, so that it shone through the semi-translucent marmalade in the glass jar.

The plate was drawn with a compass, but because the other objects were further away they weren't seen as circles but instead as ellipses. These were drawn carefully by eye. The ellipses on the mug are at a slight angle and leaning over to the right, as opposed to those on the marmalade jar. Because the jar is almost directly in front of the viewer, the ellipses here are horizontal. On the left of the plate the ellipses on the lid of the jar lean a little in the opposite direction.

The background and individual items were laid-in with a wash of their local colours, and with the suggestion of

shadows in places. No attempt was made to produce nice, smooth blends, as ultimately nearly everything was going to be painted in fairly opaque colour. A few areas of white paper were left untouched, as these were to be highlights or just areas very pale in colour.

The joints of the pine boards and some areas of deep shadow were painted with a mixture of Burnt Sienna and Lamp Black. These wouldn't normally have been painted so dark at such an early stage in the painting, but at some point the strength of the shadows has to be determined in order to judge how dark or light to make other areas. More colour was added to the boards with sweeping horizontal brushstrokes and the croissant, knife and jar of marmalade were painted with a bit more detail. The marmalade in the jar appeared to be a lot redder than that on the plate, owing to the red material of the jar cover reflecting its colour back into the glass jar.

The image has been slowly given some realism and three-dimensional weight with the inclusion of some stronger shadows.

The grain of the wood has been defined with small, semi-transparent brushstrokes, subtle enough not to compete with the main focus of the painting.

For the time being the marmalade was kept as thin washes in an attempt to retain its semi-transparent nature. The complicated surface of the crusty, golden croissant was built up slowly with layers of thin washes consisting of various amounts of Cadmium Yellow Light, Cadmium Orange, Raw Sienna and Burnt Sienna.

The reflections on the steel knife blade were painted with Cobalt Blue, Lamp Black and Permanent White, and the bone handle with a thin wash of Raw Sienna. Although the mug was actually a dark red, it had a white star on its side, which appeared as blue because of the surrounding colours reflected onto it. So for the time being the mug was painted a slightly darker blue, which was closer to the actual tone of the star. At a later stage the star was drawn in and the dark red painted around it.

The polka-dot material was painted in an opaque red, and the shadows in the fold, together with that created by the jar, were painted a darker red. The lines of white spots were drawn in pencil, taking care to follow the form of the cloth where it curved. They were then painted in pure white on the un-shaded part of the cloth. Only partial sections of the dots were painted where they disappeared into the undulating surface. For the time being those in shade were left, to be painted later in pink where the colour of the cloth was reflected onto them.

More intense colours were introduced into the croissant and the plate, and the shadows on it were painted with a more opaque mixture of Cobalt Blue, Lamp Black and Permanent White. In a couple of places on the plate the shadow appeared a little greener, due to the yellow colour of the croissant being reflected into it. The piece of croissant at the bottom of

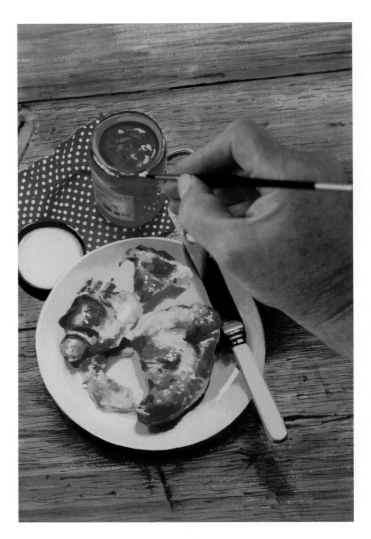

The final highlights are judiciously added to lend even more realism to the painting.

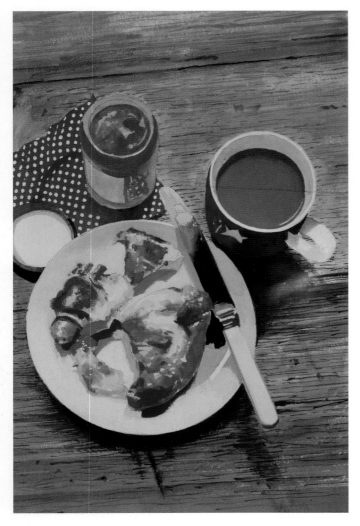

As the painting is slowly built up with ever more detail, acute observation begins to pick out small things in the composition that give the painting more gravitas.

the picture is slightly raised above the plate, and the shadow here contains a certain amount of its reddish-brown colour. A few highlights were added to the croissant and the marmalade on the plate, using Cadmium Yellow Light and Permanent White.

The grain in the wood was painted in more detail, introducing some of the colours evident in the rest of the picture.

The mug was painted a darker red, taking care to work around the star and leaving a small reflection on it from the plate beside it. The tea was painted with a mixture of Burnt Sienna and Permanent White, including the shadow. For the inside of the cup, Raw Sienna and Permanent White were used with more white being added to the area near the handle where it received more light. This same colour was used for the highlight on the

was indicated on the label. The marmalade on the knife was painted in more detail, with some of the blade's colour reflected around its edge, resulting in a greenish tinge.

Now that the pine boards had been completed, the rubber band and its shadow were added. The rim at the top of the marmalade jar was painted and finally some pure white highlights were added here, and on the marmalade at the top of the jar. Some further tidying and sharpening up of the details and the painting was complete.

Framing and Displaying

'Art consists of limitation. The most beautiful part of every picture is the frame.'

G.K. Chesterton

Because gouache is generally used on watercolour paper or board, it is more susceptible to the effects of the elements than some other media such as oil or acrylic. Therefore, the logical way of displaying your paintings would be behind protective glass in the same way that watercolours are presented. Provided you have used good quality, acid-free paper on which to paint, and your frame has been sealed at the back with archival tape or Gumstrip, glass will provide adequate protection for many years to come.

The accepted way of framing water-based paintings is behind a bevel-edged mount of an appropriate width. There are professional mount-cutters available if this is something you wish to do yourself, but you must first ask yourself if the initial outlay of the cost of one of these makes economic sense. If you are only ever going to frame just a few paintings, it is probably worth using a professional framer instead.

Mountboard is available in a great many different colours, so choose one that is complementary to your painting. Usually, you can't go far wrong with white or off-white, but even in the white range there is a bewildering number of different shades. A professional framer will have a large number of samples in the form of L-shaped pieces, which can be laid on the corners of your painting for comparison.

As a general rule, brighter-coloured mounts are best avoided, as they tend to compete with the painting even if their colour is complementary to your picture. You don't want the mount to be the first thing that the viewer notices when looking at your work.

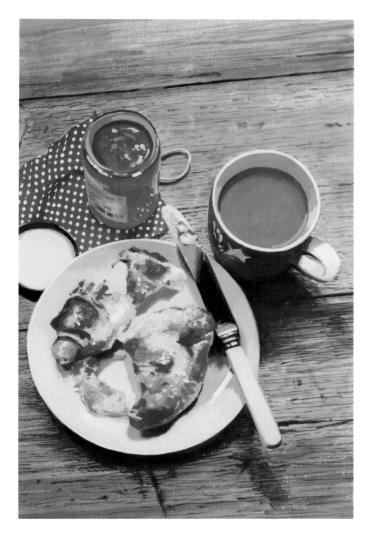

The finished painting falls into the category of 'realistic', without any attempt being made to venture into another stage of realism.

tea. The top edge of the mug was painted in almost pure white, adulterated with a little nondescript colour from the palette. The shadow below the mug now looked too dark, so a semi-opaque wash of the mug's colour was painted over it to indicate some reflection.

The knife's blade was painted with a bit more care and some colour was added to the handle to indicate its curved form. The lid was painted in more detail and the slightly wobbly ellipse was adjusted.

The marmalade in the jar was given some richer colour containing Cadmium Orange and Cadmium Red, while still trying to retain its translucency. Some lighter spots were added on the side of the jar to show the polka-dots reflected from the cloth. The remaining polka-dots were now added and some lettering

A selection of the many sample mounts that a framer will have at their disposal.

A double mount, where one is placed on top of the other, can add a certain touch of class to a framed painting, and with a bit of judicious experimentation, two different colours could be used. The second mount is normally placed a few millimetres inside the first. This has the effect of leading the eye into the painting itself.

It is good idea to make the measurement at the bottom of the mount between 10 and 20 per cent greater than the other three sides. If all sides of the mount are equal, the bottom can look strangely narrower than the other sides when viewed from a distance.

A fine keyline can also be added a few millimetres inside the mount and this is perhaps more suitable when framing a more

A simple frame paired with a suitable double mount may be all that a picture requires.

traditional painting. It is usually done with a ruling pen charged with either ink, thin gouache or watercolour. A very fine fibre-tipped pen can also be used, but sometimes the ink in these pens fades over time and black can even change colour to a dirty purple or brown, depending upon its pigment content.

If you have chosen a gilt frame for your painting, this keyline might look good in gold. Unless you are experienced in this, it is a job best left to a professional framer, as it is very easy to mess up your carefully cut mount.

When pairing a mount with a frame, there are also things to consider. Scale is of prime importance. A fairly wide mount with a narrow frame can be acceptable, while a narrow mount with a wide frame looks distinctly uncomfortable. Choosing a frame of a similar colour to the mount can be rather confusing to the eye, while a brightly coloured frame next to a brightly coloured mount can be quite alarming.

It is worth trying several combinations before you finally decide on your frame and mount.

When choosing a frame, you must also be careful not to choose one that is going to overpower your painting. As with all things, there are trends in popularity, so it is probably a good idea to look at paintings hanging in reputable galleries before making your choice. A style of frame that was popular in the 1970s or 1980s can look decidedly 'last century' and very much out of place now. An unsympathetic frame can immediately ruin a good picture. If you think your picture is worth framing, then it is worth splashing out on a decent one. There is a current trend in frames for a simple, flat, wooden profile, often in white, or one of limed ash that allows the grain of the wood to show through the semi-transparent limed surface. This combined with a plain white mount gives a neat, unfussy, contemporary

Frames don't have to be ostentatious and certainly shouldn't compete with your painting.

A plain wooden frame and single white mount would be ideal for this painting.

look. At the moment it is generally accepted that ornate, over-complicated frames look rather dated and are not particularly appreciated by gallery owners.

If you are contemplating selling your paintings through a gallery, don't compromise on ill-considered or cheap frames. The gallery owner, if the gallery is a reputable one, will not appreciate a frame in poor taste or cheap quality. Some galleries may like your work, but will insist on carrying out the framing themselves to their own exacting standards.

A watercolour or gouache painting framed behind glass will normally be quite a bit more expensive than one produced in the traditional way of framing an oil or acrylic painting that doesn't require the same degree of protection. This is, of course, due to the extra labour involved in the framing process and the cost of the materials.

If you have painted your gouache picture on canvas, canvas board, wood, MDF or any other rigid support, it is possible to frame it as if it were an oil or acrylic painting. As its surface, being water-based, will still be liable to damage from the elements, it will have to be protected in some way. There are varnishes available that will seal the surface of your painting. As gouache remains reworkable just about indefinitely, brush application varnishes should be avoided, as they will stir up the colour and ruin your painting. Instead you should use a spray varnish from a can, making sure to follow the manufacturer's instructions for use. What kind of varnish to use is a matter of personal choice. If you want your picture to resemble an oil painting then you could use a gloss varnish. However, if you would prefer it to be exactly what it is, a gouache painting, then a matt varnish would be more suitable. Be aware, though, if you do decide to varnish your paintings that the varnish will both enrich the colours you have used and darken them to a certain degree.

All in all, it is probably best to frame your gouache paintings behind glass using archival tape, mountboard and backing board, all of which have a low pH value so there will be nothing present to affect your picture. If you really want to create the ultimate framed painting, you can specify the latest non-reflective glass, which is virtually undetectable. However, at present the price is virtually unaffordable!

If you don't want to go to the expense of having your paintings framed, an alternative way of presenting them is to simply display them behind a mount without a frame. The painting can be taped to the back of the mount, which is then covered with a backing board. If they need to be protected, they can be covered with a sheet of cellophane, neatly folded at the back and taped to the backing board. They can then be stacked in a browser if you need to display several of them together. Alternatively you may want to have good quality prints made of your paintings, and these could be individually signed, mounted and displayed in the same way.

Finding your Own Way

If you are new to the medium of gouache, or have never really considered or experimented with using it in a different way, setting up a few objects on a table by a window and having a go at painting them is the perfect way to start.

If you have some experience of working in other media, perhaps you have already developed a particular style of painting

A finished painting in a simple frame and mount.

that you are happy with. If this is the case, it is hoped that this book will have given you some practical help with using a medium that is wholly or partly unfamiliar to you. If you are still struggling to find your own personal style of painting, then you may find something within these pages to set you off on a path in the right direction. While you may like and admire someone else's way of painting pictures, you may not necessarily want to paint that way yourself. It is only through experimentation and

experience that you will find a style that works for you. There is no point torturing yourself by trying to produce ultra-realistic paintings when you are far happier dashing off a loose painting in a couple of hours with a minimum of effort. There are many painters who spend their whole lives trying to simplify their work, only to find that once again they just have to add that little bit more detail.

You may be someone who likes to paint in a traditional

If you don't want to go to the expense of framing your paintings, they can be displayed in a mount without the frame, and protected with cellophane.

way, or perhaps you are more in tune with decorative or contemporary painting; either way, I hope this book will inspire you to go off in a different direction altogether and try something new.

'Creativity is contagious, pass it on.'

Albert Einstein

RECOMMENDED ART SUPPLIERS

Winsor & Newton: www.winsornewton.com

Jackson's Art Supplies: www.jacksonart.com

L. Cornelissen & Son: www.cornelissen.com

Ken Bromley: www.artsupplies.co.uk

SAA: www.saa.co.uk

Atlantis Art Materials & Art Supplies: www.atlantisart.co.uk

C Roberson & Co. www.robco.co.uk

Daler-Rowney: www.daler-rowney.com

Eckersley's Art & Craft: www.eckersleys.com.au

The Art Shop: www.theartshop.com.au

Cheap Joe's: www.cheapjoes.com

US Art Supply: www.usartsupply.com

INDEX

atmosphere 37–38, 69, 76, 86, 89, 99, 108

backgrounds 75–77, 83–87
 blending medium 23
brushes 21–22
brushstrokes 52–53, 73, 75–76, 80, 121, 123, 127–129, 131, 135

colour 46–48
 a basic palette 16
composition 25, 27–31, 34, 38–39, 43, 45, 48, 50, 59, 68–72, 78, 80, 83, 87, 89–90, 95, 98–100, 103, 105, 115, 119–122, 129, 132, 136
 appeal of 111
 from above 133
 good 59, 63
 in one colour 51
 interesting 93
 shadows in 107–108
 set up the 109
 simple 117, 126
 sensational 125
 subdued 133
 satisfactory 134
 unified 86

drawing 27, 63, 75
 observational 68

ellipses 27, 35–37, 40, 75, 134
equipment 11–12, 15–23, 18, 21, 23, 29, 37

flowers 54–81
 choosing 80
 different types 77
 dried and artificial 75
 in containers 79
 problems 70

focal point 13, 63, 133
framing 137–141

gouache 12–13
 history of 7–11acrylic 123
gum Arabic 23
 Gumstrip 18–21, 23, 51, 137

highlights 49–50, 54, 56, 67, 70, 75–76, 80–81, 84, 89, 91, 93, 95, 98–99, 104–106, 113

inspiration 25--6, 31, 40, 83, 108

lighting 37–39, 60–62

markers 117, 119
masking fluid 25, 43, 113, 117, 120, 125
materials 15–23, 117
 natural 39
mdf 120–123

object selection 39–41
other media 117–120
ox gall 22

painting styles 130–131
palettes 22, 43, 51–52, 85, 93, 119
paper 16–21
 pastel 21
 stretching 18–20
 tinted watercolour 20
 tracedown 46–47
 watercolour 16–20, 33, 44–47, 51, 63, 110, 120, 125, 137
pastels 8, 10, 117–120,
perspective 27, 33–37, 40, 69, 123, 125–126, 133–134
 unusual 89

realism 126–129
reflections 38–40, 49, 70, 80, 135
rule of odds 29
rule of thirds 30, 127
shadows 32, 37–40, 49, 53–54, 56–57, 59, 62, 67,
 70–71, 73, 75, 81, 106–111, 127–129, 131–136

sight scale 27
simplification 126
sketch 45–47, 63, 125,
 compositional 45
 enlarging 46

spontaneity 123–125
still life 13
 outdoors 93–101

tonal value 47

viewpoints 79–80, 131
unusual 132–137

water 40, 43–44, 49, 51, 53–54, 65–66, 70, 78–79
 painting 69, 80
wet-in-wet 71, 123, 125